CLEMENTINA, LADY HAWARDEN

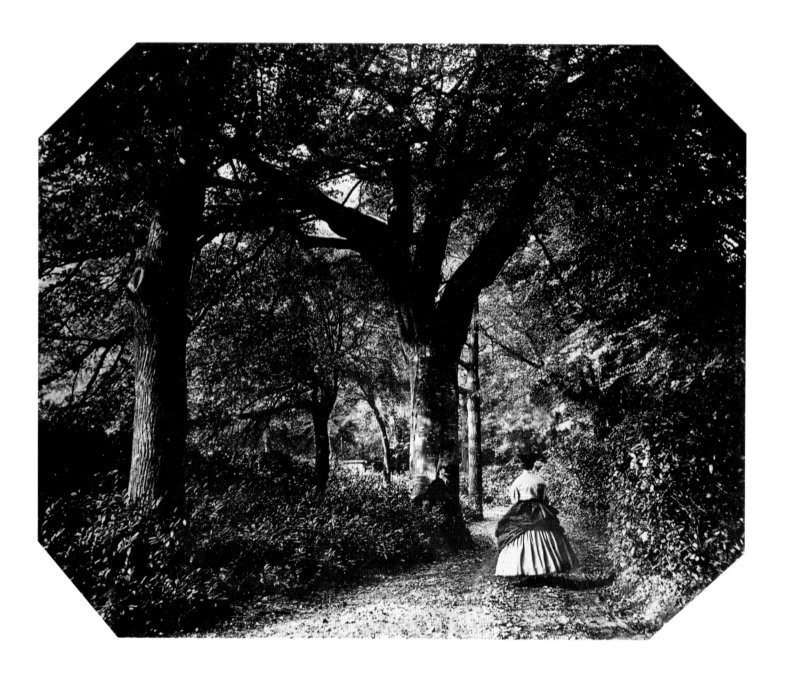

CLEMENTINA, LADY HAWARDEN

STUDIES FROM LIFE

1857 ~ 1864

BY VIRGINIA DODIER

INTRODUCTION BY MARINA WARNER

AFTERWORD BY MARK HAWORTH~BOOTH

APERTURE

In loving memory of my grandmothers,
Josefa Guerra Dodier (1888–1955) and
Nellie Wells Hernandez (1896–1997).

Posterity, by the agency of Photography, will view
the faithful image of our times; the future student,
in turning the page of history, may at the same
time look on the very skin, into the very eyes, of
those, long since mouldered to dust, whose lives
and deeds he traces in the text.

—WILLIAM LAKE PRICE
Preface, *A Manual of Photographic Manipulation*
London, 1858

Table of Contents

The Shadow of Young Girls in Flower

BY MARINA WARNER

Over ten years ago, when I was looking at some photographs in the print room at the Victoria and Albert Museum, Mark Haworth-Booth, the Curator of Photographs, said he wanted to show me something. He took me back into the stacks behind the softly closing double doors beside the desk and past several tall racks of boxes to a long, dark room where, on a huge table, I saw Clementina Hawarden's photographs for the first time. Virginia Dodier was there, working on the catalogue raisonné, and she began turning over the images as she told me about the artist who made them.

Not much is known: the bequest of an extraordinary archive (775 individual items) kept in the family until 1939 had materialized from the early years of the medium without accompanying critical apparatus, biographical background, or public history. It was an enigmatic, closed treasure: a body of work about intimacy and reverie, about interiors and disguise, about secrecy and private passions, about family, beauty, self-fashioning, and reciprocal feelings. It kept itself to itself, even though the images swam into my eyes, as they do for all their beholders, with the intensity of a hypnagogic dream.

Virginia Dodier has patiently excavated the story of the maker of this hoard, following traces in journals, correspondence, genealogies, memoirs, and family records. Clementina, Lady Hawarden, née Fleeming, was a magician with luminosity and lightness (the muslin curtains *contre jour*, the diaphanous textiles with the sun playing in them, the barred shadows on the walls and floors), and her tread on history was comparably light. Dodier's research sensitively restores the artist's family background, her childhood, and her short life as a wife, mother, and photographer. Hawarden was half-Scottish, half-Spanish, and married into the Anglo-Irish Protestant ascendancy. A fanciful bohemian streak enlivened the landed and aristocratic lineage from which her father and her husband came. After her marriage in 1845 to Cornwallis Maude, later 4th Viscount Hawarden, she bore ten children, a child every year or every other year until a matter of months before she died of pneumonia, at the age of forty-two. She lost two babies in infancy; but, like a mother in a fairy tale, she had seven daughters, who, with her only son, survived her. Her seventh child was given a family name, Elphinstone, and this little girl was known as Eppie. In the style of the crowded, tribal families of the English upper classes, all the others had nicknames too; these pet names spin a closed, private world of the nursery, since they are used only by intimates. They also tend to flatten gender: it was Trotty (Isabella Grace) and Chukky (Clementina, like her mother) and, less frequently, Bo (Florence Elizabeth) who were their mother's principal models, appearing again and again in the images. Trotty was just nineteen and Chukky seventeen when their mother died.

Confinement was a literal condition for this house of women: Hawarden was pregnant or caring for infants throughout the short years of her working life (Dodier dates her earliest photographs to 1857). With the exception of some exterior images made at the ancestral estate in Ireland, her photographs explore ideas of enclosure: they acquaint us intimately with the walls of the rooms

that she and her flock of girls inhabited. We can map, as Dodier has helpfully done, the arrangement of rooms, balcony, and terrace of the house in South Kensington where they lived. Yet the stars on the wallpaper, like the casements opening on to the city, seem to dissolve the borders of their enclave, promising something enticing, formless, and undefined that beckons from beyond. The girls are also often veiled and swathed and draped, with the laced bodices and tight waists of Victorian dresses. In some cases, they are wearing their mother's clothes, from an earlier period of corseted and enveloping fashion; in other cases, they have encircled their brows with pearl diadems and laced dancing pumps on their feet. They often recline languidly or gesture passionately, even sometimes hugging the walls like the anguished heroines of Italian opera, or, as Dodier points out, the Madonnas and Magdalenes of Italian painting, which Hawarden had seen as a young woman in Rome in the 1840s. Yet the sense of their confinement is not desperate; the photographs do not express hothouse oppression but rather the young women's command of a potent inner life and a pleasurable complicity in their mother's work.

In her book of essays *Risking Who One Is* (1994), the critic Susan Rubin Suleiman takes issue with the prevailing tendency, in psychoanalytic theory and elsewhere, to place "the artist, man or woman, in the position of the child." She questions Roland Barthes's assertion in *Le plaisir du texte* (1973), that "a writer is someone who plays with his mother," and asks, "what about the writer who is the body of the mother?" The question can be extended to artists who work in media besides language. Julia Margaret Cameron, Hawarden's contemporary and fellow pioneer in photography, also used her extended family—including her household servants and her large circle of acquaintances—to pose for portraits and play characters from Arthurian romances and biblical allegories. She too worked at home, with people with whom she was intimate. Cameron was older than Hawarden when she began her career: one of her daughters, on leaving home, gave her a camera as a substitute com-

panion. Also, Cameron told stories for a wider public: she gave identifying captions to her tableaux and published and exhibited energetically. In contrast, Hawarden's daughters pose for their young mother in attitudes and characters whose meaning and narrative are lost, if they were ever defined. As a mother confined, as a lady of high social standing, living in town with her soon-to-be-eligible offspring, Hawarden worked with the materials at hand like so much quarried marble or local clay: her photographs communicate the idleness and even the emptiness of the upper-class woman's life, but transmute these conditions through artistic control, through the intensity of her concentration on creating an atmosphere, on setting a mood. Her images represent a triumph of artistry over circumstance, a sequence of ravishing glimpses of *jeunes filles en fleur* left to their own devices, and thriving on it. These photographs are dreamlike, intensely and tenderly subjective, expressive of that "inward eye that is the bliss of solitude," as William Wordsworth wrote half a century before.

The Victorian poet who comes to mind most strongly, however, when looking at Hawarden's photographs of her daughters, is Christina Rossetti, eight years older, who published *Goblin Market* in 1862. Though the mood could not differ more from Hawarden's feminine mise-en-scènes (*Goblin Market* is a frenzied, sensual, headlong, and highly excitable journey to an accursed other world of forbidden pleasures), an affinity does exist, in the writer's and the photographer's treatments of sisterly love. Lizzie and Laura, the protagonists of the poem, both make a dream voyage to the realm where the seductive, poisonous goblins dwell; but Lizzie undertakes it in order to wrest the spellbound Laura from the clutches of those disturbing, queer little men. This same sense of a passionate alliance between sisters resonates in Hawarden's enchanted images of the two young girls questing as they gaze into each other's eyes, dressing up together to play their make-believe games, embracing, and lying dreaming side by side.

Alice Liddell, whom Lewis Carroll idolized as his very special friend, also had sisters; and they were also aboard

the famous boating expedition during the summer of 1862 that inspired the story of *Alice's Adventures in Wonderland*. Sisters and sisterhood figure in this book as well, published three years later; especially in the conclusion, when Alice wakes up from the nightmare of the trial, and her sister kisses her and says, "It was a curious dream, dear, certainly. . . ." Alice runs off to tea, but her sister remains on the river bank where she now begins to dream of Alice and of Wonderland, too. This fantasy of an empathy—a twinship—so profound that it unites and melds separate, individual consciousnesses and gives sisters the capacity to enter each others' dreams informs the Victorian concept of mutual love and the female imagination. It also profoundly colors Carroll's nostalgic yearning for ideal girlhood. So it is significant, as Dodier points out, that Carroll bought five photographs by Hawarden in 1864, and then took Mary and Irene MacDonald to be photographed by her. They were the daughters of the writer George MacDonald, his friend and colleague in dreaming up fairy tales for children; Carroll himself made several photographs of these children with their eyes closed, sunk in the kind of reverie that could transport you, he believed, to fairyland.

For Hawarden, the age when a young girl crosses the threshold of adulthood is older than it was for Carroll, who with a celibate's repulsion disliked girls older than twelve. But he may have been inspired by her compositions and adapted them to his preferred models. Furthermore, Hawarden's use of mirrors intriguingly anticipates Lewis Carroll's *Through the Looking-Glass and What Alice Found There*, published in 1871. The second Alice book opens with the heroine interrogating the mirror much as the Hawarden girls do in many of their mother's images. Tenniel's illustrations, which were closely supervised by Carroll, even show Alice grappling with the surface of the looking-glass as one of the daughters does in a Hawarden "Study from Life." Doubles fascinated Hawarden: she often composed the reflections so that they would appear to be different, to occupy another dimension at another angle. Among the photographs Carroll bought and pasted into his album is an image of Isabella Grace (page 48), which shows her doubled in the family cheval glass in just

such an unsettlingly queered manner. Hawarden's attention to composition, shadow, and tone dominates her studies in mirror images, and her mood is quiet and rapt, unlike Carroll's with his fast and sparky wit. But the coincidence between the content of Alice's opening remarks in *Through the Looking-Glass* and Hawarden's formal explorations is nevertheless intriguing. Alice tells Kitty, ". . .there's the room you can see through the glass—that's just the same as our drawing-room, only the things go the other way. . . . You can just see a little *peep* of the passage in Looking-glass House, if you leave the door of our drawing-room wide open: and it's very like our passage . . . only you know it may be quite different on beyond."

Hawarden also used a stereoscopic camera, so that her models were doubled again in twin prints side by side. It is a shame that the illusion of eerie depth created by stereoscopic images is so difficult to stage in an exhibition or a book, since in them, Hawarden's characteristic play with mirrors, windows, and walls would evoke that sense of falling into unreality that Carroll dramatizes at the start of *Alice's Adventures in Wonderland*.

In *What Maisie Knew*, Henry James imagines a world of adults from the point of view of a little girl. Uncomprehendingly, she sees their love affairs and their schemes and deceits. James writes, "She was taken into the confidence of passion on which she fixed just the stare she might have had for images bounding across the wall in the slide of a magic-lantern. Her little world was phantasmagoric—strange shadows dancing on a sheet." James published towards the end of the nineteenth century, when the subjects of Hawarden's studies from life were no longer little girls, and their mother was long dead. Hawarden had pioneered a fresh, unexpected angle of approach to her subjects, to the consciousness and spectacle of girlhood. Adults do not occupy the blurry screen of her imagination or crowd it with their incomprehensible antics. Hawarden's exquisite and enraptured compositions give young women (and we may include her among them) authority over what they see and how they are seen, over what they present and what they conceal. Her studies from life stage a secret, mutual, and loving game of private dreams and unknowable pleasures.

Commandeering a table in the museum's print room, I began sorting, measuring, and examining the photographs. Gradually I found that, far from being a random assortment, many of them could be grouped in sets of images which showed slight variations. Making educated guesses about their original context and arrangement, I identified many separate series (see Author's Note). As the photographs are undated, I established a chronological order by gauging the ages of Hawarden's children as they appear in the photographs. Close examination against the light revealed that many of the prints are inscribed on the back with the children's names, and are numbered as well. After careful consideration I decided that these numbers are random or, at any rate, that I would be unable to discover their original significance.

At the same time, I began researching Hawarden's life. Although her work had been celebrated in several major exhibitions, including " 'From Today Painting is Dead' " (1972) and "The Golden Age of British Photography" (1984–85), little was known about her. One of my first questions was, Did she keep a diary or journal? After more than five years of searching, contacting as many of her descendants and relatives as possible (each of whom was exceptionally kind and helpful), and poring over the handlists of the Royal Commission on Historical Manuscripts, London, I have concluded that if she did keep one, which seems unlikely, it is not extant.

Fortunately, there are several sources of family papers: the Elphinstone Collection, India Office Library, London; the Elphinstone and Cunninghame Graham muniments, Scottish Record Office, Edinburgh; and the Cunninghame Graham papers, National Library of Scotland, Edinburgh. (Unfortunately, the family correspondence does not cover the greater part of Hawarden's photographic career in any detail.) In this wealth of written material—the India Office Library's Elphinstone Collection, for instance, fills more than one hundred tin chests—there are no more than fifteen or twenty letters by Hawarden herself. Her relatives were prolific correspondents and sometimes, it appears, were distressed by her lack of interest in writing letters. As her mother commented with some agitation, "I have not heard from Clemmy since I saw her last . . . , she never writes if I am ill or not."[3] Hawarden's extant letters are charming but not particularly revealing examples of social correspondence, not the intimate outpourings for which every biographer hopes.

Other written records of Hawarden's life are scarce. For instance, she did not figure in newspaper society columns, except in records of her marriage, the births of her children, and her death. Apparently, she was not a frequent guest at balls and other fashionable events.

Fortunately, the photographic journals of her day recognized the merit of her work, from the time of her first exhibition with the Photographic Society of London, in 1863, until a year or two after her death, in 1865. Her contemporaries also noticed her. According to the art photographer O. G. Rejlander, her manner and conversation were "fair, straightforward, nay manly, with a feminine grace."[4] Lewis Carroll, who bought five of her photographs, thought "The best of the life-ones [at the 1864 Photographic Society exhibition] were Lady Hawarden's."[5] In 1951, a picture of Hawarden's once owned by Carroll (page 48) was exhibited—the first appearance of her work since 1865—in "Masterpieces of Victorian Photography, 1840–1900, from the Gernsheim Collection" at the Victoria and Albert Museum.[6]

Since she apparently did not like to express herself in writing, and because her life is minimally documented, Hawarden's photographs should be considered her testament. This is supported by Rejlander's comment that "she aimed at elegant and, if possible, idealised truth."[7]

The key to her photography lies in the fact that she did not give her photographs titles, but exhibited them simply as "Photographic Studies" and "Studies from Life." Believing they would illuminate my study of *her* life, I used the photographs as clues in my research.

Her photographs offer information about the woman who took them through the self-assurance evident in her handling of composition and light; the forthright expression of emotion she encouraged in her models, usually members of her immediate family; and her stylish use of lavish costume and theatrical gestures. These elements combined suggest that Hawarden was an artist in the

romantic tradition, possessed of a good eye, a sure touch, and a strong will.

Today, we may choose to treat her photographs as records of the domestic life of an upper-class Victorian family, or we may regard them as early examples of art photography. Certainly they provide evidence of rapport and cooperation among Hawarden and the members of her family—particularly among her three eldest daughters, who were her principal models. By involving her family in her work, she found in photography a medium that allowed her to direct, document, and participate in their activities. Her photographs served dual purposes: through photography, she could suggest as well as record, evoke as well as document, hint as well as tell.

I conclude with the hope that the rediscovery and examination of Clementina Hawarden's life and work will continue, and that her remarkable photographs, lost from view for so long, will linger in the mind and before the eyes.

Author's Note

Titles

Lady Hawarden did not give her photographs titles. In the Photographic Society of London exhibition catalogs, her entries are listed as "Photographic Studies" and "Studies from Life," both generic terms at that time for art photographs.

Technique

All Hawarden's photographs are albumen prints made from wet-collodion negatives, the predominant photographic processes of the mid-nineteenth century. The wet-collodion process was popular because it afforded short, nearly instantaneous exposure times, crisp detail, and a broad tonal range.

The process involved coating a glass plate with collodion, a gel-like substance made by dissolving guncotton in alcohol and ether. Potassium iodide, suspended in the collodion film, reacted with silver nitrate to form light-sensitive silver salts. This sensitizing process was carried out immediately before exposure. The prepared plate was placed in the camera while still moist. Following exposure, the plate was removed, then developed and fixed on the spot.

Albumen prints were made on plain writing paper coated with a distillation of egg whites and salt (sodium chloride) sensitized with silver nitrate. Prints were made by contact printing, the size of the negative dictating the size of the print. The negative was sandwiched with a sheet of prepared paper in a wooden printing frame that was then set in the sun, which developed the latent image. One could monitor the development by opening the back of the frame and bending back a corner for a quick look. If the print was not ready, it was replaced carefully in the same position so the image would not blur. After the image had appeared fully, the print was removed, toned according to the photographer's discretion, fixed, and washed. Albumen prints characteristically have a semi-glossy surface, depending on the thickness of the egg-white coating, and show, over time, a slight yellowing in the highlights. One could convert the overall tonality to a rich purplish-brown color, and also reduce the risk of fading and yellowing, by treating the fixed print with a gold solution. Some of Hawarden's prints appear to have been toned, but most have the reddish-brown tint of untoned albumen prints. The photographer could make the materials for these processes at home or could purchase them ready-prepared.

Hawarden was noted for her technique. A review in the *Photographic News* (February 27, 1863) of her debut with the Photographic Society stated that the photographs had been "produced . . . with a highly bromized collodion: a very strong iron developer, sometimes containing as much as fifty grains of iron to the ounce, and with [J.H.] Dallmeyer's No. 1 Triple lens, which secures this wondrous depth of definition." (Dallmeyer used this review in advertisements for his "New Triple Achromatic Lens.")

The photographs are what we now term "vintage" prints, probably made by Hawarden herself. The negatives are not extant. The prints show the irregularities of mid-nineteenth-century photographic technique. However, the subtleties effected by these early processes cannot be equaled by modern materials and processes.

Cameras and Formats

Hawarden used several cameras, of different types and formats. It appears that she took her first photographs with a stereoscopic camera. These cameras produced double images that, when seen through a twin-lens viewer, give the illusion of three dimensions. Stereoscopic photographs were very popular in the mid-nineteenth century.

The dimensions of her photographs, and therefore of her plates and cameras, are difficult to ascertain because the corners of the prints were cut or torn irregularly when they were removed from the family albums. However, when the dimensions—as measured through the center of each photograph—are averaged, seven common sizes emerge: 80 x 140 mm (3 1/$_8$ x 5 1/$_2$ in.) and 97 x 158 mm (3 13/$_{16}$ x 6 1/$_4$ in.), both stereoscopic formats; 115 x 88 mm (4 1/$_2$ x 3 7/$_{16}$ in.); 132 x 114 mm (5 3/$_{16}$ x 4 1/$_2$ in.); 152 x 127 mm (6 x 5 in.); 180 x 200 mm (7 1/$_{16}$ x 7 7/$_8$ in.); and 240 x 276 mm (9 7/$_{16}$ x 10 7/$_8$ in.).

Dates

Hawarden did not date her photographs, so I assigned dates according to information found in the photographs themselves, primarily the apparent ages of the children.

Series

Hawarden's work can be divided into groups with visual similarities—the same sitter, subject, or setting, for instance—which indicate that they were taken during the same photographic session. Within each of these groups (called series for the purposes of the Hawarden catalogue raisonné), there are slight—sometimes very slight—variations.

We do not know whether Hawarden conceived her photographs in series or sequences or sets. If she did, she may have developed this practice from working within the established methods of photographic display in the 1850s and 1860s—when pictures were grouped in exhibition frames or albums. Besides being variations on a theme (as suggested by, for example, the photographs on pages 74 through 78), the images in some of these groups may have been linked by narratives that are no longer explicit. As a genre, narrative photography reached its greatest popularity at the time that Hawarden was working—but the subtleties and nuances of her series and sequences are far removed from, for example, the straightforward tale told in four photographs by Henry Peach Robinson in his *Story of Little Red Riding Hood* (1858).

• • •

Virginia Dodier was born in Laredo, Texas and grew up in Texas, Alaska, and Oregon. She began studying photography in high school. She earned a B.A. in English literature from Portland State University, Oregon; a B.F.A. in photography from The Cooper Union School of Art, New York; and an M.A. in art history from the Courtauld Institute of Art, University of London. She was Study Center Supervisor in the Department of Photography, The Museum of Modern Art, New York, 1993–98.

Dodier began researching Clementina Hawarden's life and work in 1984. From 1986 to 1988, with funding provided by the J. Paul Getty Trust, she compiled a catalogue raisonné of the 775 Hawarden photographs in the Victoria and Albert Museum, London. In 1989, she organized the exhibition "Clementina, Viscountess Hawarden: Photographer" for the museum. In 1990 and 1991, a smaller version of this exhibition toured to the Musée d'Orsay, Paris; The Museum of Modern Art, New York; and the J. Paul Getty Museum, Malibu, under the auspices of The British Council.

Dodier is the author of *Domestic Idylls* (Malibu, CA: The J. Paul Getty Museum, 1990); *Lady Hawarden: photographe victorien* (Paris: Musée d'Orsay, 1990); "Clementina, Viscountess Hawarden: 'Studies from Life,'" in *British Photography in the Nineteenth Century: The Fine Art Tradition*, ed. Mike Weaver (Cambridge: Cambridge University Press, 1989); and "Haden, Photography and Salmon Fishing," *Print Quarterly*, 3:1 (1986).

Chapter One: Early Life

Family Background

Lady Hawarden (pronounced Haywarden) was born Clementina Elphinstone Fleeming (pronounced Fleming) on June 1, 1822, at Cumbernauld, the family estate near Glasgow. She was the third child of five; her siblings were Carlota, John, Mary Keith, and Anne. A portrait of her at age sixteen, turned out in gypsy costume (figure 2), evinces the great personal beauty and flair for dress-up that marked both sides of her family—and came to fruition in her depictions of her own children in fancy dress.

The source of Hawarden's penchant for dramatization and masquerade is no mystery—but no less compelling for that, as her family was a colorful lot. Her Scottish father, Admiral Charles Elphinstone Fleeming, was celebrated for his naval exploits off the coasts of Spain and Portugal, and was a key player for the British empire in the Venezuelan and Colombian wars of liberation. Hawarden's mother, Catalina Paulina Alessandro, of Cádiz, married the forty-two-year-old admiral when she herself was sixteen. She was renowned as an exotic beauty, and routinely appeared at costume balls dripping white satin and emeralds in the guise of Madame de Sévigné, the seventeenth-century French woman of letters.

Admiral Fleeming was born in 1774, the second son of the 11th Lord Elphinstone, a Scottish peer and member of an old, distinguished network of Scottish families. In 1799 he assumed the surname of his father's mother, Lady Clementina Fleeming, niece and heiress of the last Earl of Wigton, and inherited the family estates, Cumbernauld and Biggar. His youngest brother, Mountstuart Elphinstone (1779–1859), was widely regarded as one of the most accomplished men of his generation, having spent over thirty years in the East India Company, serving as governor of Bombay from 1819 to 1827.[1]

While on assignment as commander-in-chief on the western coasts of Spain and Portugal, the Admiral met and married his wife in Cádiz in 1816. His reputation likely preceded him to the southern coast of Spain, as he was "a colourful character" whose Byronic escapades purportedly included the abduction of a convent nun.[2] He was dubbed "a terror to every ship's company he commanded."[3] Yet according to his friend Lord Holland, the politician and art patron, he was a man of "honour, veracity and intelligence."[4] His grandson Robert Bontine Cunninghame Graham, the writer (who never knew the

Admiral), recalled stories of "a man who neither writes, nor speaks, nor has excelled in his profession, yet in himself excels."[5]

The family origins of Hawarden's mother are shrouded in mystery. Her Roman Catholic baptismal certificate states that she was the daughter of Luis Alexandro, of Vienna, and Antonia Felipes, of Gibraltar.[6] Additional stories abounded among her family members: one account has it that she descended from the same family as Bonnie Prince Charlie's grandmother, Mary of Modena,[7] while another traces her roots to the Count-Duke of Olivares, chief minister of Philip IV and patron of Velázquez.[8] Her sister's version of events is the least extravagant: their father came from Ancona, on the Adriatic coast of Italy, and though he had been very well off, he lost all his money under unknown circumstances.[9]

Childhood and Education

Clementina and her siblings, like their father, grew up at Cumbernauld House, built in 1731.[10] Family correspondence and records reveal that the Fleeming girls were educated in art, music, languages, poetry, needlework, and sewing. They were trained and encouraged in what is now termed "accomplishment art," the type of arts education then available to young girls of the middle and upper classes.[11] Such learning was considered a suitable accompaniment to feminine beauty—which tends to discount the keen talent, skill, and industry with which many girls and women pursued their artwork. In Clementina's case, for instance, "accomplishment art" may have provided the sound understanding of light, composition, and modeling that she used to great effect in her photographs of the 1850s and 1860s. She evidently shared this type of arts education with her own daughters, whom she often photographed reading, sewing, or playing musical instruments.

Clementina was also likely to have been educated through popular contemporary books such as *Essays Towards the History of Painting*, by Lady Callcott, and—in the days before the great public art museums—visits to private collections of Old Master paintings, such as that of the 3rd Marquess of Lansdowne,[12] a friend of her father's cousin, the Comtesse de Flahault.[13] Though the extent of her knowledge of art history is undocumented, she probably received the same training as her younger sister Anne, whose letters in later life reveal familiarity with questions of style and attribution, particularly regarding Italian and Spanish Old Masters. Many of her costume-tableaux photographs of the 1860s are reminiscent of such masterpieces (page 51).

Beyond these broad outlines of possible subjects, the emphasis of the girls' education cannot be determined since neither schoolroom records nor itemized inventories of the Cumbernauld House library exist. Clementina's academic achievements are unrecorded, but her sister Anne was reputed to be a bluestocking. In 1850, at age twenty-two, Anne wrote in jest to her uncle Mountstuart Elphinstone, "It will be dreadful if I become another illustration of the story of the [too-learned] bear."[14] To this he replied, "I am afraid of ruining your reputation by an opinion that you are going to set up for a *sussante*, & so I have been protesting that your thoughts never went beyond the surface."[15] The anxiety behind these jokes was that Anne (or any woman) would not be considered a suitable marriage prospect if she exhibited her intellectual capabilities. Nevertheless, after her marriage in 1851, Anne continued to pursue art, literature, and politics, and numbered George Bernard Shaw among her many correspondents.

When Clementina was only four, her father was assigned to command the West Indian station of the British Navy. Her parents departed for the Caribbean in February 1827, and the girls were sent to live near London with a "gentlewoman-like Goody."[16] Two years later, the children returned to Scotland, where they were placed in the custody of their paternal aunt Keith and her husband David Erskine at their estate, Cardross. The family wasn't reunited until 1830, with a new addition—baby sister Anne, who had been born aboard her father's ship in the harbor of Caracas.[17] The family resettled at Cumbernauld in 1831.

The Fleemings returned in characteristic high style with a veritable menagerie. Enhancing their reputation for extravagant gestures, they brought from South America

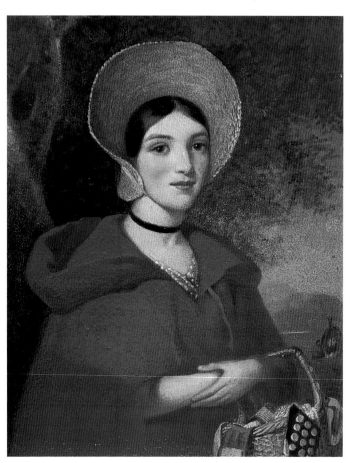

"two packing ponies, a tapir, parrots and peccaries, some boa-constrictors, and a small marvel of the animal creation locally known as a *chirhuiri*, which used to eat off ladies' petticoats as they sat at meals."[18] According to family legend, they also brought the first dahlias to England, from Lima, but the Admiral gave these to Lord Holland, who received the credit for the introduction of a new species.[19]

Admiral Fleeming served as a Whig member of the Reform Parliament from 1832 to 1834.[20] Then as a reward for his long service in the Royal Navy, he was made commander-in-chief at The Nore in Kent (1834 to 1836) and at Portsmouth (1839).[21] Finally in 1839, he was named governor of Greenwich Hospital[22]—a patronage appointment usually allotted to a high-ranking officer of heroic repute. As the Admiral was not a decorated hero, the decision was criticized as an example of Whig favoritism and as evidence of an abuse of family connections.[23] He chiefly concerned himself with restructuring education programs for children of naval personnel, but his tenure was brief.[24] One year later, in October 1840, he died, a few weeks after the death of his eldest daughter Carlota.

His wife and three surviving daughters were left in financial straits, as the Cumbernauld and Biggar estates had passed to the ne'er-do-well only son, John. Mountstuart Elphinstone stepped in, however, and saw that the bills were paid. Mrs. Fleeming vigilantly sought to maintain the quality of the education her daughters had received while their father was stationed at Greenwich, including the instruction of a governess, a music mistress, and a German master. The girls' trustees, Mountstuart Elphinstone and David Erskine, decided they should go abroad, where they would be able to receive a good education despite their diminished resources, and where they would enjoy greater social prospects than in London.

Sojourn in Rome

In the fall of 1841, when Clementina was not quite twenty years old, Mrs. Fleeming took her, along with Mary Keith and Anne, to Rome, accompanied by their uncle Mountstuart. On their six-week journey from London to Rome, the party passed through

Frankfurt, Heidelberg, Schaffhausen, Zurich, Milan, and Florence. On reaching Milan they were "done with lakes & mountains & began churches & pictures," the latter at the Brera Gallery.[25] Clementina was very moved by the art they saw, especially the collection at the Pitti Palace in Florence. Later, in Rome, she wrote to her uncle, who had just left the group to return to Florence, "The only thing I envy you . . . are the pictures. I should like very much to be going with you this beautiful morning to the Palazzo Pitti."[26]

They arrived in Rome in late 1841 and took up residence at the Palazzo Valdombrini, on the Via della Rissetta. Mountstuart Elphinstone introduced his sister-in-law and nieces to the sights. A note to himself on a scrap of paper lists a dozen places to which he apparently planned to take them. St. Peter's tops the list. Clementina especially enjoyed seeing the sights from the many famous vantage points of Rome. She wrote: "The other day we went up to the top of the tower of the Capital [sic]. I certainly prefer the view from thence to that from the Cupola of St. Peter's. We went unfortunately a little too early but at Sunset it must be perfect."[27] On drives in the Roman Campagna, she admired views of the aqueducts and the Frascati hills.

As a pilgrimage destination for artists and art lovers, Rome was nearing the end of its greatest popularity in the 1840s.[28] Yet art, music, and language tutors could still be employed inexpensively. The city provided galleries, museums, antiquities, archaeological sites, churches, and other fine buildings to explore. Not least of all, the girls, after their father's death, stood a better chance socially in Rome. Correspondence between Mountstuart Elphinstone and David Erskine makes clear that the best London society was now closed to Clementina and her sisters. Rome at this time, however, was home to a colony of expatriate artists and intellectuals, many of them kindred Scots.[29]

In Rome, Clementina and her family became acquainted with Mary Somerville, the mathematician and astronomer for whom Somerville College at Oxford University is named. An "old acquaintance" of Mountstuart Elphinstone,[30] she was a lifelong friend of the scientist Sir David Brewster.[31] Although it cannot be shown that Clementina was introduced to Brewster, it is intriguing to speculate that her interest in photography was kindled by a meeting with him, as he was instrumental in the promotion of photography in the 1840s and 1850s, particularly in Scotland.[32] Brewster was also close to Clementina's cousins, the Anstruther-Thomson family; but, again, we cannot know whether they ever met through this connection.[33]

Somerville's activities and pleasures in Rome in the 1840s suggest the ways in which Clementina and her family may have spent their time. The comforts of Rome enabled Somerville to pursue her work; the society and the sights were added pleasures. She "enjoyed herself thoroughly, whether in visiting antiquities and galleries, making excursions in the neighbourhood, or else going with a friend to paint on the Campagna. . . .

The visitors were far less numerous but there was more sociability and intimacy. . . . The artists residing at Rome, too, were a most delightful addition to society." [34]

Clementina's eager observations and keen interest in spectacle and effect are apparent in her response to the carnival season in Rome. Her costume-tableaux photographs of the 1860s demonstrate that masquerade was an enduring and sustaining interest. She wrote, "The Carnival got more and more animated till . . . I really thought every one had taken leave of their senses, it is certainly the most brilliant illumination one can imagine while it lasts, but it is exceedingly difficult to *contribute* to the effect of the scene for long. . . . We went to the Masked Ball at the Theatre which I found much less amusing than I expected, perhaps it may be very amusing for the Masks but for those who only look as we did I think it is quite the contrary." [35] At Somerville's home, Clementina also attended an evening of amateur theatricals, which seems to have made a lasting impression.

Marriage and Children

Although Clementina's family planned to remain in Italy indefinitely, they returned to London in the summer of 1842, after spending only about a year abroad. They returned in order to prepare for Mary Keith's wedding—which left the future for Clementina and Anne less clear. Their guardians regretted their return, because, as David Erskine wrote, "the risk will be their getting into bad society in London, as I fear they will not get in to what they ought to do from their connections, and their beauty will be a snare." [36] With the girls' social standing diminished, he feared that Clementina—whose beauty was considered her greatest asset at this time—and Anne would be enticed into improper liaisons or inauspicious marriages. Moreover, Clementina and her mother and sister had no home to return to, with Cumbernauld now in the possession of her brother John.

Erskine's fears proved unfounded. On March 24, 1845, Clementina married the Honorable Cornwallis Maude (page 19) of the 2nd Life Guards at St. Peter's, Eaton Square, London. [37] This love match was not approved by his parents, the 3rd Viscount and Viscountess Hawarden, who initially would not receive Clementina at their home. Cornwallis Maude was the heir to a title and to a large and valuable estate. Correspondence suggests that the elder Hawardens would have preferred their son to marry a woman who could bring him wealth and property.

Clementina's cousin John, 13th Lord Elphinstone, was rumored to have experienced an unhappy love affair with the young Queen Victoria several years before. His expression of sympathy offers clues to the Hawardens' rejection of Clementina. He wrote, "Poor Clemy! I hope she will be happy, but it is a sad thing to marry into a family that is unwilling to receive you—& it requires a great deal of love on the part of the husband to make up for the want of it in the others. . . . I hope that old Lord Hawarden will be softened at the eleventh hour. Possibly the chance of Clemy's inheriting Cumbernauld might not be without some weight in the scale & of this chance she will be deprived if the entail is smashed [by her brother]." [38]

Marriage in the face of this disapproval required a good deal of courage on the couple's part. If they were ostracized by his family, they risked not only their social stand-

ing, but also their financial security until inheritance of the family title and estate. Clementina, however, was not completely without resources: she and her sisters shared £10,000 after their father's death, and if her brother died childless, she stood to inherit Cumbernauld. In the end, she did inherit the estate, which in turn passed to her son after her death.

It is also possible, however, that the Hawardens—who were Protestant landlords in Ireland—disapproved of Clementina because her mother was a Roman Catholic. Furthermore, they were staunch Tories, while Clementina's father and uncle were well-known Whigs. Despite their disapproval, whatever the cause, when her husband inherited the Hawarden title, Clementina would have a place in that stratum of society known as the "Upper Ten Thousand," the wealthiest landowners in Great Britain.

The couple's devotion to each other, and to their children, is evident in her photographs as well as in family correspondence. A few years after their wedding, Mountstuart Elphinstone wrote that "Maude & Clemy's marriage when they were very ill off was a proof of their attachment at the time, & I am persuaded that the difficulties they have gone through together has [*sic*] only tended to strengthen the tie."[39]

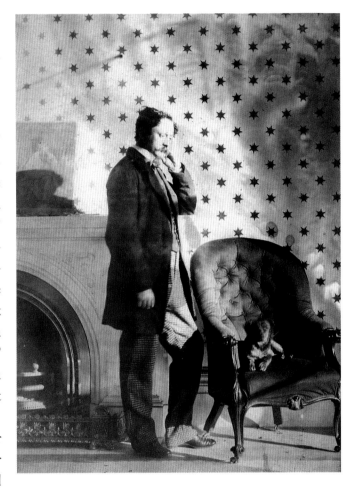

Clementina and Cornwallis had ten children, eight girls and two boys, two of whom died in infancy: Isabella Grace (nicknamed "Trotty," born January 15, 1846); Clementina ("Chukky," born July 15, 1847); Florence Elizabeth ("Bo," born November 18, 1849); Cornwallis ("Toby," born October 22, 1852); Kathleen ("Tibby," born June 18, 1854); Beatrix Emma (born May 4, died August 4, 1856); Elphinstone Agnes ("Eppie," born July 18, 1857); Eustace Mountstuart (born December 6, died December 7, 1859); Leucha Diana (born November 30, 1860); and Antonia Lillian ("Tony," born May 3, 1864).[40] Clementina's life and work centered on the children. According to her sister Anne, she was a "great baby lover."[41]

Love notwithstanding, the quest for male heirs was another reason Clementina gave birth so many times. She was under pressure from her in-laws to produce boys. After her second child, a second daughter, was born, Mountstuart Elphinstone wrote, "I do wish it had been a son. Whatever her former conduct to the family may have been, her not giving it an heir is atrocious. Luckily she has plenty of time left to make amends."[42]

That same uncle, however, also praised Clementina as a mother. In 1854, when she had five children (the fourth one, finally, a male), Mountstuart Elphinstone wrote: "I never saw nicer children or better brought up. This is the opinion of better judges than I. . . . It seems strange in Clemy who could never keep her own shawl in order & whose devotion to her children seemed enough to spoil a whole generation, but her good sense and regard to duty has kept all right."[43]

Chapter Two: Dundrum, County Tipperary, Ireland

For the first twelve years of their marriage, Clementina and Cornwallis Maude and their children lived in London. He was apparently reconciled to his parents soon after marriage, and the couple's circumstances appear to have been modest but comfortable. When his father died on October 12, 1856, however, the couple's standing improved dramatically. Maude succeeded to the title of 4th Viscount Hawarden and inherited the large family estate, Dundrum, in County Tipperary, Ireland. The family moved there in 1857. According to Anne, the new Lord and Lady Hawarden "expected to be now very comfortably off,"[1] as the size and value of the estate placed them in the ranks of Britain's wealthiest landowners.[2]

Although it is not obvious from Hawarden's photographs of Dundrum, the romantic and picturesque landscape was man-made. Until the last quarter of the eighteenth century, the estate grounds had been formally landscaped with "parterres, parapets of earth, straight walks, knots and clipt hedges."[3] When the agriculturist Arthur Young visited Dundrum in 1776 to assess the "system of husbandry" then in use, he noted that the grounds had been renovated into "one very noble lawn . . . scattered negligently over with trees," with a river winding through.[4]

The troubled history of conflict between Protestant landowners and Roman Catholic tenant farmers, however, roiled behind the calm stillness of Hawarden's landscape photographs. The local people resented the Hawarden clan, who had arrived with Cromwell's army in the mid-seventeenth century. The troubles climaxed in 1776, when Lord de Montalt (as the family's title then was) was instrumental in the execution of a Roman Catholic parish priest for alleged complicity in a murder.[5]

When the new Lord Hawarden and his family moved to Dundrum eighty years later, the memory of this event was still fresh. So were the effects of the evictions of some two hundred families, reportedly carried out by his father in the 1820s,[6] and of the potato famine of the late 1840s. Records suggest, however, that the new owners were deservedly more welcome in Dundrum than their predecessors had been. The fact that Clementina's

mother was a Roman Catholic probably softened the way in which locals perceived her and her children.[7] Furthermore, her charity is well-documented—especially her efforts to raise funds in London for famine relief in Tipperary. At the time of her death, she was eulogized by the local Protestant paper as "the respected and beloved Viscountess Hawarden." The obituary said, "Her study through life seemed to have been how she could best relieve the wants of the poorer classes not only on the Hawarden estate, but on the surrounding estates; and well did she succeed in her charitable undertaking."[8]

Neither was Clementina's husband an absentee landlord. Rather, he took an active interest in the management of the estate. Even after they acquired a house in South Kensington, London, in 1859, he often returned to Dundrum, sometimes accompanied by his wife and family.[9] He was considered an expert on the "Irish Land Question," often speaking on the subject in the House of Lords, where he was a Conservative representative peer for Ireland from 1862 until his death in 1905.

First Photographs

Lady Hawarden began taking photographs after the 1857 move to Dundrum. Her interest in photography may have preceded her first pictures by several years, but it was her husband's inheritance that afforded the money, time, and work space necessary for photography in that era. The exact date of her first pictures is unknown, but judging by visual evidence, such as the apparent ages of her children, she probably started in 1857. In October and November of 1858, Hawarden's stepfather Admiral James E. Katon visited Dundrum. According to her mother, he "assisted Clemmy with her Photography, to which she seems as much devoted as ever, and has really done some very pretty landscapes."[10]

The date is significant because it places Hawarden as a transitional figure between the aristocratic and learned amateurs of the 1840s and the professional art photographers of the 1860s.[11] She began working some eighteen years after the announcements of the first photographic processes in 1839. She used the wet-collodion-on-glass negative process, which was published without patent restriction by its inventor, Frederick Scott Archer, in 1851. By the time she began, photographic technique, materials, and equipment were relatively standardized, although a good deal of care and a certain aptitude were necessary to ensure success. Hawarden's photographs demonstrate that she had the requisite knowledge and skill, but she could not have advanced as quickly as she did if she had begun much earlier and been forced to struggle with unreliable materials and equipment.

Hawarden may be considered one of the second generation of amateur photographers, those who came to the fore during the wet-plate era. Many of the first generation, active in the 1840s and early 1850s, were upper-class and well-to-do, steeped in learning and culture, and driven by an enthusiasm to advance science. Many were members of such learned groups as the Royal Society, the Linnean Society, and the Society of Antiquaries. It seems that Hawarden, however, was more interested in the art than in the science of the medium. Despite her demonstrated aptitude for the refinements of photographic technique, her chosen genres—the self-consciously artistic "Photographic Studies" and "Studies from Life"—suggest that her motive was not primarily scientific. The stylistic qualities of her work point to a person with a sophisticated visual vocabu-

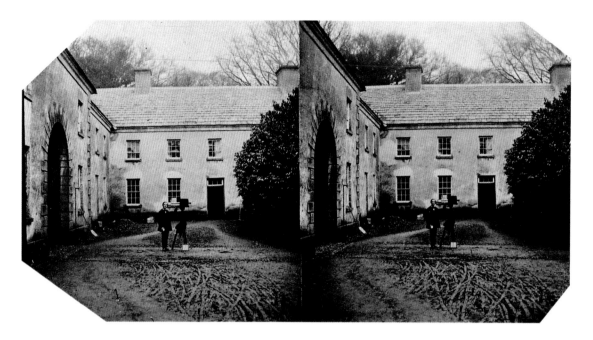

lary who wished, above all, to make pictures—though her achievements in composition, lighting, and expression were undergirded by a sound technical base.

It was not necessary to take lessons in photography, as handbooks were widely available. William Lake Price's *A Manual of Photographic Manipulation* (London, 1858) was popular. A photographer who began as a painter, Lake Price wrote the first photographic manual to discuss image and technique together. His headings under "Subjects: Their Nature and Treatment" include categories that would easily accommodate Hawarden's subjects, such as: Portraits, Groups of Several Figures in the Studio, Rustic and Picturesque Figures, Instantaneous Pictures, Landscapes, and Animals.[12]

Lake Price's book noted that the wet-collodion process superseded the daguerreotype because of its "rapidity of action," because it could be "manipulated at infinitely larger sizes," and because of its "unlimited power of reproduction." Its advantages over the calotype were "incomparably greater sensitiveness . . . superior discrimination of textures, and minuteness of detail."[13]

If Hawarden received instruction in making wet-collodion negatives and albumen prints, the identity of her teacher or mentor has not been established. The speed with which she became proficient is impressive. Because her first photographs appear to have been taken at Dundrum after the family moved there, it seems unlikely that she studied in London—where it was relatively easy to take lessons in photography at establishments such as the Photographic Institution. Another option was to pay a professional photographer for instruction in his studio. O. G. Rejlander learned the wet-collodion process this way in 1853 from Nicolaas Henneman, a former employee of William Henry Fox Talbot, at his London studio.[14]

Because Rejlander's style was similar to Hawarden's it has been suggested that perhaps he taught her. He was well known and well liked in photographic circles, and his advice was sought by amateurs, including Lewis Carroll.[15] The fact that Hawarden began taking photographs in Ireland, however, and that Rejlander lived in Wolverhampton, England until 1862,[16] tends to discount the possibility. Henry Stuart Wortley (an amateur who quickly rose to prominence in the Photographic Society of London in the early

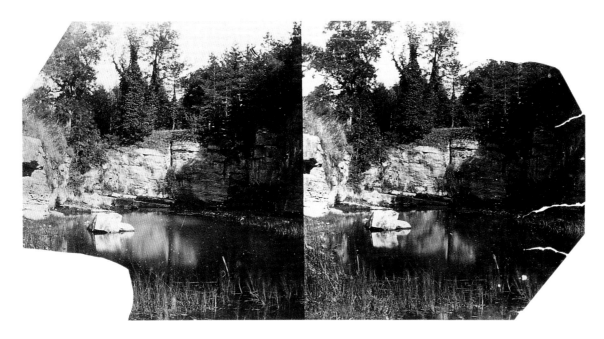

1860s) also may have influenced Hawarden, as he was an associate of her husband's in a business venture, the United Association of Photography,[17] which began in 1864. It has not been established, however, that he knew Hawarden at the time she began taking photographs.

When Hawarden worked outdoors at Dundrum, family members or servants probably helped her lift and carry her equipment: the camera itself, glass plates, bottles of solutions, dishes, and a "dark tent," a portable darkroom necessary for outdoor work. She probably prepared her plates herself. This involved first cleaning, drying, and polishing the glass. Then the plate was coated with a thin, even film of collodion, a gel-like substance made of guncotton dissolved in alcohol and ether, in which potassium iodide was suspended. The swirls and feathering effects in many of Hawarden's photographs demonstrate the difficulty of coating the glass smoothly without mishap (page 31). In subdued light or darkness, the coated plate was sensitized in silver nitrate solution immediately before exposure.

Hawarden composed each photograph by viewing the image on the ground glass of the camera, where it appeared upside down, inverted by the lens. (In modern single-lens reflex cameras, this inversion is corrected by a mirror.) First she focused the lens and gauged the exposure time. She placed the prepared and sensitized plate, while still moist, in the back of the camera, and removed the dark slide. Then she exposed the negative by removing the lens cap, counting out the seconds or minutes of the exposure, and replacing the cap. The dark slide was returned to its place in front of the exposed plate to protect it from light. Then she removed the whole negative holder and put it to one side to await development of the plate. The entire process took about twenty minutes.

Photographic chemicals could be purchased ready-made from pharmacists or photographic suppliers, or prepared with the aid of published formulas. In 1863 the *Photographic News* wrote that Hawarden used "a highly bromized collodion: a very strong iron developer, sometimes containing as much as fifty grains of iron to the ounce"[18]— probably her own formula, devised through trial and error. Printing paper could be prepared by coating plain writing sheets with albumen (a distilled solution of egg whites)

and sensitizing these with silver nitrate, or one could purchase ready-coated sheets. Hawarden probably printed her own photographs as well, as her prints are marked by the inconsistencies and idiosyncrasies of amateur production.

Landscapes and Views

At the time of her initial visit to Dundrum, in 1855, Hawarden was reported by her sister to have found the estate "very pretty but much too large for the fortunes of the family. All the fences, roads, garden &c were in dreadful order, which is a melancholy prospect for [her husband] who will have to put them all in order; and [that is] no joke."[19] At the same time, Hawarden was "enthusiastic in praise of Tipperary scenery."[20]

The photographs that seem to be her earliest feature Dundrum House and scenes around the estate in stereoscopic format. She worked with stereoscopic cameras for a

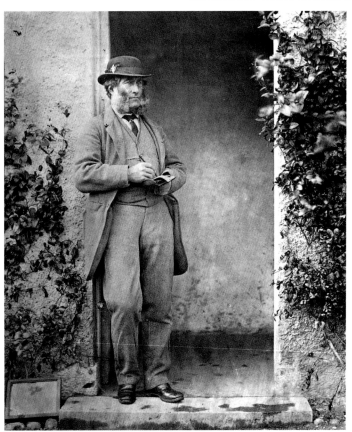

few years before converting to cameras of larger, single-image formats. (Details regarding her lenses and other equipment may be found in the Author's Note.) Stereoscopic cameras were introduced to the public in 1851 and were greatly popular through the end of the century. Small, compact, and portable, they required relatively brief exposure times because of the short focal length of the lenses. They were compatible with various subject matters, both indoors and outdoors. Finally, it was possible to adapt a stereoscopic camera for use as a *carte-de-visite* camera, as Hawarden did.

At first glance, Hawarden's early stereoscopic views seem to be unoriginal or, at best, typical records of appearances. Their merit is fully apparent only in stereoscope. In three dimensions like miniature stage sets, clumps of shrubbery, rocks, and trees form scenic flats, progressing in orderly perspective into the distance. These pictures possess a palpable sense of exploration, not only of a new environment but of a new medium.

A fellow amateur photographer, Dr. W. D. Hemphill, who lived some fifteen miles from Dundrum in Clonmel, County Tipperary, was also experimenting with a stereoscopic camera. Hawarden may well have been familiar with the photographs he published in *The Abbeys, Castles and Scenery of Clonmel and the Surrounding Country*. These were taken in 1857 and 1858, but were not published until 1860. As Dr. Hemphill wrote in his preface, "the only credit . . . I can lay claim to is that of being the first to use Stereoscopic Photographs for the purposes of book illustration and also the first to photograph in detail the antiquities and beauties of this neighborhood."[21] Dundrum House was not among his subjects, nor were the Hawardens listed among his patrons and dedicatees. From about 1864 on, however, Dr. Hemphill began to photograph tableaux (figure 3) of the daughters of his patroness, Mrs. Osborne of Newton Anner House, near Clonmel, in a style that reminded viewers of the "effects of . . . Lady Hawarden."[22]

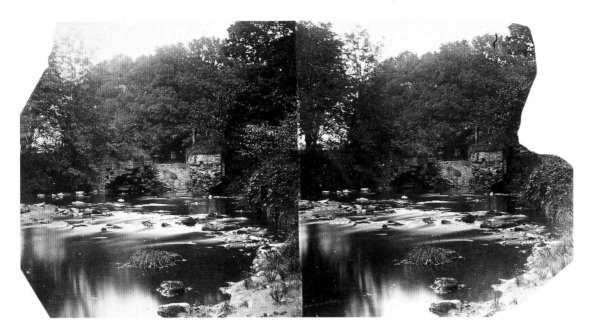

It seems likely in any event that Hawarden's enthusiasm for photography would have brought her to the attention of other photographers in the Dundrum area, such as the unidentified young man in the photograph on page 22, who was probably a fellow amateur. His camera, on a tripod, appears to be a single-lens bellows type. The object leaning against the tripod is possibly a dark slide or negative holder; against the wall in the left background is what may be a printing frame.

When Hawarden's stepfather, Admiral Katon, visited Dundrum in late 1858, he may have helped her with her photography simply by carrying her equipment. Or he may have helped her to choose appropriate motifs or scenes. He was an enthusiastic amateur watercolorist who filled sketchbook after sketchbook, although he seldom painted landscapes, favoring ships and seascapes instead.[23] Hawarden's appreciation of Admiral Katon's métier is evident in her photograph of him sketching at Dundrum (page 24). Standing framed in a doorway, he is placed firmly in context in a composition that illustrates two methods of picture making: as he sketches, the action of sunlight is making a photograph. The printing frame is placed beside him deliberately to draw out this parallel. When William Henry Fox Talbot termed the photographic process "the pencil of nature," he had precisely this sort of analogy in mind.

Dundrum Scenes

Dundrum afforded many opportunities for pastoral landscapes of a type popular with early amateur photographers. The prototype of the landowning amateur photographer was set in the early 1840s by Talbot at his home, Lacock Abbey, and by his kinsman John Dillwyn Llewellyn at his Welsh estate, Penllegare. The connection between amateur photography and property is easy to identify: for the landed amateur, a country estate was not only a source of income and place of pleasant recreation, but a picturesque setting for photographs as well.

Many of Hawarden's photographs, however, record the other side of life at Dundrum. For instance, men hard at work in the fields and in the stables pause for her camera, perhaps not unwilling but slightly puzzled by this unfamiliar form of attention. Hawarden's attitude to these men seems respectful of their autonomy in that she photographs them

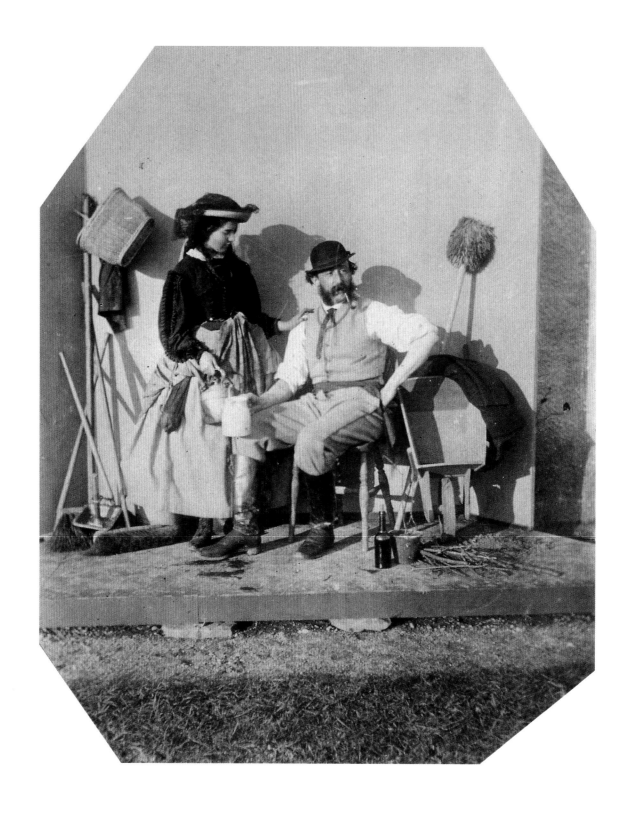

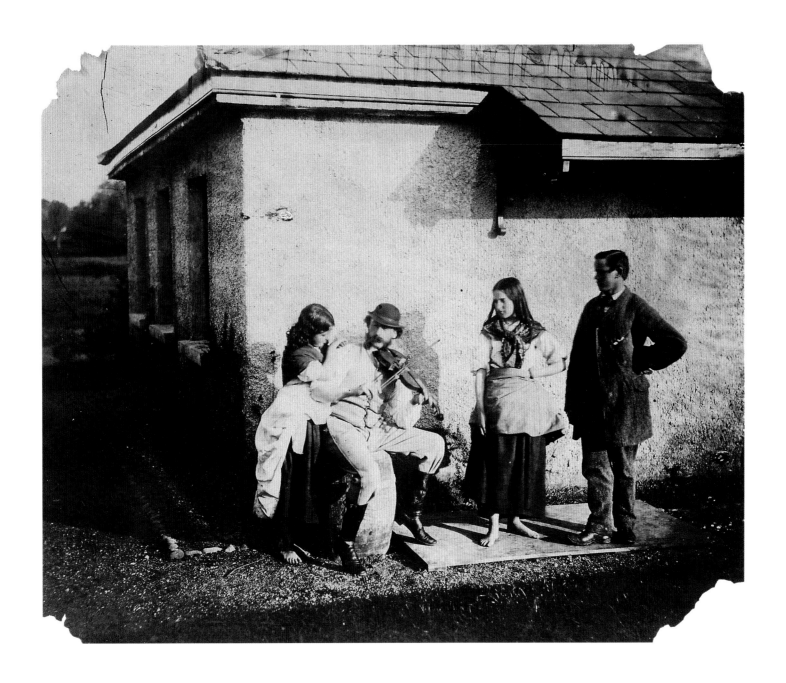

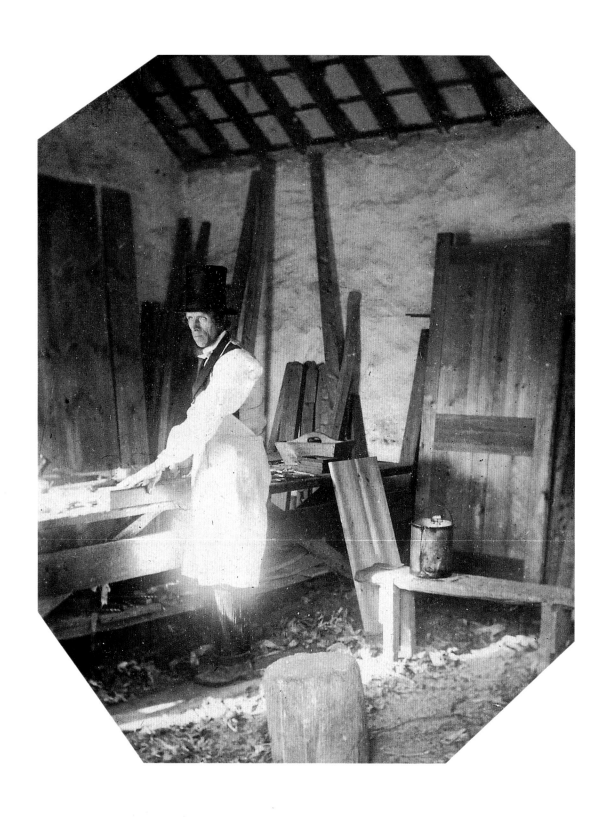

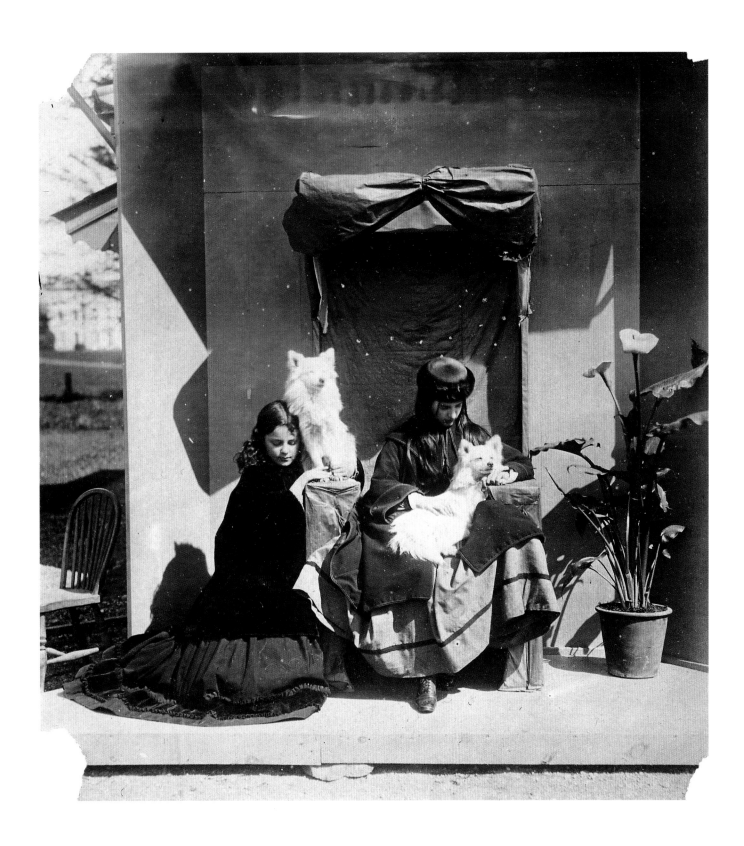

at work, not in stiff emblematic poses of her making. On the other hand, a certain detachment is evident in the artistic arrangement of the scenes, suggesting a well-defined distance between photographer and subjects.

The lighting and composition of the photograph on page 28 evoke seventeenth-century Dutch genre paintings, works which the Victorians praised as realistic. Hawarden sought to emulate this quality, as did other contemporary artists and photographers, including James McNeill Whistler in his "French Set" etchings and Talbot in his photographs of workmen at Lacock. In Hawarden's photograph, bright sunlight beams through the small, high window and reflects off the man's apron, illuminating the otherwise unlit interior. In a technical tour de force, the dark, cramped workplace is revealed, exemplifying a common plight of the poor, often romanticized by artists in this period. Around the time that this photograph was taken, John Ruskin wrote in *Modern Painters* that the living and working conditions of the poor afforded subjects "exquisitely picturesque, and no less miserable." By contrast, Hawarden's children stroll across the gentle landscape of Dundrum, happy and at ease. They pose for the camera in attitudes that suggest they are intended to provide a human key to nature, or that they are simply enjoying the view or just passing through.

Figure 3
Dr. W. D. Hemphill, *Our First Drawing Room*, 1867

The Togge House, a small stone building on the Dundrum House grounds, which may have been used as a photographic workshop,[24] was the site of several tableaux of "peasant life," Hawarden's first costume photographs. In the photograph on page 26, young Clementina and Lord Hawarden pose as peasants. They are surrounded by common objects and dressed in everyday clothes made "picturesque" by the addition of scarves and sashes. The action of the tableau turns not on a grand gesture but on an ordinary act. There is no attempt at realism, nor, conversely, at total disguise. Father and daughter appear as themselves, cheerful participants in a family activity.

The artifice of this photograph is heightened by its setting, a photographic booth (also seen on page 29). Instructions for building these were given in photographic journals and handbooks. Often photographers who used such backdrops trimmed or vignetted their prints to remove extraneous details, but Hawarden has not done this. The construction of the booth and the messy strip of grass before it are part of her composition. In form and in function, the booth recalls Emma Hamilton's attitudes box (the portable stage on which she performed),[25] a comparison brought to mind by the delicate shadow play enacted on its wall.

Another tableau of "peasant life" is offered on page 27. In costume, but again making no attempt to completely disguise themselves, father and daughters are joined by an unidentified man, possibly an estate employee or a tenant. In the mid-nineteenth century, the dominant style of representing peasant life is exemplified by the paintings of Jean

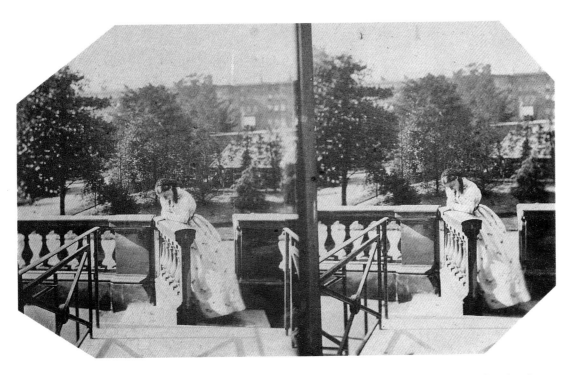

north. She took a few photographs in these grounds and may have taken a few in the nearby Horticultural Gardens.

Conventionally, the second floor of a large London house of that period comprised reception rooms for entertaining. Three rooms on the second floor were interconnected. Hawarden photographed both in the north-facing room where French windows opened onto the terrace (actually a flat roof extending over the rear of the ground floor) and led to private gardens, and in the drawing room, which faced south. As seen in many of Hawarden's photographs, the drawing room had a large fireplace with an ornate mantel and fender, and three floor-to-ceiling windows, two of which opened onto the front balcony. An arched doorway led to a central room. None of the photographs appears to have been taken in this room; perhaps Hawarden used it as her darkroom, although she would have had to take special steps to ensure that no daylight was admitted.

The floor plan for 5 Princes Gardens has not been located. However, that of 8 Princes Gardens, shown in figure 24, is probably identical, as all the Princes Gardens houses were built by the same developer, C. J. Freake.[3] The second-floor rooms were minimally decorated, and the drawing-room floor was not carpeted, though rugs were sometimes laid over the floorboards. In a period when over-decoration, even clutter, prevailed, the simple, stripped quality of these rooms may have been considered unusual—familiar though this style has become in the mid- to late-twentieth century. The floor of the room that led to the terrace was covered with an inexpensive, unpatterned carpet or matting. On the plain, painted walls of this room, Hawarden occasionally pinned up a sheet, rug, or piece of fabric as a backdrop. Instead of drapes, flimsy muslin sun curtains, conventionally used in summer, were casually pulled back from the windows in both rooms. There were no sofas, armchairs, side tables, or bookshelves arranged in conventional groups, nor any pictures on the walls, nor objects displayed on wall brackets or floor stands. Instead, Hawarden used several unmatched pieces of furniture as studio props, moving them about the rooms as she wished. She also incorporated a few favorite *objets d'art* in her portraits and tableaux.

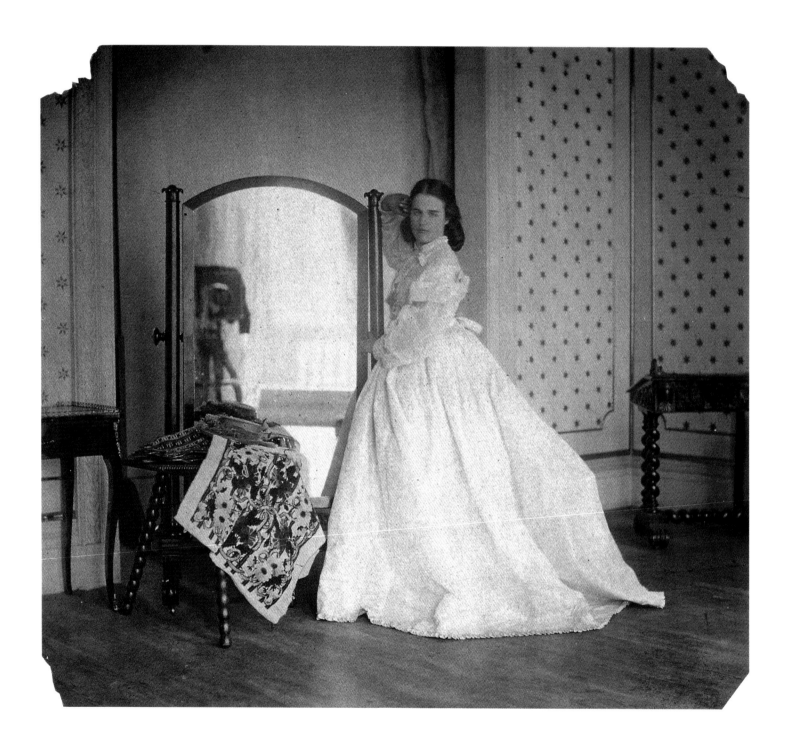

The distinctive wallpaper in the drawing room (recalled years later by one of her daughters as being "grey with gold stars"[4]) was installed about a year or two after Hawarden began photographing in the room. The paper, of a fashionable pattern, was probably mass-produced. The way in which it was hung and finished with gold fillets and edging would have been considered quite smart at that time. Although the papering of the room might have been a first step toward using the room for entertaining guests, Hawarden continued to use it as her studio, sometimes working the wallpaper pattern into her compositions. In her later work, however, she sometimes used plain fabric screens to create neutral backgrounds.

Between about 1859 and 1861, Hawarden used furniture and props similar to those generally found in the studios of professional portrait photographers. Photographers adopted these standard props, such as tables, chairs, mirrors, rugs, and drapes, from the studio equipment of professional portrait painters. The photograph on page 34 shows the basic furnishings of Hawarden's drawing room-cum-studio, including a movable screen placed across the opening to the next room. Except for the faint suggestion of a disembodied hand in the act of removing or replacing the lens cap, there is no sign of the photographer herself in the mirror.

After her husband succeeded to his title, they were apparently able to employ a governess for the children, freeing Hawarden to take pictures. A photograph of young Clementina wearing a shapeless garment splashed with stains, like a darkroom apron, suggests that Hawarden's daughters assisted her with her photographic work. Clementina's fingertips appear to be slightly blackened, which could have resulted from handling chemicals such as silver nitrate. In 1865, the *Photographic News* attributed the dearth of female photographers to the dirtiness of the developing process: "Undoubtedly the difficulty of keeping their dainty fingers stainless is the great reason why we have comparatively so few lady amateurs."[5] In response to a letter from a female correspondent, the advice column of the *British Journal of Photography* reassured that it was "not at all un-ladylike to pursue the black art. We know many ladies who do so, and who excel in it. . . . With a little care there is no need to black your fingers—much!"[6]

The volatile chemicals used in a photographic darkroom could be dangerous, however, if the room was not ventilated properly. In August 1859, Mountstuart Elphinstone commented that "Clemmy was laid up with a headache to which she is at present subject & the blame of which her friends lay on Photography in the dog days."[7] It seems possible as well that Hawarden's sudden death from pneumonia, after just one week of illness,[8] could be blamed on a weak immune system debilitated by her work with photographic chemicals.

<div style="float:right">

Portraits

</div>

At the time of Hawarden's first portraits, the dominant professional method was that of the *carte-de-visite*, patented in 1854 by the French photographer André Adolphe Eugène Disdéri. Eight separate exposures—eight separate poses, that is—could be made on the same large glass plate. The images were contact-printed, trimmed, and mounted on cards which usually bore the photographer's studio logo, and distributed for purchase, presentation, or exchange. Everyone who could afford the hobby kept a *carte-de-visite* album—comprising double-backed pages with windows into which the cards could

be slipped, eliminating the need for paste or paper corners—as a memento of family, friends, and acquaintances, as well as celebrities, whose *cartes-de-visite* could be purchased from photographers' studios and print sellers.

Hawarden used her stereoscopic camera (which produced two images on the same plate) to make family portraits in which the accessories and poses owe much to the conventions of the *carte-de-visite*. Most of these photographs were left as dual images. Some, however, were trimmed to *carte-de-visite* size and format. In one untrimmed example, Lord Hawarden appears in his army uniform, and in another, the Hawardens' son Cornwallis stands up straight beside a battered nursing chair. The child-sized chair subtly scales the photograph down to the little boy's size, so that he appears bigger and taller. Perhaps in emulation of his father, he holds a toy rifle, a hint of his subsequent army career. Cornwallis, who took his mother's family surname, Fleeming, when he inherited Cumbernauld on her death, died in battle at the age of twenty-eight.

Though she regularly made portraits of her family, Hawarden does not appear to have taken self-portraits often, if at all. The woman in the photograph on page 37 may be either her or her sister Anne. They looked very much alike, though Anne was the more robust—she lived to be ninety-seven. The slenderness of the woman in the photograph supports the suggestion that she is indeed Hawarden. If it is, then this is her only known self-portrait. Significantly, she is holding a photograph, apparently a landscape featuring bare-limbed trees, similar to the image reproduced above. The way the photograph curves easily between her fingers, without resistance, demonstrates the fine quality and light weight of the printing paper she used. The white border around the image indicates that this is an untrimmed print, possibly just removed from the printing frame. Before a photo-

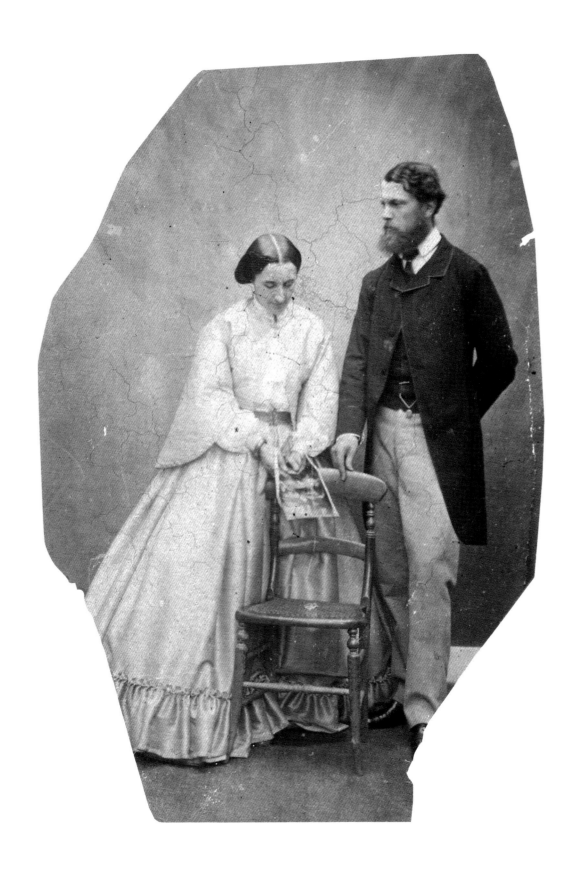

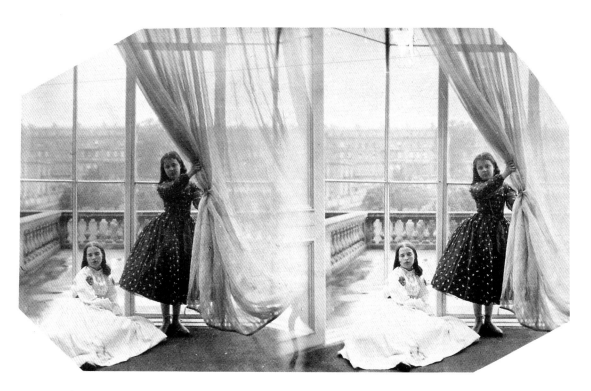

graph was mounted, it was trimmed with a sharp knife around a piece of glass placed over the image. Various shapes—circles, ovals, rectangles, and squares—were available. The process of trimming and mounting a photograph could be time-consuming. Lewis Carroll, who fastidiously arranged and assembled his photograph albums, noted in a diary entry that, even after twenty years' practice, it took him about nine minutes apiece to trim and mount each picture.[9]

The man in the photograph is Donald Cameron of Lochiel, who was, coincidentally, chief of the Scottish clan to which Julia Margaret Cameron's husband Charles belonged.[10] His identity has been established through a caption beneath a variant of this photograph in a family album. His association with Hawarden and her immediate family is otherwise undocumented.

Domestic Scenes Between about 1859 and 1861, Hawarden also photographed her children playing, reading (pages 17 and 45), and doing needlework in and around the house. Some of these photographs simply seem to be records of their activities. Others, in their careful composition and lighting, anticipate her figure studies and costume tableaux.

In the photograph on page 41, she used a blanket-draped box and fabric pinned to the wall as prop and backdrop for a picture of her sixth daughter, Elphinstone Agnes. The child's poignant profile is silhouetted against her hair. The surreal quality of her stark, stork-like pose is heightened by the casual positioning to the side of her shiny button boots—as if her feet were still in them.

The photograph on page 40 makes use of the same inanimate components. Isabella Grace's elaborately dressed hair and highly detailed dress are set off by contrast with basic geometric shapes and straight lines. The strongly converging perspective lends a sense of tension to the composition, which appears to have been intended as a purely formal arrangement.

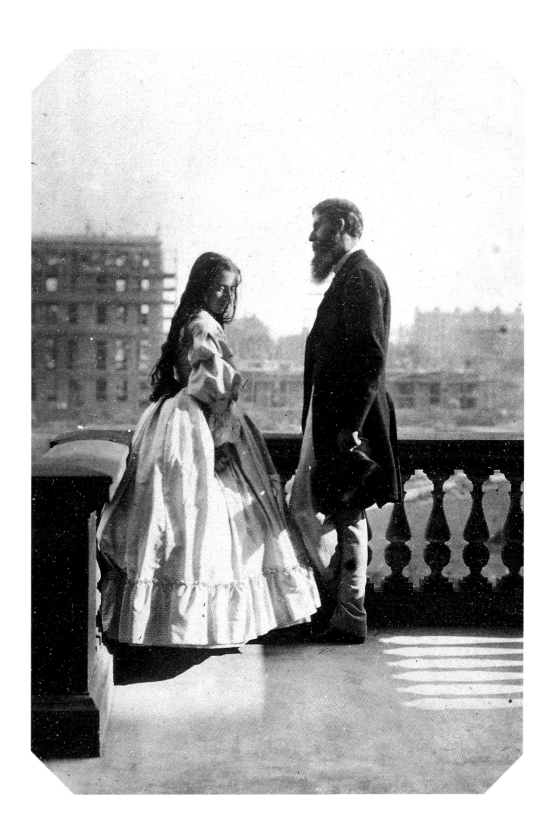

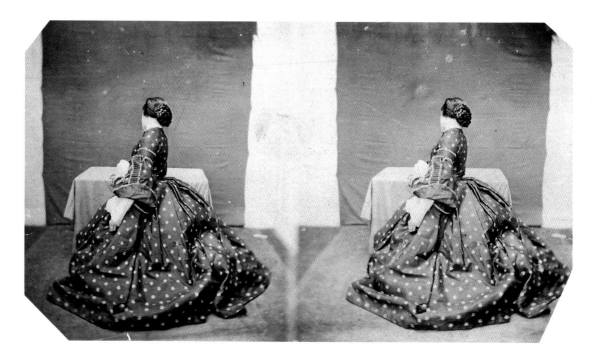

In a variation on a theme explored in other photographs, page 118 presents Isabella Grace and Clementina seemingly caught between two worlds. The sisters are nearly anonymous, though recognizable. Like ghostly companions, their images appear on either side in the window glass. Though Hawarden worked frequently with mirrors and windows, she never appears in a reflection. In this instance, she has deliberately manipulated the French doors so her own presence is erased.

In the center of this photograph is part of a headrest, a photographer's studio prop generally used to hold the sitter's head steady for long exposures. Hawarden did not usually employ this prop, as she worked either outdoors or in a room filled with natural light, with photographic materials that were sufficiently light-sensitive to facilitate relatively brief exposure times. Her daughters were talented models who clearly enjoyed posing and were capable of bracing themselves in naturalistic attitudes for exposures that lasted at least several seconds, or even tens of seconds. By contrast, Julia Margaret Cameron's models endured lengthy exposures necessitated by her extremely tight framing; one recalled that "the torture of standing for nearly ten minutes without a headrest was indescribable."[11]

The French doors again provide a backdrop in the photograph on page 38. With a stereoscopic camera, Hawarden has evoked the distance between interior and exterior worlds. The construction of the windows here resembles that of a cage. Indoors, the girls are safe from the wet weather evidenced by puddles of rain on the terrace. As Florence Elizabeth holds back the net curtain, she presents Clementina to the spectator, and her upright figure counterbalances her sister's languid form. Their informally staged tableau recalls scenes of pastoral dalliance, played not in a drawing room but *sur l'herbe*.

Hawarden often used the balcony overlooking Princes Gardens as a setting. By photographing through the open window she gave some of these images a dramatic thrust and enhanced the illusion that the balcony was a small detached platform floating above the ground. This effect comes to the fore in the photograph on page 39, of Isabella Grace and her mother's cousin, Henry Brougham Loch. In the distance, the houses on the

south side of the square are still under construction,[12] fixing the date of this photograph as the summer of 1861.

In 1861, Loch was a celebrity. A distinguished soldier, he had survived imprisonment by the Chinese during the Second Opium War. Loch figures in more of Hawarden's photographs than anyone else outside her immediate family, indicating that they were close friends. As a child, Hawarden in fact had stayed with the Loch family while her father was stationed in the Caribbean.[13]

The terrace overlooking the communal gardens between the houses of Princes Gardens and those of Princes Gate was another favorite stage (page 33). Much larger than the balcony, broad and flat with a well-proportioned balustrade of the type often seen in painted conversation pieces, the terrace was an ideal outdoor setting. The trees and shrubs of the gardens combined with the back walls and windows of the houses in Princes Gate to form a backdrop. In sunshine, the balustrade and its shadow provided a useful variety of light and dark patterns.

A performing poodle takes center stage on page 119. The exposure probably lasted no more than a second, considering the difficulty of keeping the dog in such a precarious position. He is perfectly aligned with the balustrade, and his shadow is carefully linked with those of the chairs.

The photograph on page 42 transforms the houses and trees glimpsed over Hawarden's daughters' shoulders into a backdrop. Before this, the girls are grouped in a pyramidal composition and linked as in a conversation piece, communicating with each other by touch and with the spectator through the little girl's direct gaze. Isabella Grace, well groomed as always but not too fastidious to put the dog on her lap, and Elphinstone Agnes, as solemn as the bronze owl she hugs, form a solid base. Between them rises Clementina, almost disguised behind her tilted hat, lifted hand, and all-embracing cloak. With one hand she grasps the dog's paw, much as she clasps her sisters' hands in other photographs. With the other hand she probably suppresses a giggle.

At first glance, the photograph on page 43 could be mistaken for a fashion plate, the models turning just so in order to display the sweep of their dresses. On looking more closely, it becomes clear that Isabella Grace is dressed in the height of style. In keeping with fashion developments of 1863 and 1864, her crinoline is fuller at the back rather than round, in a style that led ultimately to the bustle in the 1870s. With her hat and jacket on, she could be preparing to make social calls. In contrast, Florence Elizabeth is costumed from the dressing-up box. The skirt that has been draped over her light summer dress appears in many other photographs. Though she seems to be wearing no crinoline, her outfit has been carefully arranged so that her silhouette complements her sister's form.[14] The basic formal contrasts of the composition serve to counterpoint its center: Isabella Grace's serene face, steady and in focus, poised beside Florence Elizabeth's wavering, unfocused *profil perdu*.

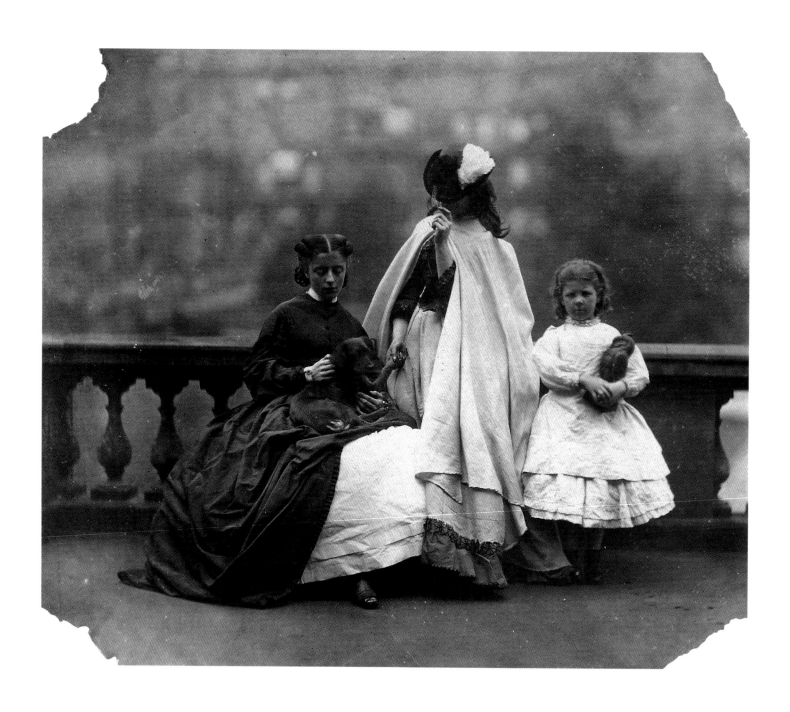

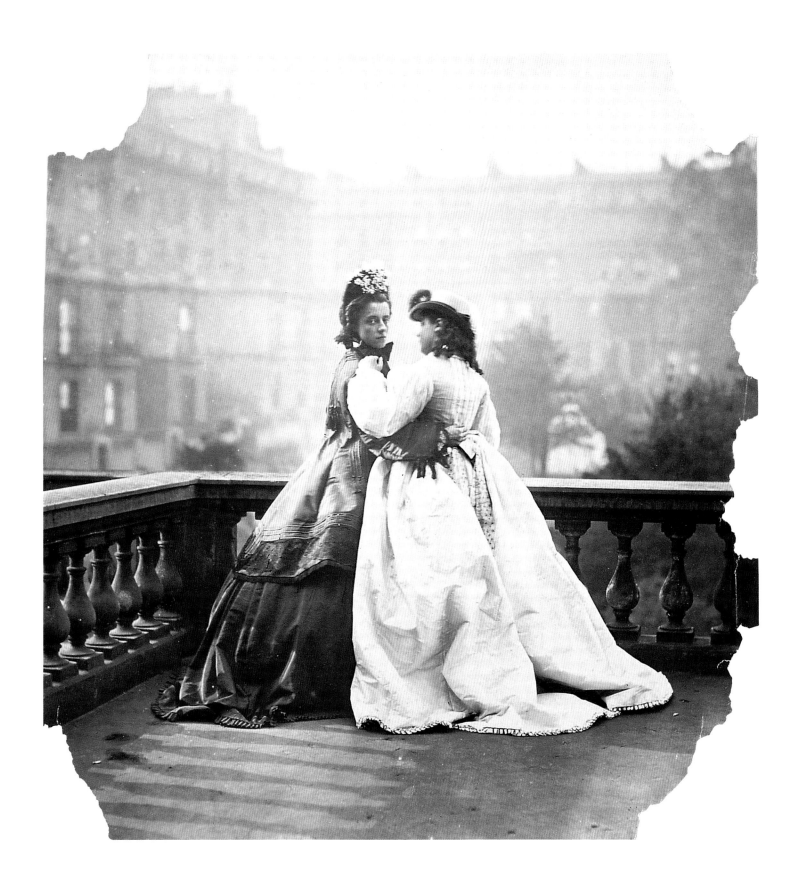

Chapter Four: Studies from Life

Hawarden exhibited her work as "Photographic Studies" and "Studies from Life," phrases that, in her day, signaled "art photography," of the sort created by O. G. Rejlander, William Lake Price and, slightly later, Julia Margaret Cameron. As Rejlander made clear in his published writings, the tenets of the photographic study were adapted from painting. By adopting art terms and art practices, photographers of the 1850s and 1860s announced that they were not simply technicians, a claim frequently disputed by those who wished to preserve painting's domination of high art. Traditionally, the study is a stage in an artist's working method. Intimate and small in scale, loose and free in execution, it is a preparation for a larger, finished work. The execution of a study signaled a serious and intellectual approach to picture making. From the late eighteenth century on, artists (and, later, connoisseurs) collected studies in appreciation of their intrinsic aesthetic merits.

The phrase "from life" differentiated photographs of people and places from photographs of art works. (As listed in the Photographic Society of London exhibition catalogs of the 1850s and 1860s, art reproduction photographs were often shown without explanatory titles, for example, as *Murillo Madonna* rather than *Copy after Madonna by Murillo*.) "From life" also meant that a photograph was not retouched or enlarged.

Hawarden's contemporaries recognized her photographs as studies from life, but related them to the category of portraits as well. In 1863 the *British Journal of Photography* noted, "If Lady Hawarden's 'studies' had been presented as 'portraits,' . . . [she may] have been entitled to the medal for that branch of the art."[1] Her contemporaries perceived her work as deriving truly "from life," as portraits are, and understood that these images were not to be "read."

Indeed many Hawarden photographs are comparable to mid-Victorian "subject pictures" of women reading, sewing, dressing, regarding themselves in the mirror, or just losing themselves in thought. They are part of a tradition that can be traced back from the early nineteenth-century Biedermeier artists to the work of seventeenth-century Dutch and Flemish painters. These images might more rightly be called "subjectless" because, whatever the premise, they have no real subjects beyond the beauty of women and the comforts of home. Certainly there is no suggestion of narrative or anecdote. The

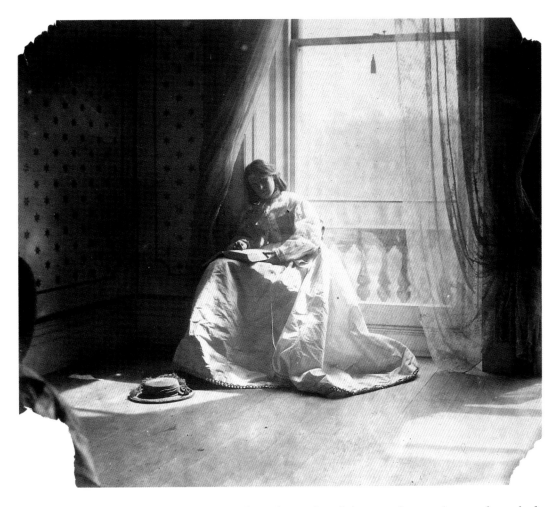

images are open to interpretation; in fact, through subtle use of metaphor and symbol, they *invite* different readings without resorting to contrivance. In the photograph on page 59, for instance, the viewer is drawn to contemplate the image of a young girl, who in turn is deep in reverie. In the photograph above as well, Hawarden surmounts photography's challenge of instantaneity, of recording a given moment, while simultaneously suspending time. Such moments are marked for us as surely as Clementina marks her line on the page as she pauses to be photographed.

Although Hawarden did not usually incorporate narratives into her compositions, the photograph on page 57 contains a few clues to a possible interpretation. Such a scene would have been rendered more explicitly in a Victorian genre painting and given the title *Bad News* or another clichéd phrase. Yet Hawarden consistently relied on visual rather than verbal elements as pretexts for her photographic studies.

The photograph on page 55 is an example of Hawarden's small single-figure studies in fancy dress, generally with slight variations between multiple images of the same scene. Here Clementina's pose evokes the penitent Mary Magdalene, who was to the Victorians both an elliptical reference to prostitution and a symbol of redemption.[2] A shawl draped over a curved chair back mimics the way the girl's blouse slips over her curving shoulders. The implied relationship between these two forms sets up a spatial tension that reinforces the pervasive sense of stillness. This relationship between animate and inanimate forms is used to the same effect in the photograph on page 56. The sense of space and depth is emphasized further by converging diagonal shadows.

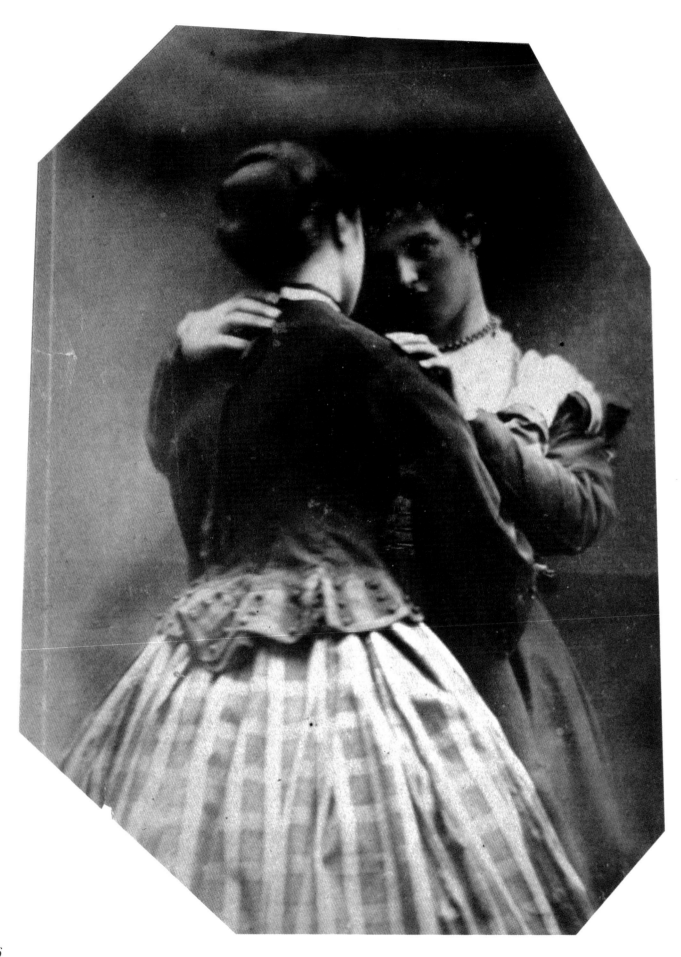

46

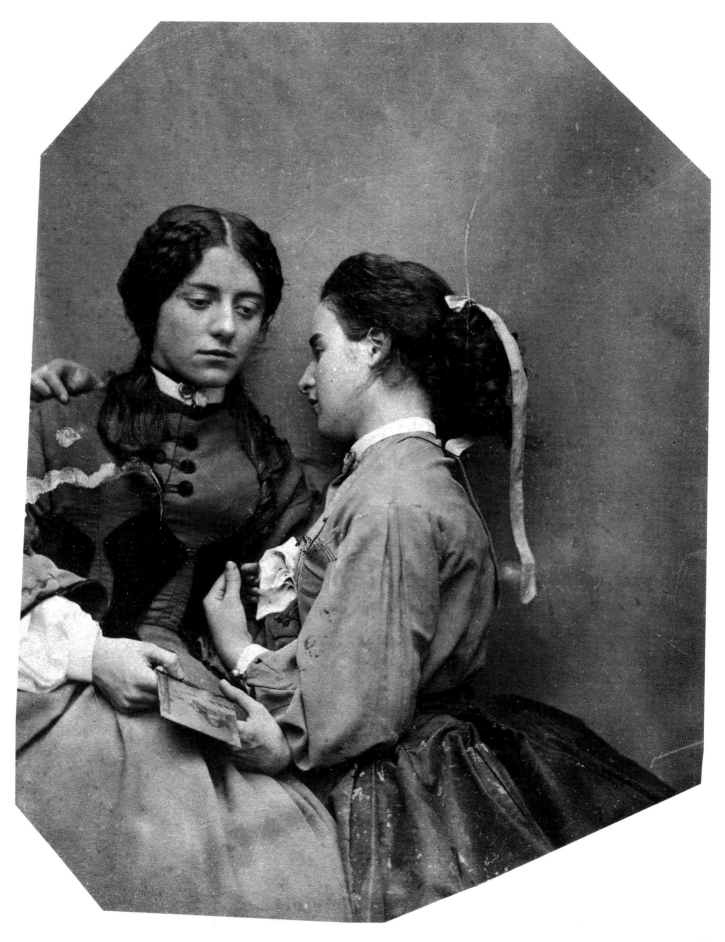

Clementina's pose in the photographs on pages 60 and 61 recalls the tortured posture of the country girl whose country lover has discovered her working as a prostitute in the city, in Dante Gabriel Rossetti's 1853 pen-and-ink study for his unfinished painting *Found*.[3] The same type of pose was used by Victorian genre painters to suggest that a woman's proper relationship to a man was that of clinging ivy, as in George Elgar Hicks's *Woman's Mission: Companion to Manhood* (1863).[4]

Because Hawarden concentrated on photographing her daughters in and around their South Kensington home, to the near exclusion of other subjects and settings after 1859, casual modern-day observers have concluded that she was something of a mysterious

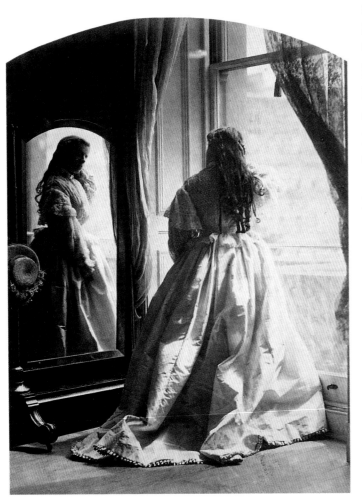

recluse. Her family and friends, however, did not describe her as withdrawn. Rejlander wrote that he found her "straightforward."[5] The restricted focus of her work is in keeping with the Victorian preoccupation with conflicts between interior and exterior, between private and public, or between haves and have-nots. In the photographs on pages 60 and 61, for example, the distraught and yearning attitude of Clementina's outstretched arms is reinforced by the proximity of a closed window. The Pre-Raphaelite painter John Everett Millais similarly exploited the potent combination of a contorted female figure and a sealed aperture in *Mariana* (1850–51).[6]

Hawarden's recurring use of the woman-at-the-window motif reminds us that she was essentially a romantic artist. To the romantics, such scenes were both a commentary on our progressive estrangement from the natural world, and an invitation to contemplation and reverie, the window being "a threshold and at the same time a barrier."[7] But to one modern observer, Hawarden's interiors are a "full expression of introversion and desired escape from the wallpapered rooms and French windows imprisoning [her] sitters."[8]

Another romantic preoccupation is with the self and its twin, or doppelgänger. Hawarden often paired Isabella Grace and Clementina, or twinned each girl with her mirror reflection. In the photograph on page 46, the sisters seem interchangeable, entwined, one the mirror image of the other. Isabella Grace's face is not visible, though its expression is suggested by the look in Clementina's eyes. That photography was a bond between mother and daughters is evident in the photograph on page 47. Holding a photograph of one of the younger girls, Isabella Grace is in turn held by Clementina.

Hawarden regularly returned to the lady-and-looking-glass motif, perhaps as much for its formal possibilities as for its stylistic antecedents or literary allusions. This combination in fact became something of a cliché in portrait photography in the 1850s and 1860s. A technical reason in part explains its popularity: the mirror not only reflected the sitter, perhaps showing off the back of a graceful neck and well-rounded shoulders,

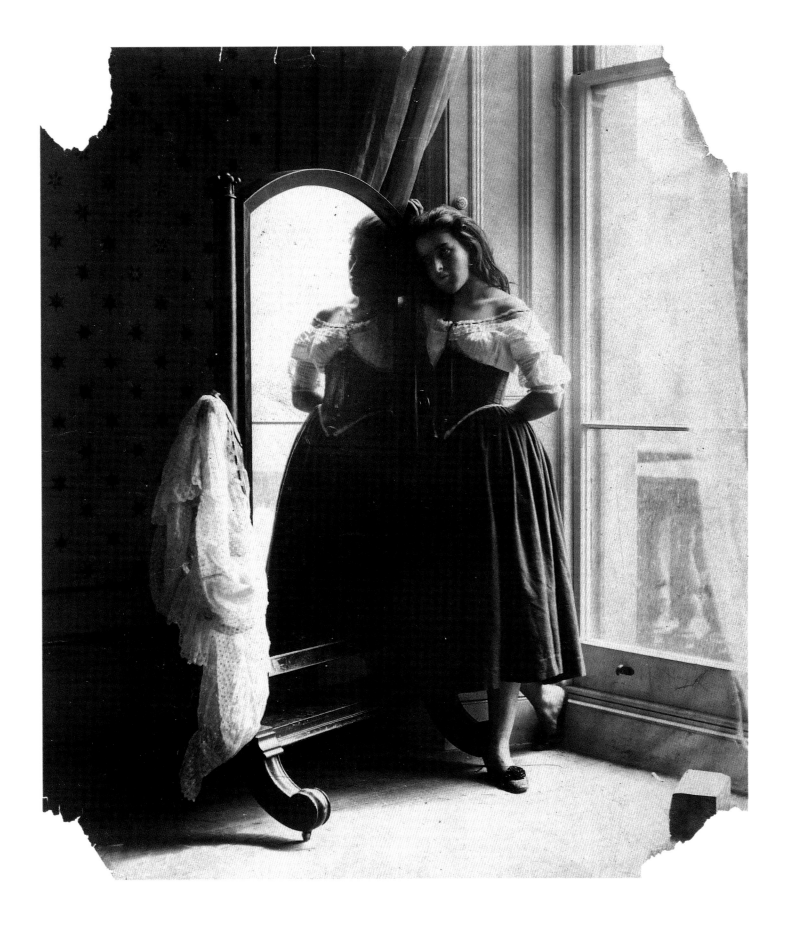

à la Jean Auguste Dominique Ingres's *La Comtesse d'Haussonville* (1845), but also reflected light, illuminating areas that would otherwise have remained in shadow.

In the photograph on page 62, Isabella Grace's reflection in the mirror is obscured by the position of her body. Despite this, her gesture is easy to read and her purpose in standing before the mirror is clear. The slight but eloquent inclination of her head lends a measure of gravity to the scene. In the photograph on page 63, Clementina is seated in a shaft of light, yet paradoxically the figure in the mirror is dark. The light models the form of her bare shoulder and also reveals that her blouse is transparent.

Such images have reinforced a latter-day view of Hawarden's work as introspective, self-regarding, and even hermetic. But expression rather than repression is the key to her endeavor. These photographs explore her daughters' progress from girlhood to womanhood through their identification with each other and their self-contemplation in the mirror. These themes have been exploited since classical times.

To late-twentieth-century eyes, some of Hawarden's photographs of her daughters carry a sexual frisson, particularly when measured against a received notion of Victorian prudery. In 1865, the *Photographic News* reported that studio photographers often sold images of "young ladies (?) at their toilette—some lacing their corsets, some exposing their legs while lacing their boots and arranging their garters, some stooping just to exhibit their bosoms, others reclining on couches in exciting postures."[9]

It seems likely that visitors to the Photographic Society of London exhibitions were aware that the girls in Hawarden's photographs were her daughters. Could the photograph on page 49, which shows Clementina in a state of undress, have been exhibited? The issue of "decency" would have been mitigated by the presentation of this photograph as an art object in a serious exhibition, and not in a shop window.[10] In June 1864, when Hawarden sold some of her photographs to benefit the Female School of Art, Lewis Carroll purchased one that showed her daughter Isabella Grace in a peignoir (page 48). Much speculation has centered on Carroll's penchant for photographing children and young girls, sometimes semiclothed or nude. Yet at the time most of the parents involved were not concerned unduly.

Costume Tableaux

During the years 1863 and 1864, Hawarden primarily photographed her three eldest daughters in extended series of untitled costume tableaux, in a tradition of British portraiture that can be traced back to Sir Joshua Reynolds and earlier practitioners. The particular popularity of this genre with photographic amateurs is exemplified in Julia Margaret Cameron's tableaux and in those of the man she called her "master," David Wilkie Wynfield, who photographed his contemporaries costumed to resemble Renaissance heroes, princes, painters, and poets.[11] Like Cameron and Wynfield, Hawarden also reused the same pieces of drapery and articles of fancy dress over and over again, in different combinations and different settings. By 1866, such practices were widespread

enough for the *Photographic News* to poke fun at the novice who "has picked up at random a few of the adjuncts of the theatrical property-room or of the painter's studio, consisting of a nondescript piece of drapery with braiding, embroidery or fringe on it; a head-dress of some kind; a piece of old armour; some stuffed birds; a vase or two; a few plaster casts, and a bronze statuette. These represent various periods and styles of art, classic and Gothic, ancient and modern." This piece concluded by suggesting that, if the result were visually coherent, "some lines are hunted out of a dictionary of quotations" and appended [12]—forging an instant link to a literary classic.

Cameron added allusive titles to her photographs, providing keys to her usually typological meanings. Hawarden's choice not to announce her meanings, if any, makes it seem inappropriate today to attach tag lines to photographs that are quintessentially visual experiences. Also, contemporary reviewers of Hawarden's photographs did not "read" them, but wrote instead of their formal, aesthetic, and technical qualities. Most of the following comments are therefore intended to leave the photographs open to interpretation in keeping with Hawarden's own practice, and to contextualize them in the Victorian era.

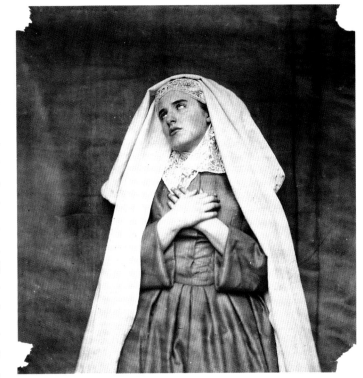

In many ways Hawarden's costume tableaux, which despite their fanciful nature remain portraits of her daughters, are reminiscent of Reynolds's paintings featuring aristocratic beauties as mythological heroines. Reynolds adeptly used costumes, props, and titles pulled from standard sources to complete his scene setting. [13] Beginning with *Miss Frances Ann Greville and her Brother, as Psyche and Cupid* (1760), Reynolds's works in this vein set a trend for allegorical and costume portraiture. Though the sitters' names were not always given in the titles, their identities— like those of Hawarden's daughters—generally were no secret to exhibition visitors. Reynolds wrote that the portraitist who wished to endow a female subject with presence would "not paint her in the modern dress, the familiarity of which alone is sufficient to destroy all dignity. He takes care that his work shall correspond to those ideas and that imagination which he knows will regulate the judgement of others; and therefore dresses his figure something with the general air of the antique for the sake of dignity, and preserves something of the modern for the sake of likeness." [14]

In Reynolds's time, the shepherdess was a favorite fancy-portrait role. In the photograph on page 69, Clementina's eighteenth-century-style costume—a shepherdess in the mode of Marie Antoinette—nearly fills the frame. The textures of cloth, lace, net, wood, hair, and skin are described through careful handling of the bright sunlight. The swirls in the upper left corner, possibly the result of uneven collodion coating, are a happy accident that provides a counterpoint for the other textures. As here, Hawarden often gave her photographs dramatic tension by placing the subject in a corner, at the center of converging diagonal lines.

Figure 5
Albert Moore, *Pomegranates*,
1866

Clementina appears to have been her mother's favorite model. She was very gifted, capable of a range of expressions and gestures, and superbly photogenic. For her mother's camera she portrayed saints and sinners, men and women, the contemporary and the classical. She was Hawarden's Magdalene, and in the photograph on page 51 she is the Madonna, in an attitude and costume borrowed from the Old Masters (figure 4).

Though the narrative content of the photograph on page 68 is not clear, the costumes suggest that this tableau dramatizes the triumph of Christianity over paganism. In other Hawarden photographs, however, Clementina, the pagan seeress, triumphs over Florence Elizabeth, the nun.

Many Victorians had a casual interest in the occult. Clementina, in the photograph on page 67, seems to play a fortune teller, with cards and dice. In the photograph on page 66, Clementina, in prophetess robes and headdress, perhaps appears as Florence Elizabeth's guide, as in a dream.

The image of a beautiful woman with a box immediately brings to mind Pandora, though there is no other indication that this was the reading Hawarden intended in the photograph on page 54. The sensuous pleasure of a beautiful woman in beautiful garments, preferably draperies, juxtaposed with a beautiful *objet d'art* or piece of furniture, preferably of classical or Oriental origin, became a hallmark of the Aesthetic Movement. The combination was exploited by Albert Moore in paintings such as *Pomegranates* (figure 5), and Cameron also used the motif on occasion (figure 6). In the photograph on page 58, Clementina stands beside an early eighteenth-century cabinet of Indian origin, a favorite family heirloom and reminder of ties with the East.[15]

The photographs on pages 74 through 78 may form an Orientalist series, as there are only slight variations between the images. The exotic dress and tentlike atmosphere (an artful conversion of the drawing room) suggest harem scenes and add an erotic frisson

to the tableaux. In painting and in photography, the Orientalist genre made it possible to evoke sensuality on the premise of presenting quasi-ethnographic information about the customs of the East. In Britain the popularity of this genre was well established by the 1850s, particularly through the work of John Frederick Lewis, painter of many harem scenes featuring beautiful young women who, in spite of their exotic costumes, were essentially the "English rose" type. Roger Fenton also used European models in his "Nubian Series," examples of which he exhibited at the Photographic Society of London in 1859.[16] Possibly Fenton's work provided the impetus for Hawarden's variations on the Orientalist theme.

Like an odalisque in a harem (pages 72–73), Clementina reclines on a divan draped with rich fabrics. Her body is made nearly weightless by light, and she seems to be rising, perhaps to the plane of dreams, as the outside world recedes. The cheval glass (also called a "psyche") isolates her cheek, resting on her hand in the classical gesture of contemplation. Clementina grasps an epergne (a fruit basket, symbol of sensuality) close to her breast. On the table's edge beside another mirror (this one blank) is a jug whose shape echoes the contours of the female body and whose precarious position recalls the traditional predicament of feminine virtue.

The poses and costumes in the photograph on page 71 may have been inspired by the sensational appearance of the young actress Kate Bateman in the biblical play *Leah*, produced in London in late 1863. A *carte-de-visite* of the actress in this role or a wood engraving such as the one published in the periodical *London Society* in November 1863 may have inspired this tableau. The distorted shadow profile lends a sinister dramatic note.

The girls' dramatic skills are evident in the range of roles they took on. In the photograph on page 82, Isabella Grace acts the part of Mary, Queen of Scots, a tragic heroine to the Victorians and a perennial subject of historical genre paintings and costume-tableaux photographs. This tableau is a typical representation, with Mary listening as one of her attendants plays the lute, a scene that was popular with artists because it captured a light moment in a tragic life.[17]

Some of the costume tableaux (pages 80 and 81) suggest that Hawarden and her daughters were interested in playing out courtship rituals, with Clementina in breeches taking the part of the importuning male lover. Whether or not the participants were aware of it, these scenes reverberate with romantic, even sexual, feeling. Such are the models' powers of persuasion that it seems not to matter that this eighteenth-century idyll is set, not on a mossy rock in a wooded glade, but on a rolled-up mattress on a bare wooden floor (page 83). The elegant line of Clementina's legs, revealed by her Cherubino-like

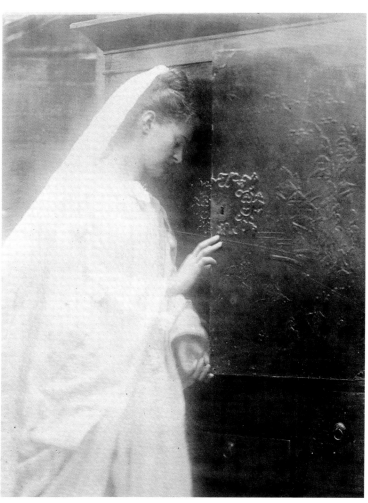

Figure 6
Julia Margaret Cameron,
Enid, from *Illustrations to Tennyson's "Idylls of the King,"* vol. I (London, 1874–75)

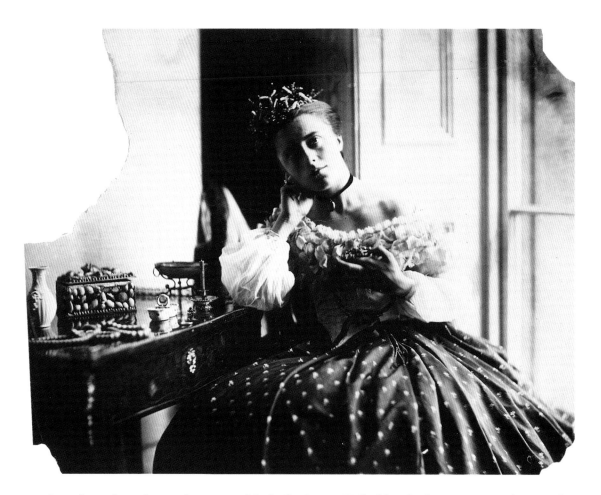

knee breeches, thrusts her toward Isabella Grace. Foiled by the latter's crossed arms, the lover does not enfold the beloved. Rather, in a gesture epitomizing the scene's pervasive delicacy, Clementina merely fingers the brim of Isabella Grace's hat. A shadow hangs over the pair, though it serves to draw them closer.

The photographs on pages 84 and 85 appear to date from the summer of 1864, the last summer of Hawarden's life. Here the two eldest daughters reaffirm their bond with each other and with their mother. Isabella Grace, in evening dress with her hair elaborately arranged, stands at the French window to the terrace. With her back to the camera, she exhibits the intricacies of her dress and hair to full advantage. Clementina, poised like a mirror before her sister whose expression she perhaps reflects, incongruously wears a riding habit and appears disheveled. Their rapport is strengthened visually by the lines of the window, which direct our eyes to their linked arms.

The photographs on pages 55 through 85 show Isabella Grace, Clementina, and Florence Elizabeth Maude at 5 Princes Gardens, South Kensington, London, from about 1862 to 1864.

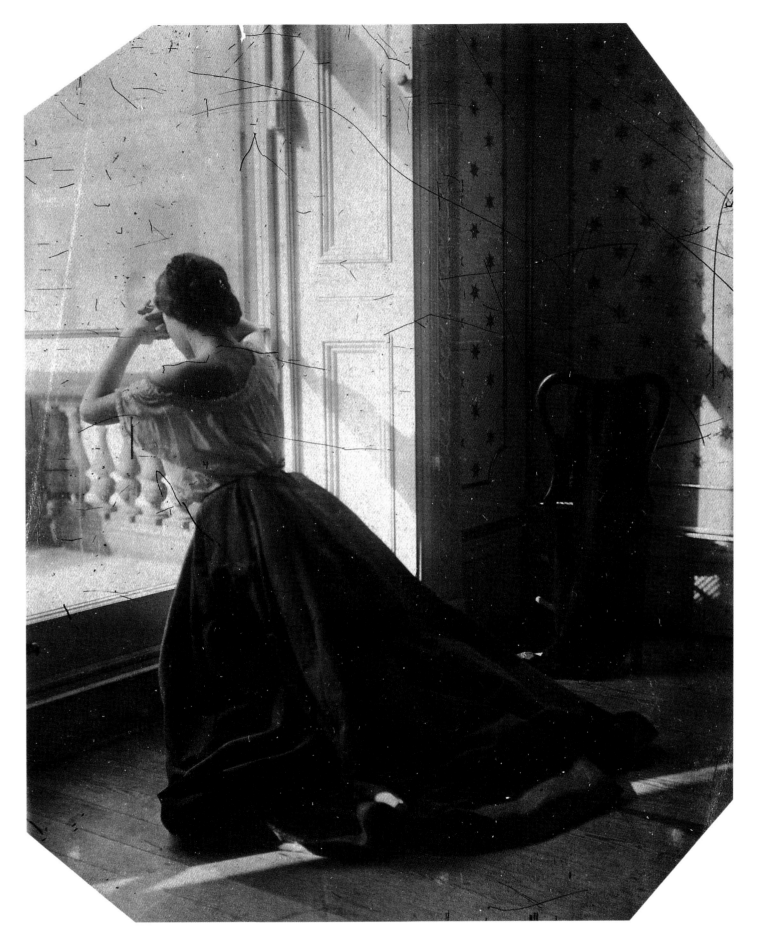

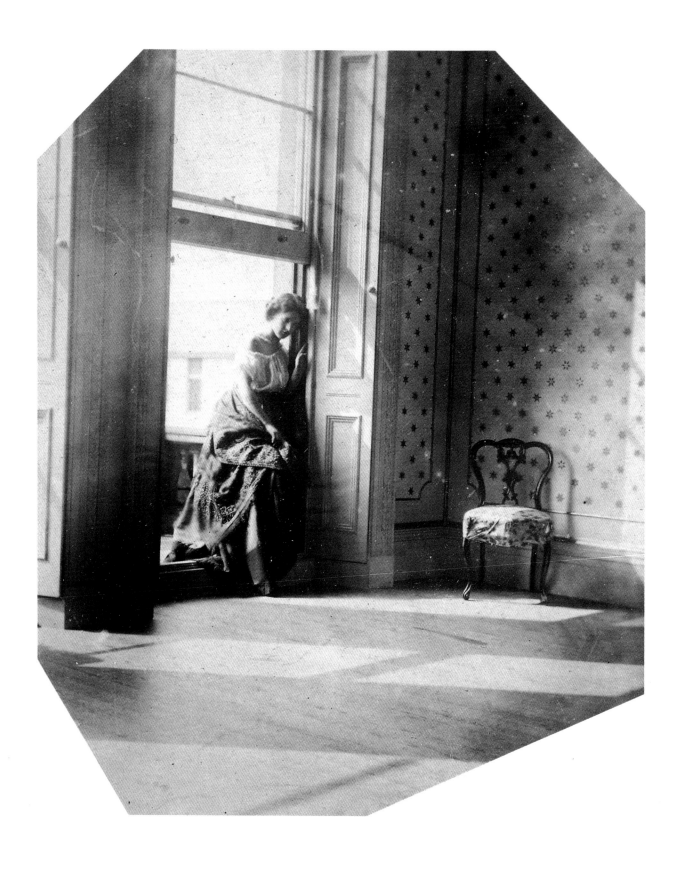

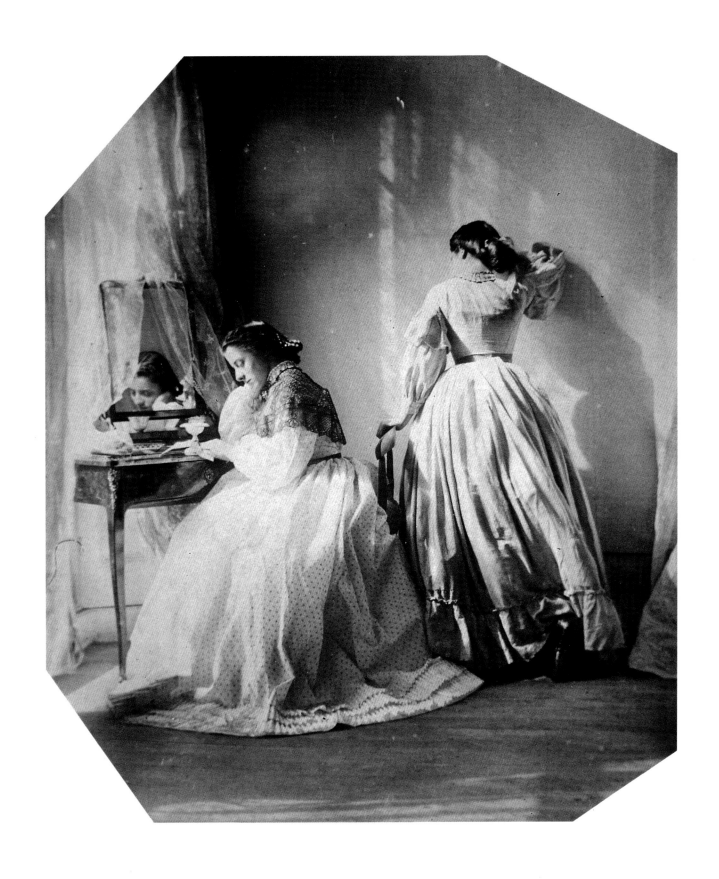

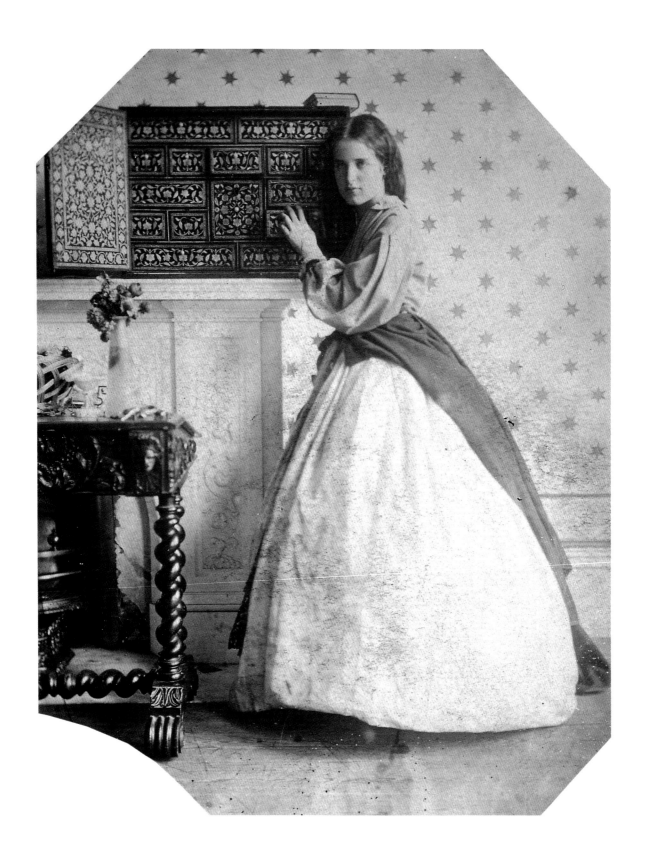

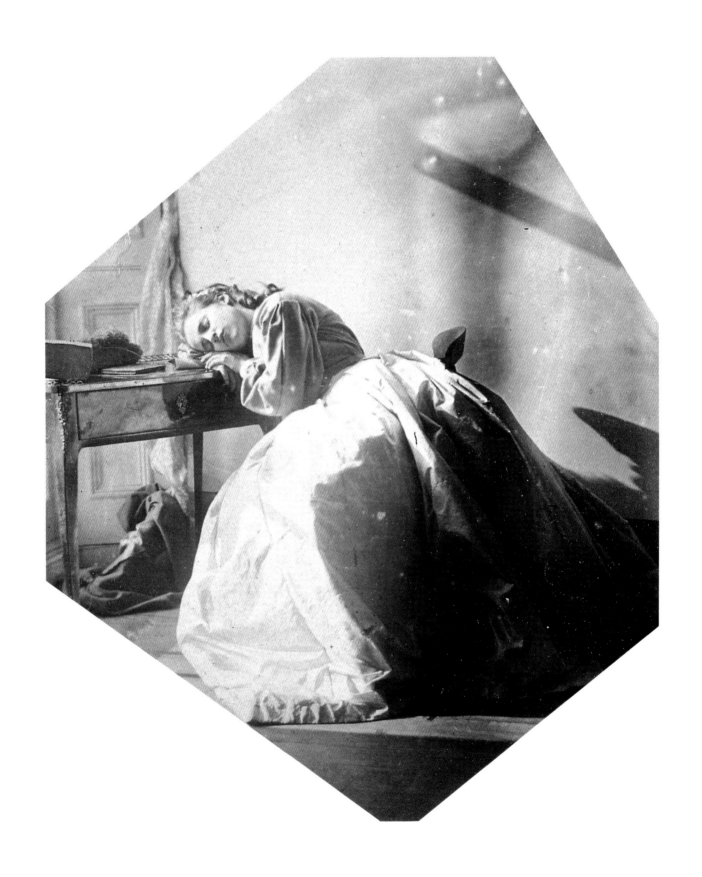

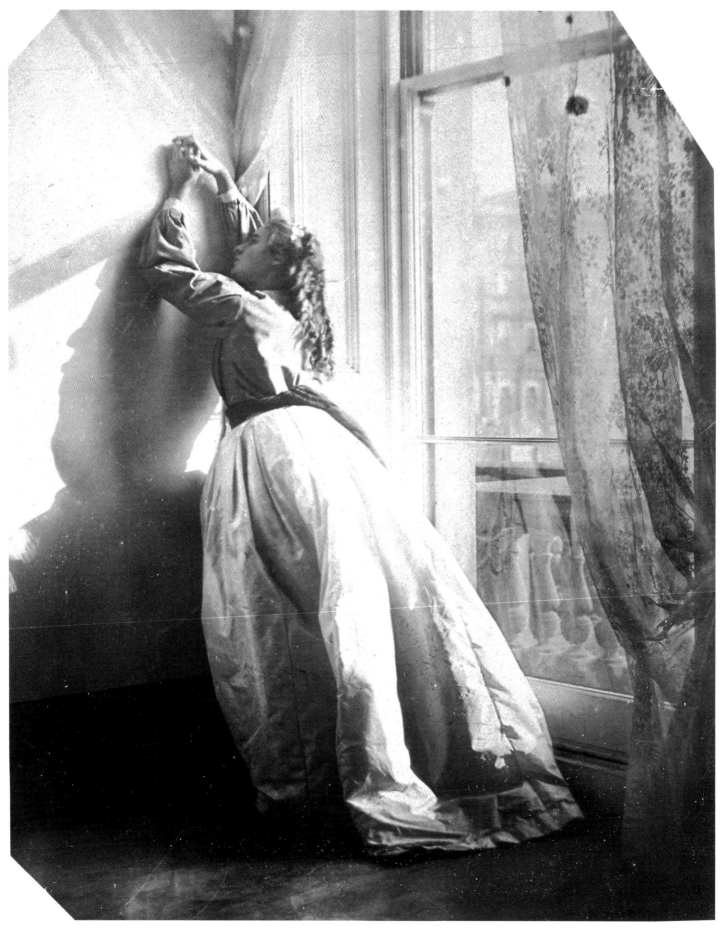

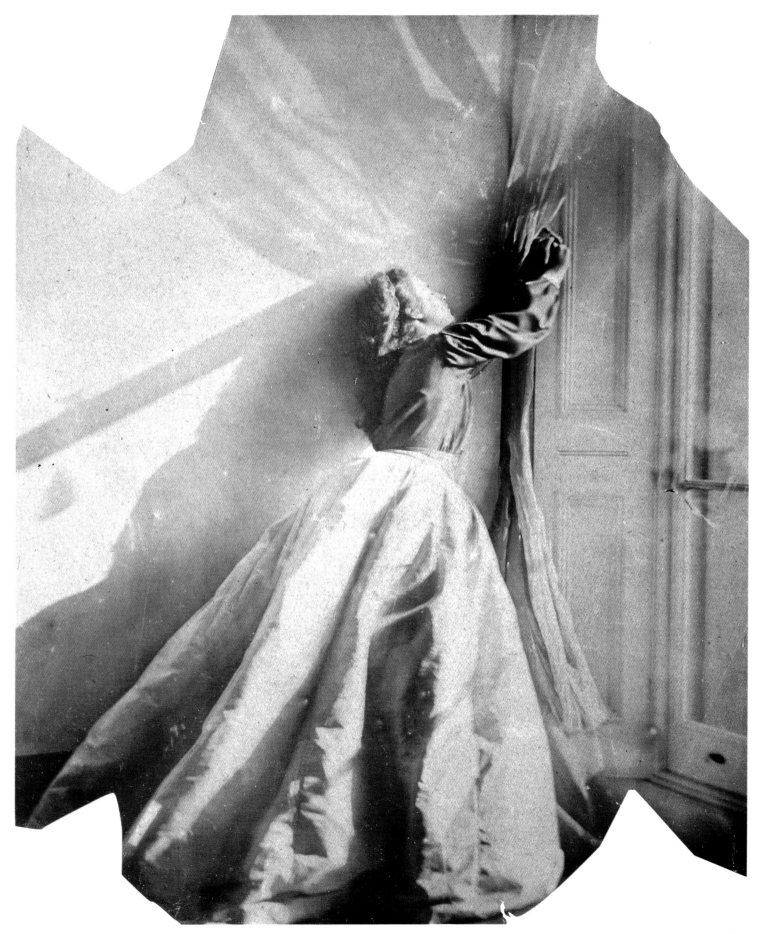

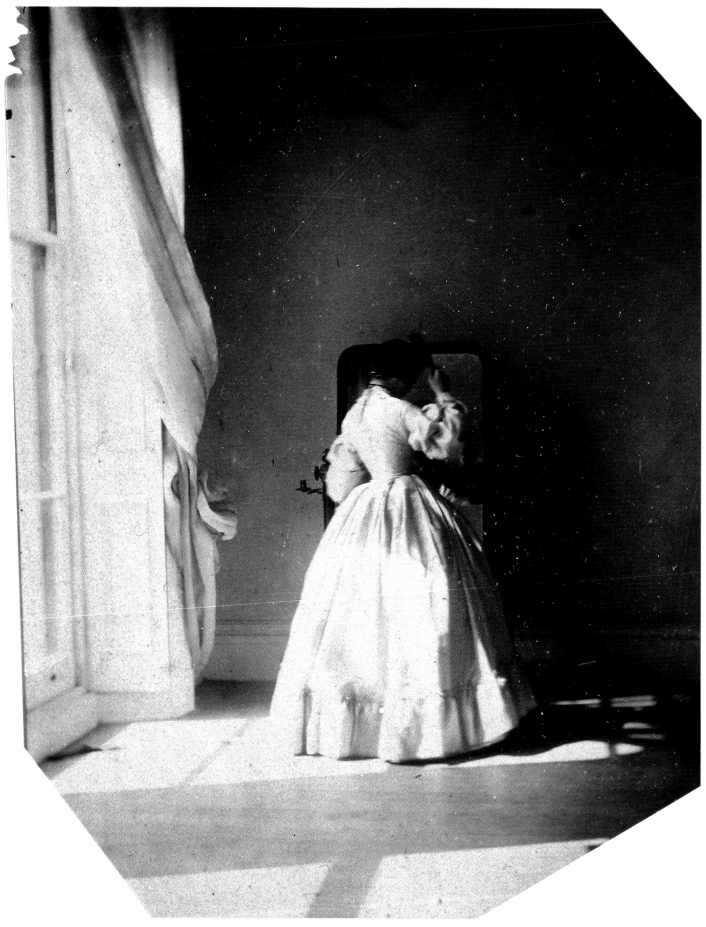

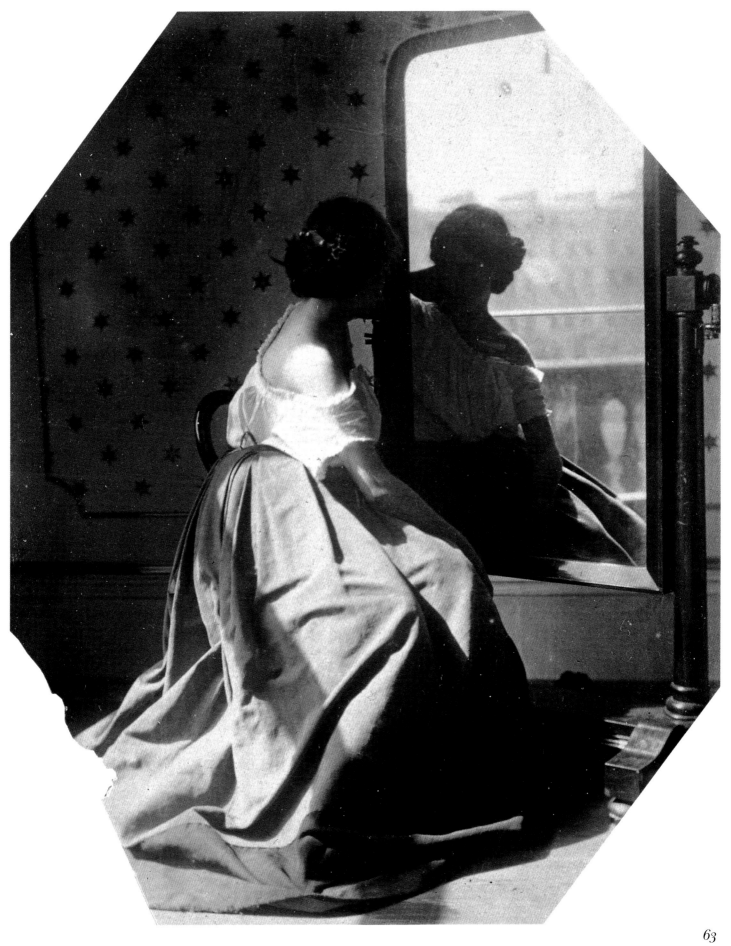

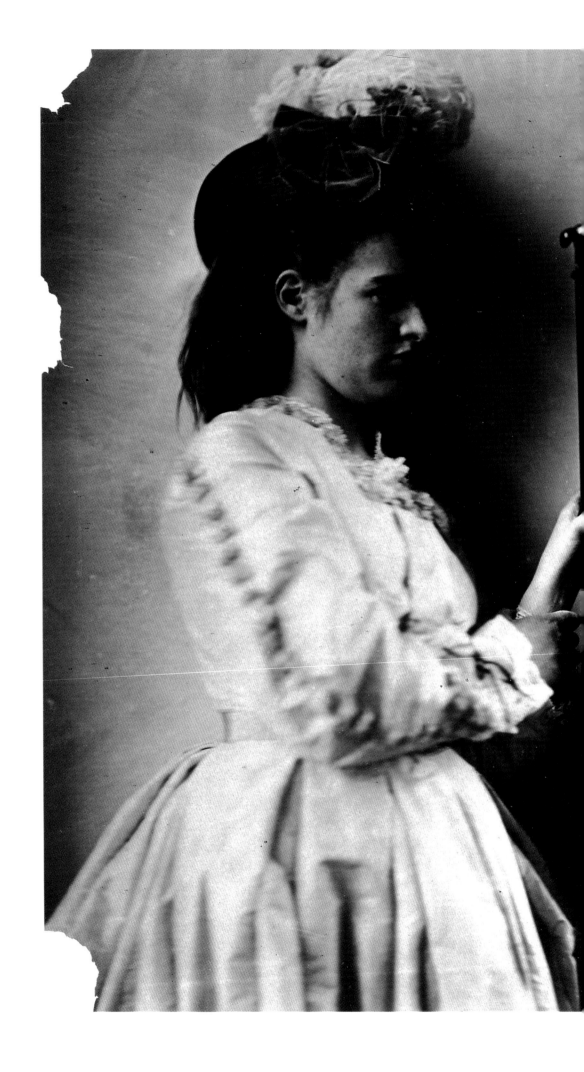

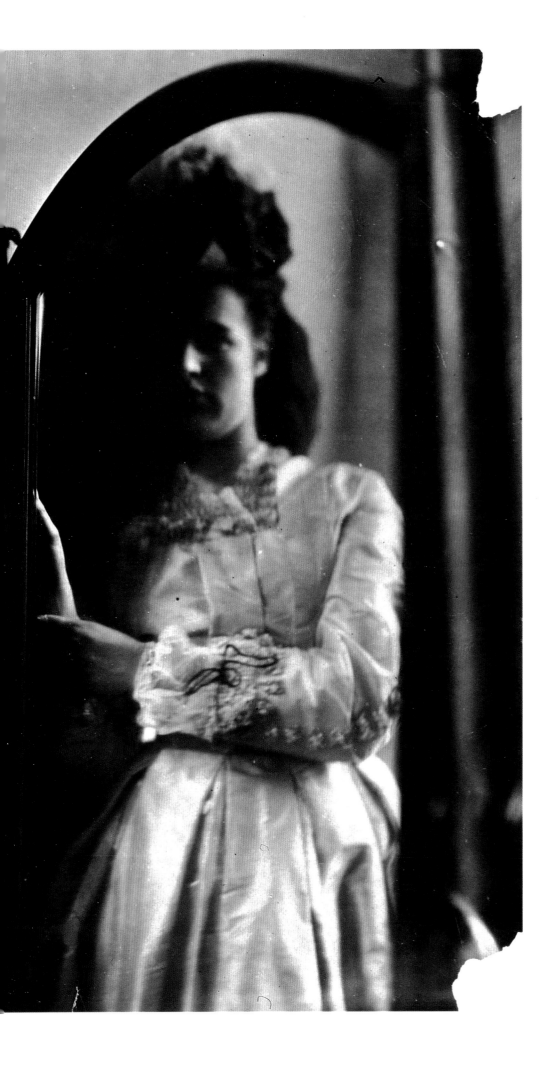

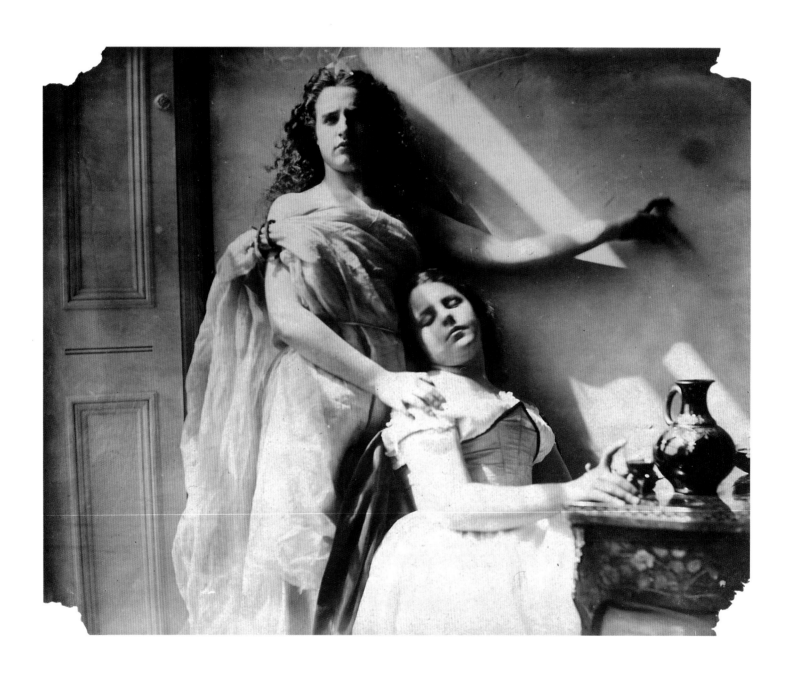

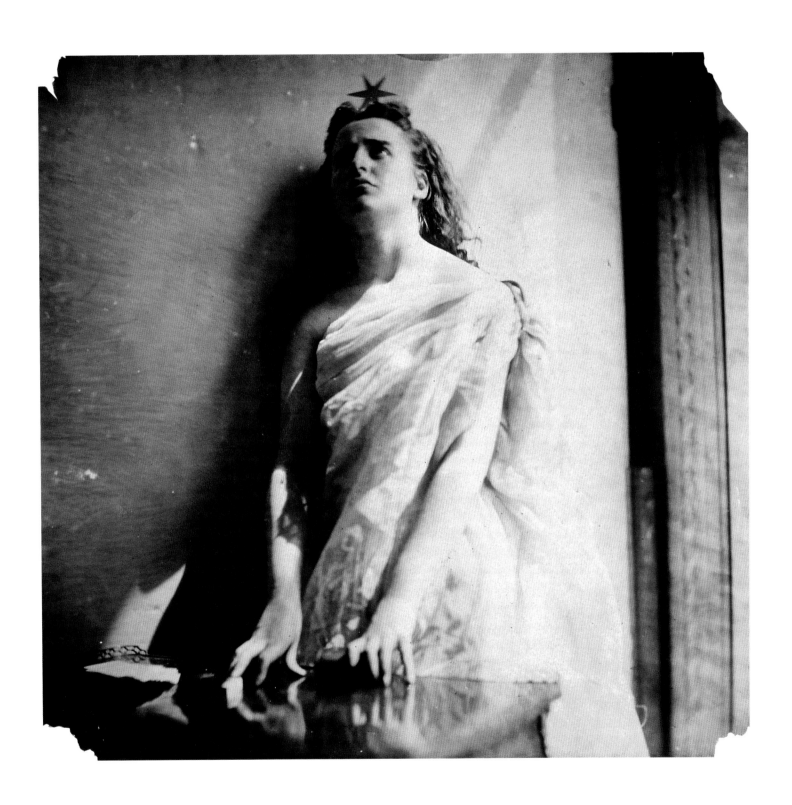

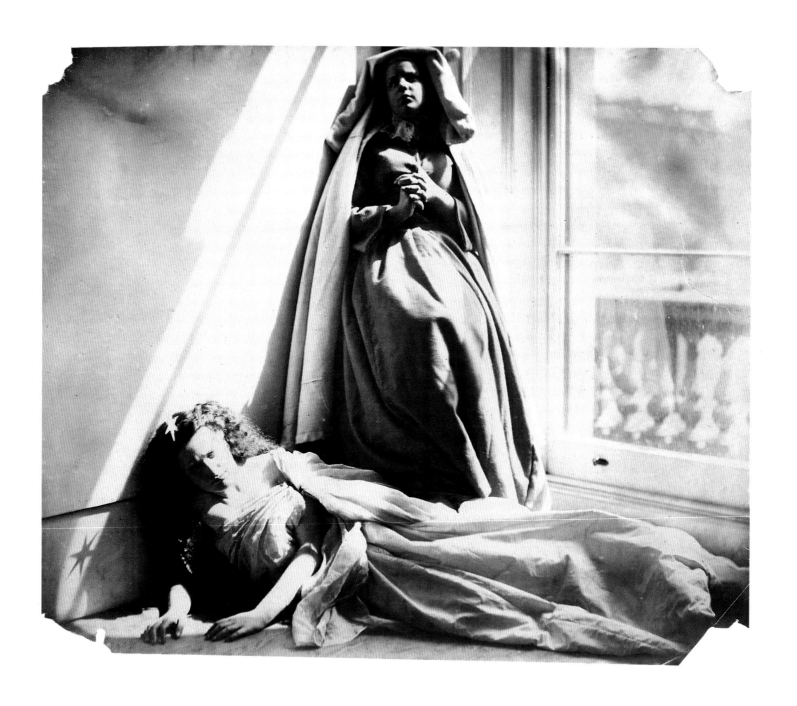

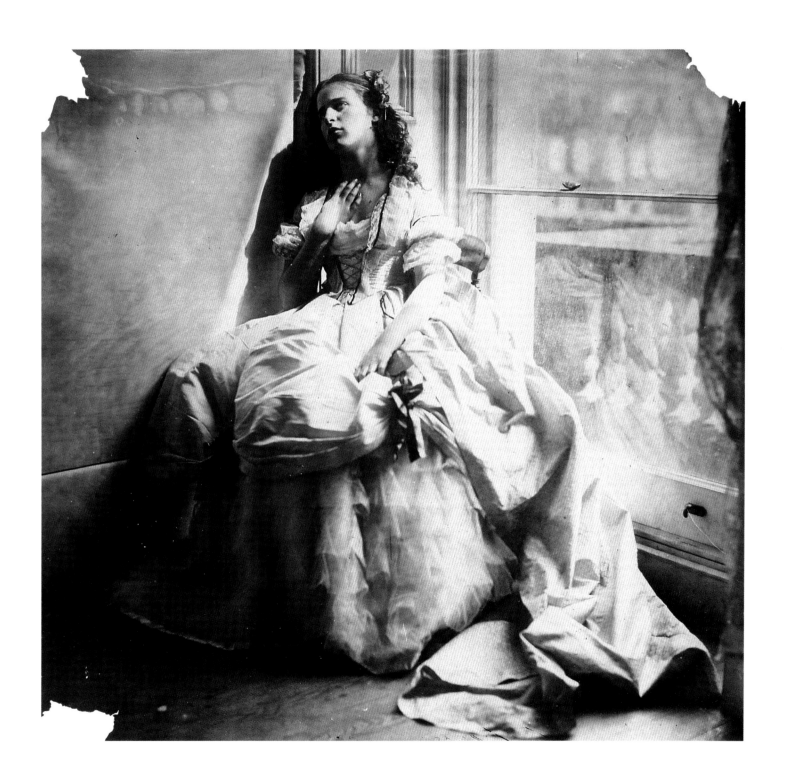

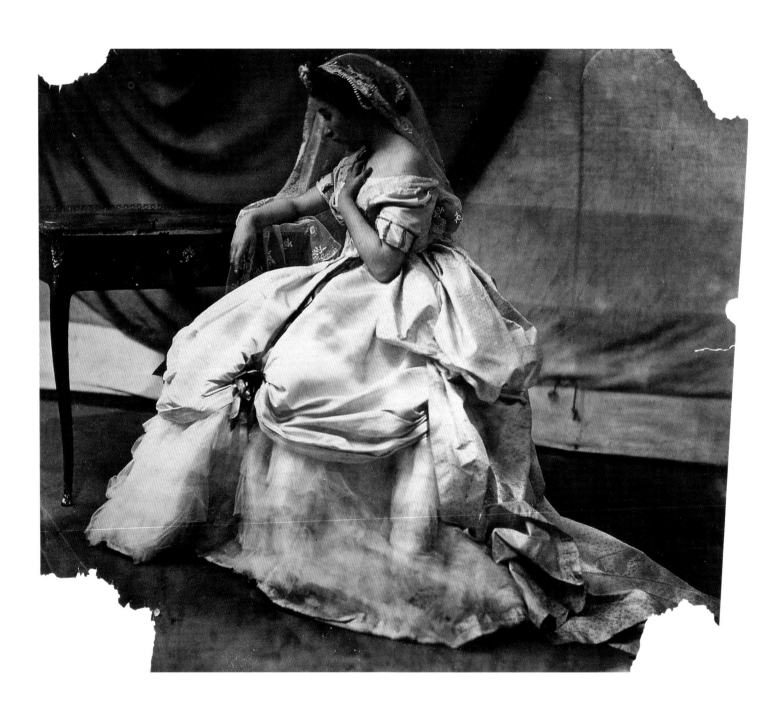

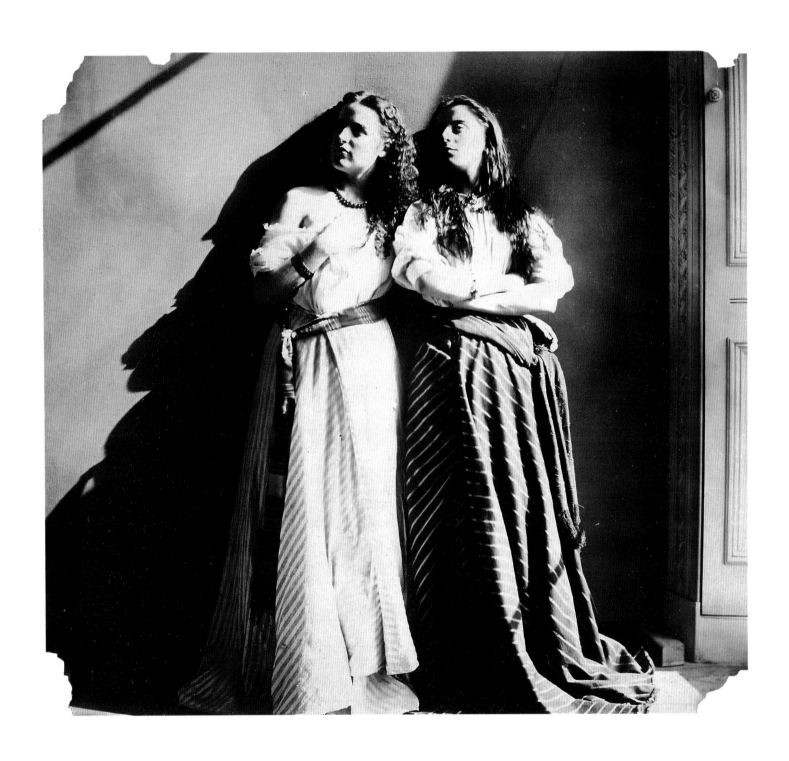

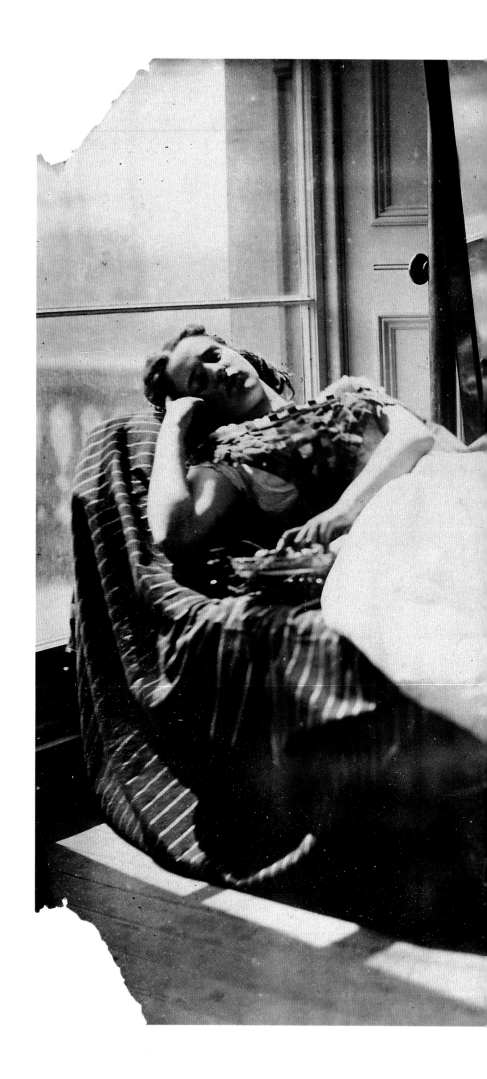

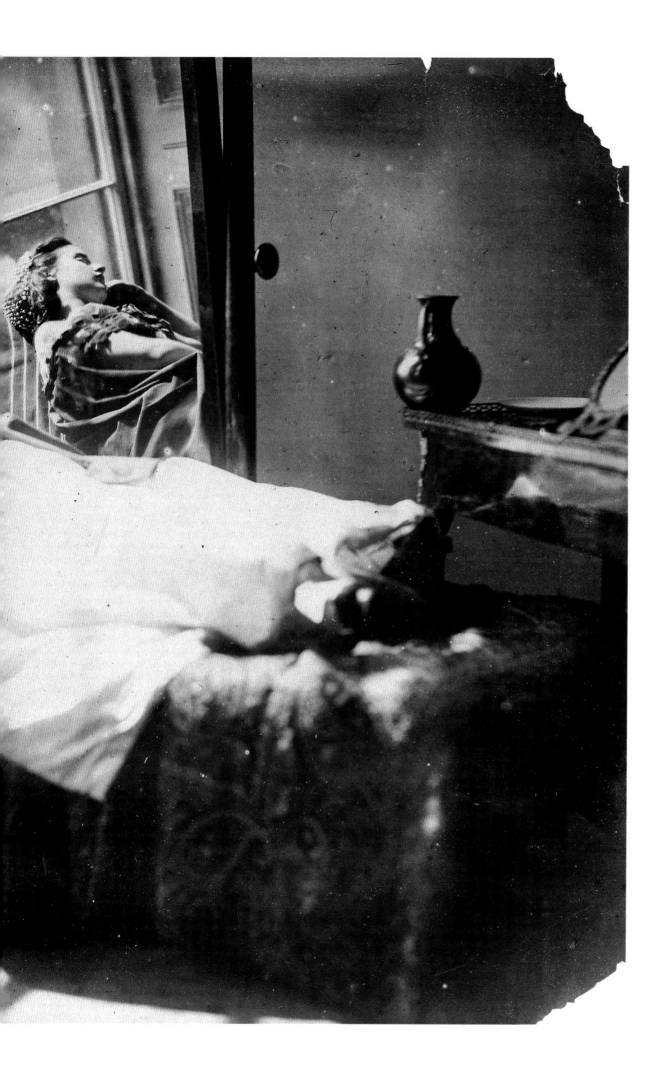

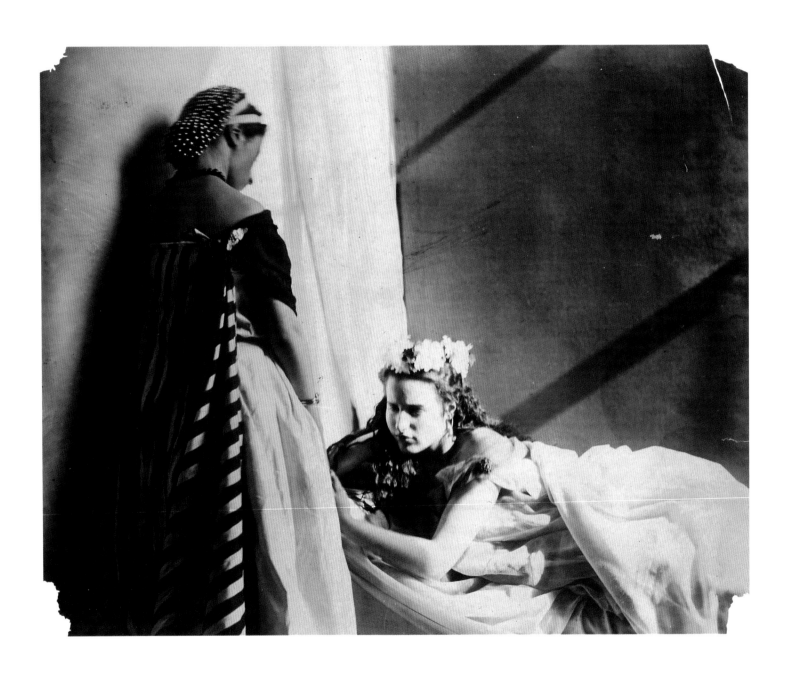

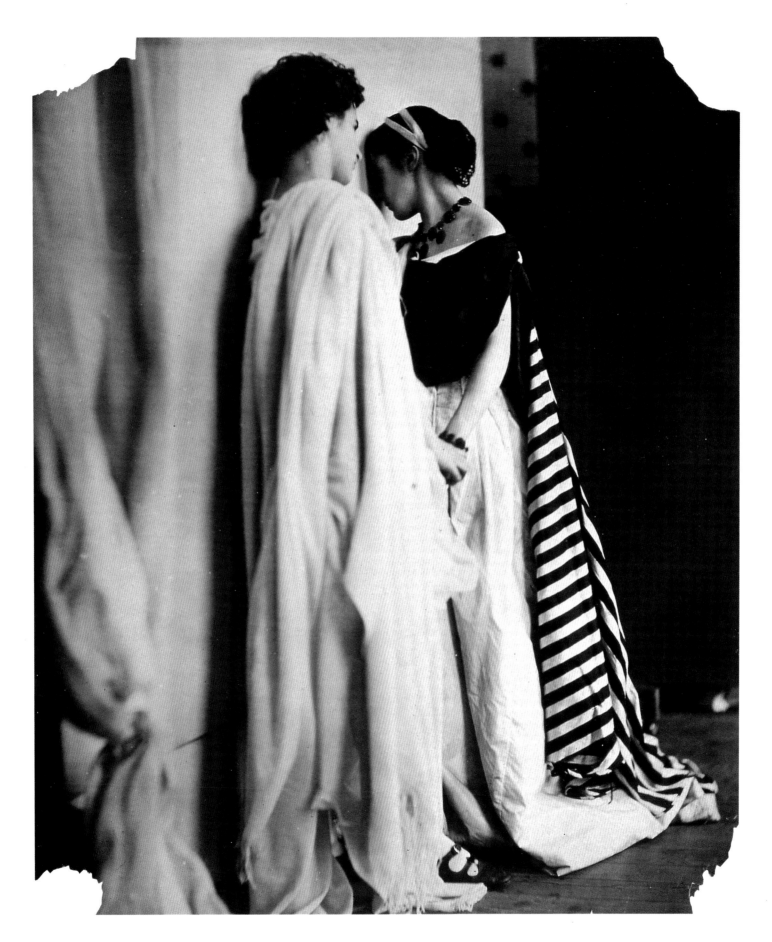

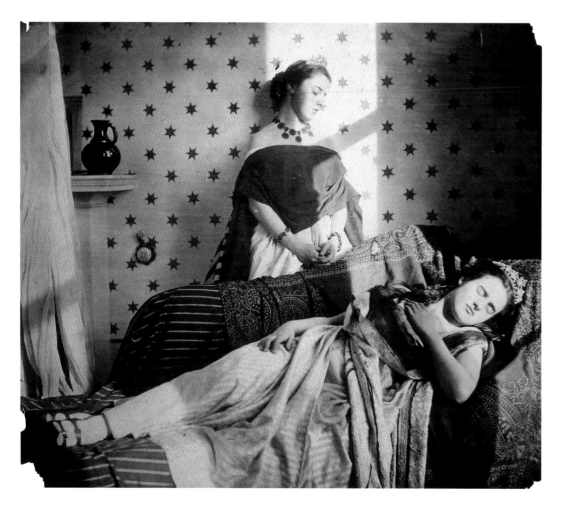

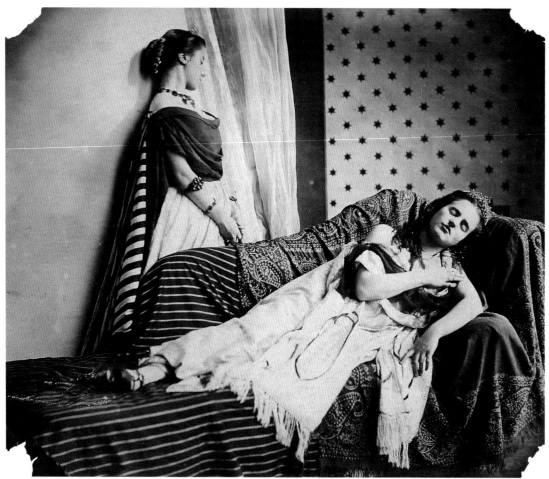

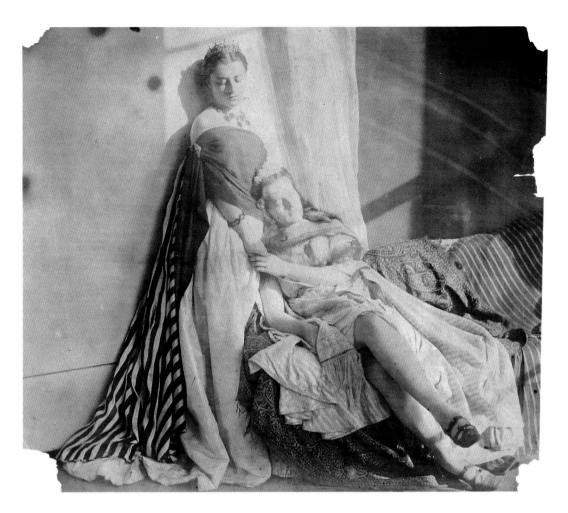

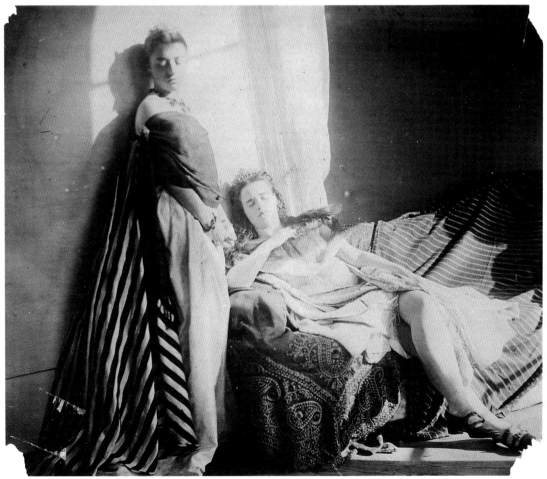

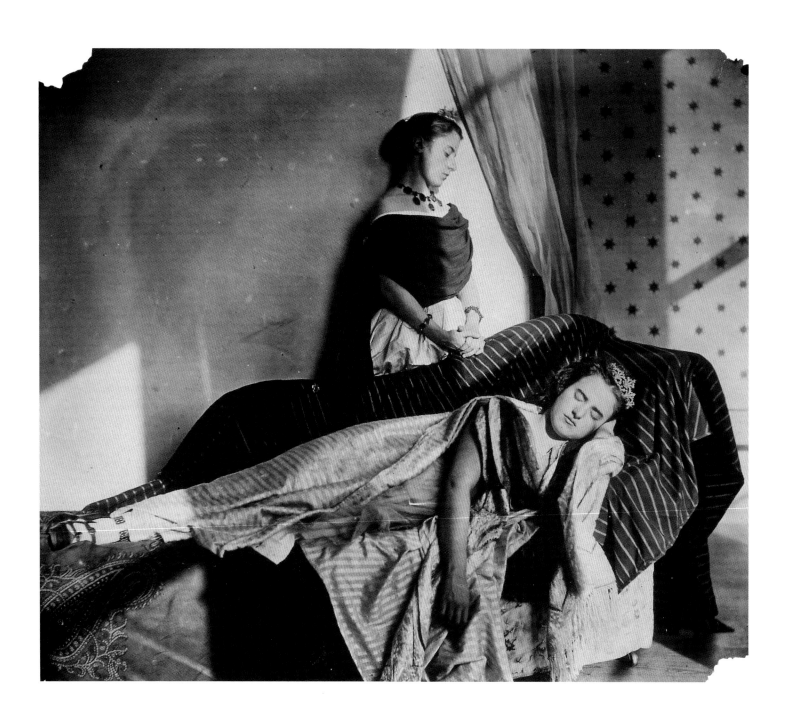

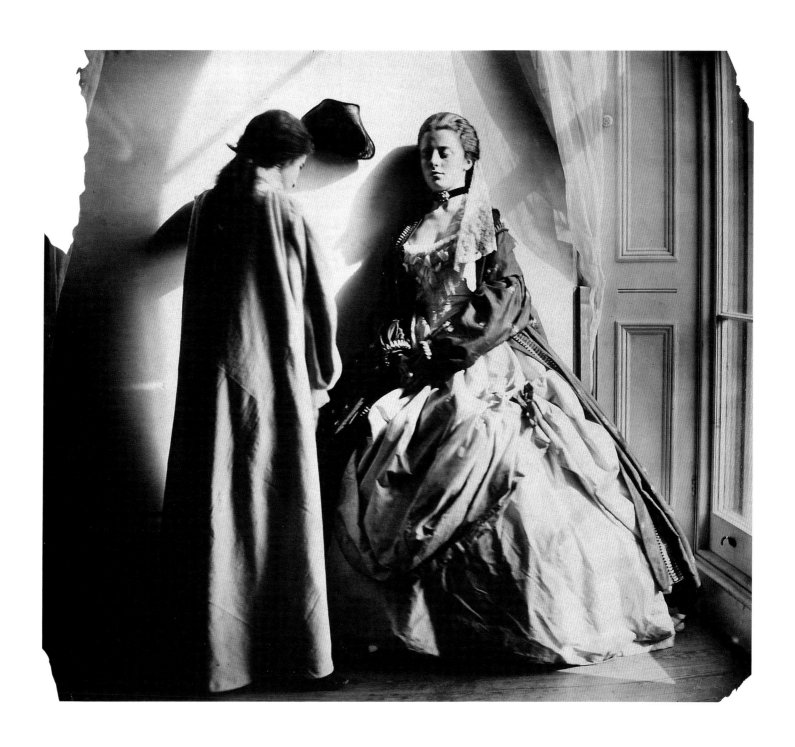

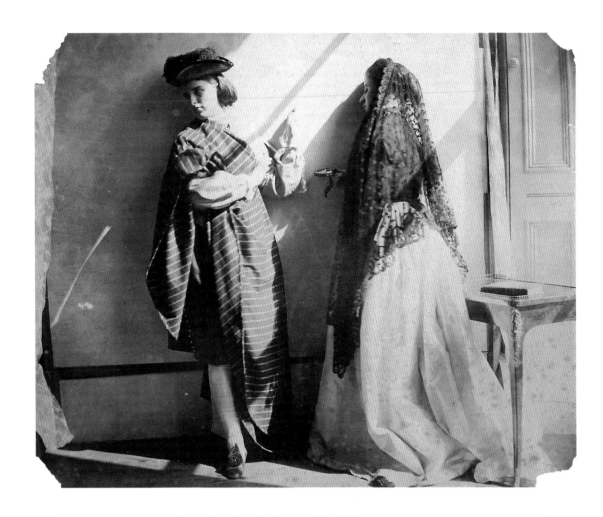

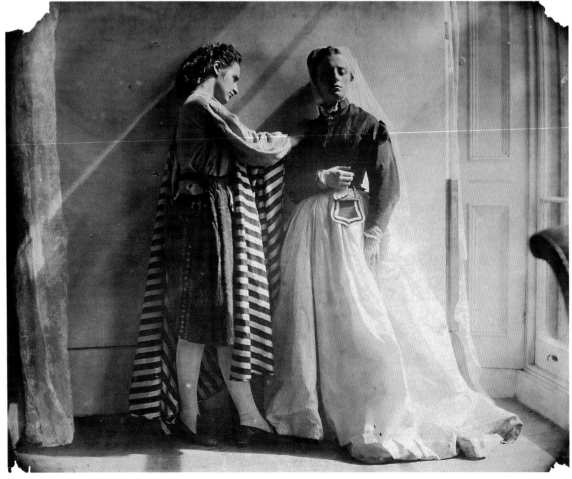

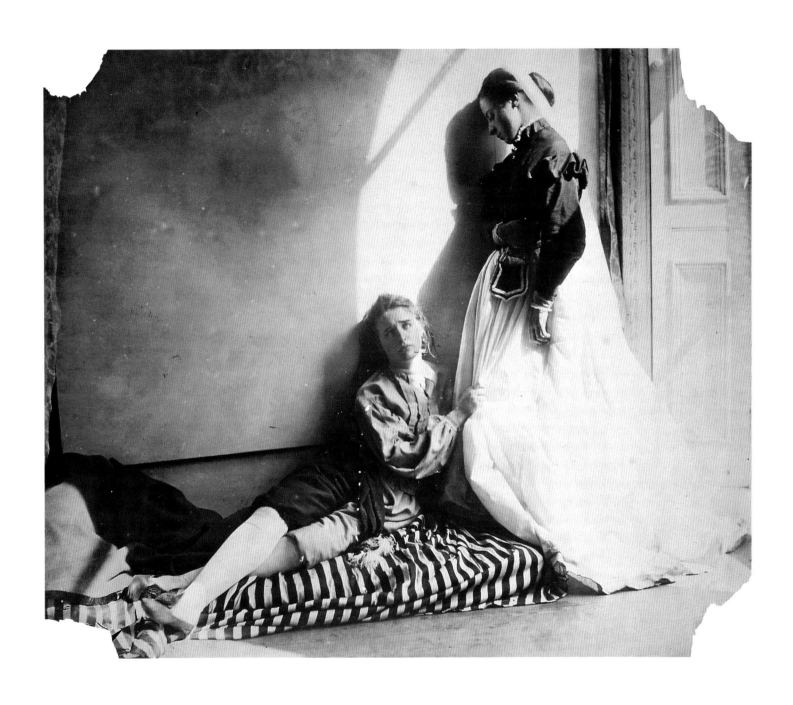

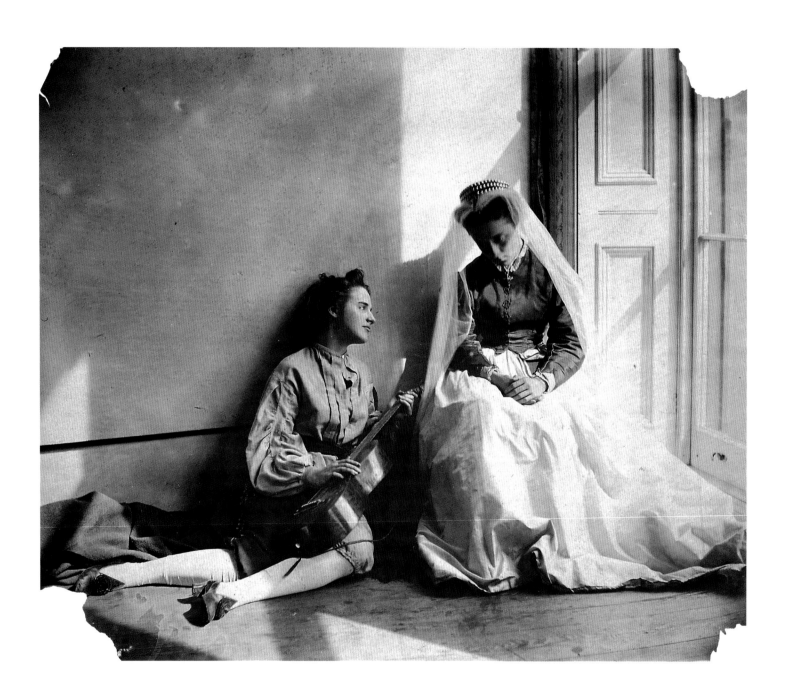

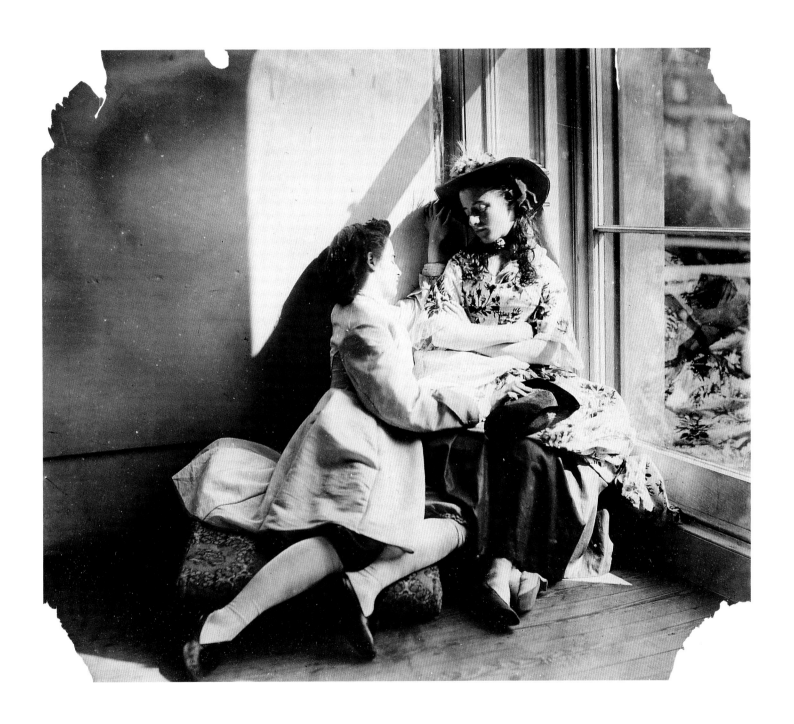

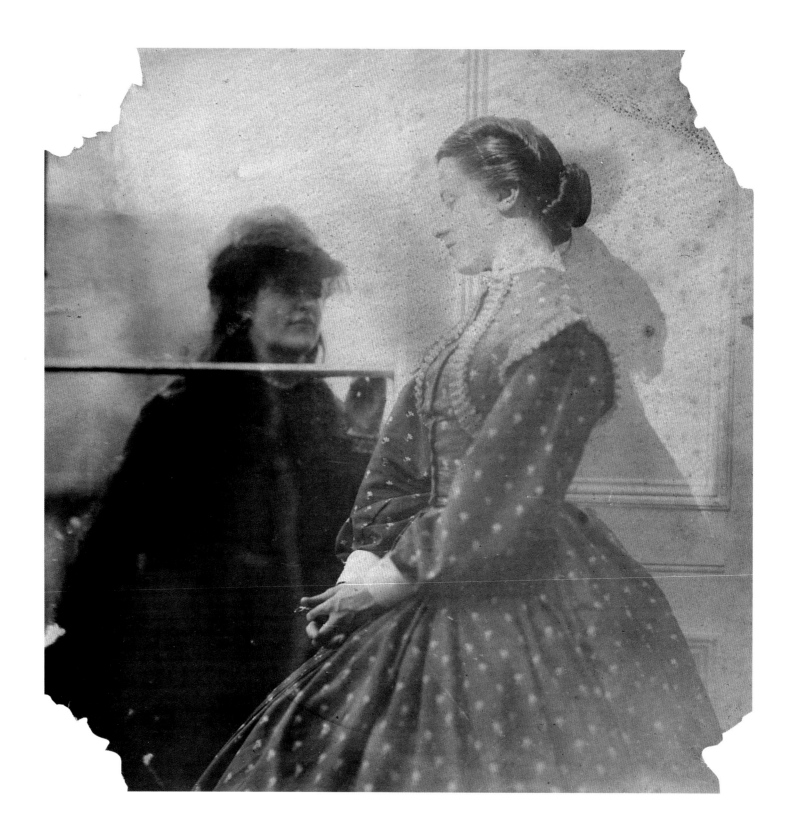

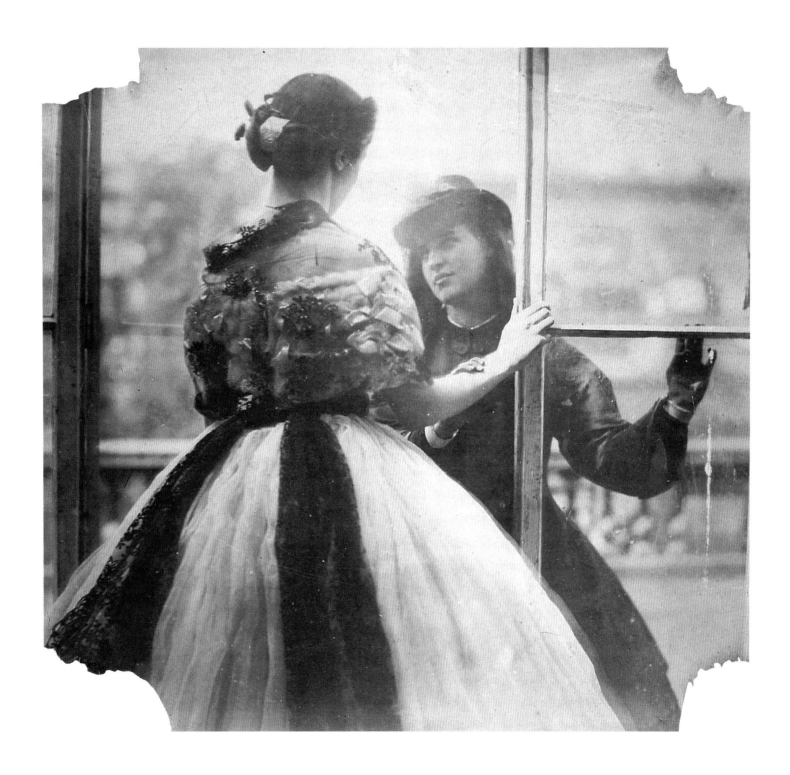

Chapter Five:
The London Art World

After their move from Dundrum, the Hawardens became acquainted with Henry Cole, first director of the South Kensington Museum[1] (which opened in 1857 and was renamed the Victoria and Albert Museum in 1899) and his brother-in-law, Charles Thurston Thompson, the museum's official photographer.[2] After Hawarden's death, her husband and children continued to be associated with the museum, lending objects for exhibition and display.[3] This association culminated in 1939, when her granddaughter donated the body of Hawarden's work to the museum.

The Hawardens' connections in South Kensington may have led to her involvement in the Photographic Society of London (now the Royal Photographic Society), where she exhibited her work for the first time in 1863, after photographing for about five years. She may have been influenced in her decision to do so by the very extensive showing of photographs at the 1862 International Exhibition, which took place almost on her doorstep. The rules of the 1863 Photographic Society exhibition allowed "Negative and Positive Photographs of every description, whether on paper, glass or other material, including Daguerreotypes . . . and also Stereoscopic Pictures and Stereoscopes" as well as "coloured" and "touched or painted" photographs.[4] Hawarden's catalog entries are No. 160 "Photographic Studies," No. 168 "Photographic Studies," and No. 678 "Photographic Studies, Dundrum, Ireland."[5] Since she did not use titles, and because there are no clues on her prints, it is impossible to establish which she actually showed, though references in reviews indicate the type of photograph she exhibited.

The Photographic Society of London, founded in 1853, was the longest-established and most prestigious of the British photographic societies. In the late 1850s and early 1860s, its ranks included amateurs as well as professionals. Hawarden was elected to the Photographic Society at the annual general meeting of February 3, 1863. The election procedure required the signed support of at least two members of the

society, followed by the unanimous election of the nominee.[6] Hawarden's sponsors
in the group have not been identified, but members of the society at the time included
O. G. Rejlander, Roger Fenton, and Henry Peach Robinson, each of whom had an
established reputation as an art photographer. It is interesting to speculate that one
of these individuals recognized the artistic merits of Hawarden's exhibited work and
nominated her.

For her 1863 entries she was awarded the society's first silver medal "for the best
contribution by an amateur." No provision for an award in this category had been
made when the exhibition rules were announced in November 1862,[7] suggesting that
Hawarden's work was considered so outstanding as to merit a new category.

In the early 1860s, the society was in the throes of a struggle between its amateur
and professional members. At stake, some believed, was photography's claim to the
status of art. Some commentators claimed that amateur photographers, working exper-
imentally for pleasure, had advanced "the art," while the professionals had worked
cautiously for profit alone. The case for the amateurs' supremacy was expressed by
one member who asked: "Who formed the first photographic society and established
the first journal? The amateurs. They formed the bulk of the members, and still retain
the main management. The provincial societies mainly rely on the amateur element.
The bulk of the papers read at the societies, and of the communications sent to the
journals, are by amateurs."[8] Henry Stuart Wortley, a prominent amateur soon to turn
professional, wrote that the professional photographer "does it by machinery; he has
no knowledge of Art, no feeling for the Beautiful, and in many cases . . . is entirely

ignorant of the optical properties of his lenses. And the amateur, he takes to photography because it is so nice to be able to get pictures of all one's friends!"[9]

The committee that awarded Hawarden's first medal included Joseph Durham, a sculptor who was part of the South Kensington circle, and Roger Fenton. Fenton's approval was proof, from the moment of Hawarden's debut, of her ascent to the pinnacle of the photographic establishment. From about 1854, when he left his law practice, to 1862, when he retired from photography, Fenton was the protean figure of the medium. By birth, education, and inclination Fenton was typical of those amateur photographers who turned professional. Like Rejlander, Fenton had studied painting, possibly in the studio of Paul Delaroche in Paris, and with Charles Lucy in London.[10] The paintings Fenton exhibited at the Royal Academy are lost, but their titles[11] indicate that he specialized in genre scenes, such as *The letter to Mama: What shall we write?*

Hawarden showed her work for the second, and final, time at the society's 1864 exhibition. In contrast to the 1863 show, the 1864 rules stipulated that "pictures from painted or touched negatives, and also touched and painted positives, will not be exhibited." Many photographs exhibited in 1863 had been seen previously in the 1862 International Exhibition and in print sellers' shop windows, but in 1864 pictures previously exhibited in London were forbidden.[12] Hawarden's 1864 catalog entries are No. 157 "Studies from Life," No. 187 "Photographic Study," and No. 208 "Photographic Studies."[13] Numbers 157 and 208 were probably frames containing several photographs mounted together, a common method of displaying photographs, as can be seen in figure 7.

Number 187 was apparently a single photograph, described by a reviewer as the largest of Hawarden's exhibits, "a picture about 10 by 10 . . . a most charming picture, surpassed by nothing in the exhibition." The reviewer continued,

It consists of a graceful female figure in rich drapery, standing beside a window, the full light from which falls upon one side of the drapery without producing chalkiness or destroying detail; whilst the deep shadow produced by the intense direct light on the other side of the figure is so exquisitely transparent that no detail is lost or any approach to blackness apparent. The pose and the arrangement are graceful and artistic, possibly a little more reflected light on the face seen in the mirror would have been an improvement, and a more flowing or sweeping line in the drapery where it cuts the light would have been better. But the picture is altogether charming notwithstanding. Lady Hawarden exhibits a few smaller studies having

similar characteristics, graceful arrangement, and unusual and extremely artistic lighting, great transparency, and much tenderness and delicacy of treatment.[14]

The description is closest to the photograph on page 48.

For her 1864 entries, Hawarden received a second silver medal, for composition. The award committee included Thurston Thompson, Durham, Stuart Wortley, and the amateur photographer Dr. Hugh Diamond.[15]

There were marked differences between the 1864 exhibition, with its provisos against combination prints and colored photographs, and the 1863 exhibition, at which the great success had been Robinson's multi-negative composition, *Bringing Home the May*. What had occurred in the interven-

Figure 9
Lewis Carroll,
Ellen Terry, July 1865

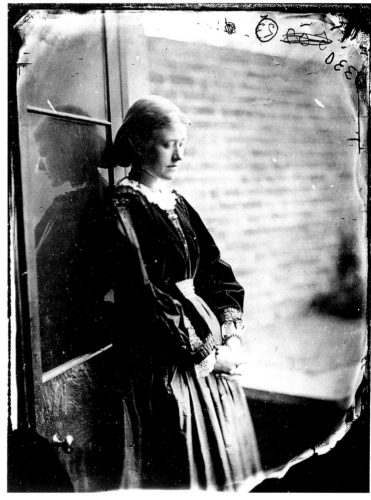

ing year that caused the Photographic Society to prohibit multiple printing and other methods of photographic manipulation? Perhaps the fact that the art photography controversy had heated up in early 1863, instigated by Thomas Sutton, editor of the periodical *Photographic Notes*, with his paper "On Some of the Uses and Abuses of Photography."[16] Sutton raked up long-slumbering controversies over Rejlander's ambitious combination print, *The Two Ways of Life* (1857). Rejlander counterattacked with his paper, "An Apology for Art-Photography," in which he said, "The same way a painter goes if he means to paint, a photographer must go if he wishes to make a composition-photograph." He concluded with the exhortation, "Now, use photography: don't abuse it."[17] In the obituary he wrote for Hawarden, Rejlander echoed this phrase when he noted that "she was an earnest believer in the progress of photography, and that it could be used as an art and abused like a daub."[18]

No doubt the Photographic Society felt it would not be wise to rekindle the controversy, but careful planning did not guarantee a popular exhibition. The public stayed away from the 1864 show, and Hawarden's second triumph took place in a dispirited atmosphere. The exhibition was judged "dull and dreary in the extreme."[19]

O ne of the reasons the 1864 Photographic Society exhibition did not fare well with the public was the number of competing events and entertainments. Among the other attractions was the "Grand Fête and Bazaar . . . in Aid of the Building Fund of the Female School of Art," which was held in the Horticultural Gardens, June 23–25, 1864.[20] At this event, Hawarden sold her work from a stall described as "covered by a number of very artistic photographs executed by her ladyship,"[21] as part of the successful fundraising effort. A handbill advertised Hawarden's offer to take

Female School of Art Fête

portraits at the fête (figure 8), assisted by Thurston Thompson. The engraved decoration seems to depict Hawarden at work; although the face of the woman behind the camera is obscured, the group resembles her husband and children gathered on a terrace like that of 5 Princes Gardens. The wand-carrying fairy plays on the idea of the camera as a "magic box"—an image very much in the spirit of the event, which included farces and skits performed by a troupe of amateur players.[22] Photographs that Hawarden took of her daughters suggest they performed at the fête.

Fancy fairs were social occasions at which the participation of "distinguished ladies" ensured that visitors who wished "to feast their eyes upon a titled personage [would] have ample scope for this amusement."[23] One of the attractions of a fête was that the restrictions of well-bred behavior could be abandoned when upper-class women worked at the counters. At a fête, a lady could sell her handiwork or her possessions for the satisfaction of making money, not for herself, but for a good cause.

Lewis Carroll

The sort of visitor the Photographic Society hoped to attract was Lewis Carroll. He often journeyed to London from Oxford in pursuit of his hobby, photography, which he used as a means of introduction to artists, writers, and aristocrats and, through them, to their children or young relatives. In the early 1860s, his subjects included painters Dante Gabriel Rossetti, William Holman Hunt, and John Everett Millais (figure 10), writer George MacDonald, and photographers O. G. Rejlander and Julia Margaret Cameron.

In his diary for June 23, 1864, Carroll wrote, "went to the Photographic Exhibition which was very scanty and poor. I did *not* admire Mrs. Cameron's large heads taken out of focus. The best of the life-ones were Lady Hawarden's."[24] Their subjects were those he preferred in his own work: famous and/or titled people, and beautiful children and adolescent girls.

The following day Carroll visited Rossetti's studio, where he watched the painter at work. "Thence I went to the Bazaar held in the Horticultural Gardens for the benefit of the Female Artists. . . . I saw Lady Hawarden's name as keeping a stall there, and wanted to buy some of her photographs. There was one of which they had no copy, and I gave my name and address that one might be sent. This led to Lord Hawarden's introducing himself to me as an old pupil of my father's and he introduced me to the Viscountess. She had a studio there, and I decided on bringing some MacDonalds to be photographed by her. . . . June 25. (Sat.) Went to the MacDonalds and took Mary and Irene with me to the Bazaar, where Lady Hawarden photographed them."[25] Carroll paid Hawarden the double compliment of buying her work and of allowing her to photograph two of his favorite child models, daughters of George MacDonald. (Unfortunately, the photograph she took of them has not been located.)

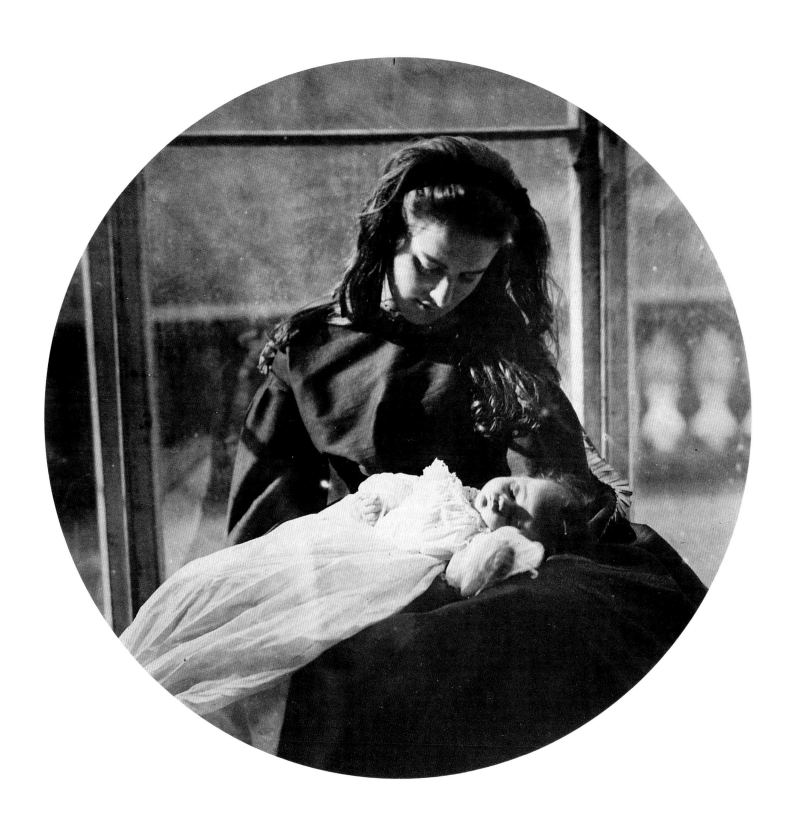

The five photographs Carroll bought are representative, in style and in subject, of Hawarden's late work: a portrait; a double portrait reminiscent of a Madonna-and-Child tableau (page 91); two tableaux perhaps forming a sequence; and a genre scene. These Carroll carefully pasted into his album entitled "Professional and Other Photographs," [26] which comprises fifty-three photographs, including some of Rejlander's best-known work, as well as many photographs by Cameron. Carroll's album provides a rare opportunity to assess Hawarden's work in a contemporary context, and demonstrates that a member of the cognoscenti considered her in the same class as Rejlander—the most admired art photographer of the day.

To Carroll, Hawarden and her family presented an interesting prospect for cultivation, but he was stymied in his attempts to become a friend of the family, as seen in the following diary entry from July 22, 1864. He wrote, "A regular 'Friday' . . . went to call on Lord Hawarden, to get the print I bought—& was just in time to see Lady Hawarden get into her carriage & drive off, & of course *he* was out—*Dies non*." [27] On July 24, Carroll "called on Lord Hawarden [who] showed me a number of Lady Hawarden's photographs (very beautiful). I find that he is *not* a photographer himself." The next day he wrote, "Left some photographs for Lady Hawarden, as well as a copy of the one she took at the bazaar." [28]

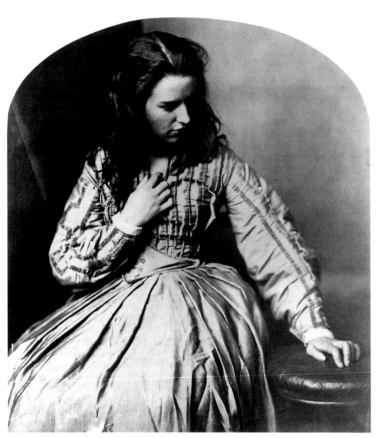

Figure 11
Attributed to O. G. Rejlander,
Untitled, ca. 1863

Although Carroll's association with Hawarden was brief, her influence on his work is evident in a photograph he took of the actress Ellen Terry in July 1865 [29] (figure 9). The soft light through the open door and the figure caught *contre jour* are not typical of Carroll's oeuvre and suggest that in this instance he consciously emulated the effects of a photographer whose work he admired.

Carroll was fortunate in finding Hawarden's work for sale at the Female School of Art fête, for she did not sell photographs at the Photographic Society exhibitions, nor was her work published. Judging by comments in the photographic press, if she had sold or published her work there would have been a ready market. During the 1863 exhibition, the *Photographic News* said, "Should these studies be published, and we believe we may venture to hope they will be, Lady Hawarden having, we believe, given her consent, we should recommend every portrait photographer to possess and study them." [30] These hopes were not realized. In 1864, the same periodical, in response to a letter from a reader, was forced to disappoint by reporting that Hawarden's work was neither published nor for sale. [31]

O. G. Rejlander

Hawarden's work from 1859 on manifests concerns and preoccupations that seem personal, but at the same time may be seen as part of a general trend in art pho-

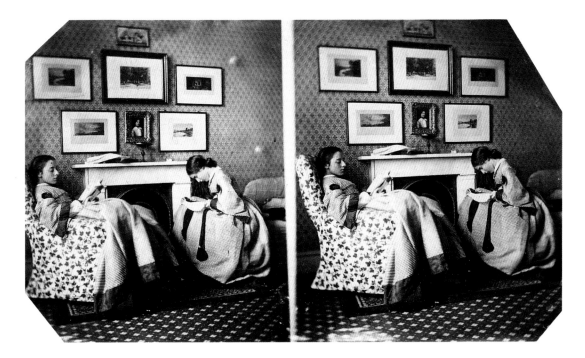

tography, as exemplified by her contemporaries, most notably Cameron and Rejlander. In fact, Rejlander may have influenced Hawarden in her choice of subjects and in her handling of composition and light.

Similarities between some of Hawarden's work and examples of Rejlander's work from the 1850s and 1860s, plus the appreciative tribute he wrote after her death, suggest that the two photographers were acquainted. They could have known each other through the Photographic Society, to which Rejlander had been elected in 1856,[32] but such an association is not documented. That Hawarden admired Rejlander's work can be seen in the photograph above, in which a copy of his *After Raphael's Sistine Madonna* (ca. 1857) is displayed in the Hawardens' home above an arrangement of Francis Seymour Haden's etchings.

Several elements of a photograph attributed to him (figure 11) further suggest that Rejlander and Hawarden may have worked together at least once. Although her face is turned away and obscured, the model appears to be Hawarden's daughter Clementina. The girl poses in a highly dramatic manner familiar from many Hawarden photographs. The setting, lighting, and props, however, are not typical of Hawarden's work. The dark background and the light, coming from an invisible source, give a two-dimensional quality of the type Rejlander consistently achieved in photographs produced in the London studio that he designed and built for himself in 1863. As Rejlander was "master of light and shadow,"[33] the secrets of his "tunnel studio" were relayed to a waiting public by the *Photographic News*. The studio, constructed in such a way as to provide diffused light from the side and top, produced what was considered the most artistic type of lighting.[34]

Hawarden's photographs, taken in her drawing room-cum-studio, were considered by the *Illustrated London News* to have "a great deal of artistic knowledge and feeling in composition, 'posing,' and management of focus and light and shade." This was achieved "by tasteful selection and posing of models, and arrangement of accessories, and by admitting only direct light from the comparatively contracted aperture of a large

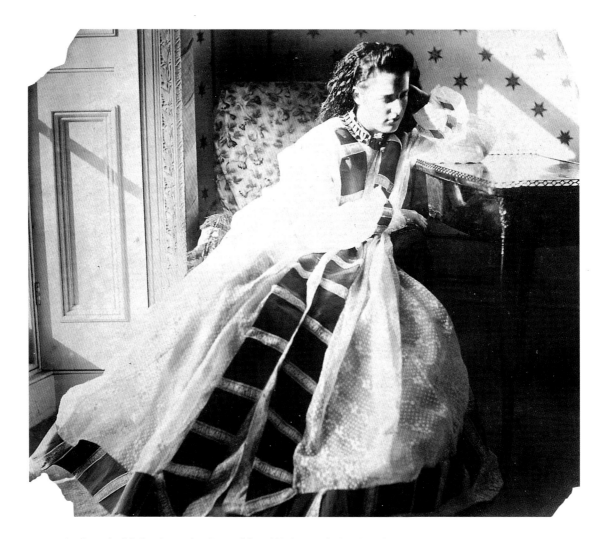

window (which gives the breadth of light and shade of an artist's studio)."[35] According to the *Photographic News*, the success of Hawarden's photographs was due to "the daring lighting and the artistic effects of light and shade secured. . . . In some cases the effect of light reminds [us] of some of Rembrandt's pictures in which one bright light is in strong contrast with a mass of shadow into which, however, the light is sufficiently carried to secure both transparency and breadth."[36]

If Hawarden learned from Rejlander's example, it may have been because he had the proper credentials for a photographer who sought the status of an artist. He had studied art in Rome, where he supported himself with portraiture, copying, and lithography. In 1848, he exhibited paintings at the Royal Academy. He sold photographic studies of hands, drapery, and figures to painters.[37] His popularity with the art establishment—his friends included Rossetti, Cameron, and Carroll—prevailed despite his being "a genial native of artistic Bohemia."[38]

Like Hawarden, Rejlander conflated the categories of portraiture and studies from life. He also, as she did, encouraged his models to express emotion freely through facial expression, as well as through their posture and gestures. The emotion expressed for the camera in, for example, *Grief* (1864) was perhaps coaxed from the models by Rejlander's own histrionic abilities. His success in this was admired and led to his photographic illustrations for Charles Darwin's *On the Expression of Emotion in Man and Animals* (1872). Rejlander himself posed for five of the studies.[39]

Women contributed to the young art of photography in greater numbers than are usually acknowledged. By the time that Hawarden began working in the late 1850s, women photographers were not considered unusual or eccentric. Nor was their work segregated, either in Photographic Society exhibitions or in exhibition reviews. Although women had exhibited with the society since its foundation, Hawarden was perhaps the first woman to be elected and certainly the first to be accorded the unqualified praise of the public and the photographic community alike. In its first ten years, approximately twenty-five women exhibited with the society.

The proportion of female to male exhibitors remained relatively unchanged throughout these years. In 1854, for example, there were 840 catalog entries, of which ten are credited to four women photographers—Mrs. Guppy; Mrs. Catherine Verschoyle; and Lady Augusta Mostyn and Lady Caroline Nevill, sisters who exhibited jointly as "The Ladies Nevill."[40] (Guppy made photographic copies of manuscripts;[41] Verschoyle's work is apparently lost; and the Nevill sisters photographed their relations, friends, and servants on the family estate, where they also took picturesque landscapes.)

Other women photographers active during this period include Viscountess Jocelyn and the Countess of Rosse. Fanny Jocelyn belonged to the Amateur Photographic Association. Like Hawarden, her favorite subject was her family, particularly her daughters, and her photographs are reminiscent of Hawarden's in intimate mood and domestic setting.[42] Mary Rosse also concentrated on photographing her family at their Irish estate, Birr Castle.[43]

Hawarden and Cameron, however, have come to represent all nineteenth-century female photographers. Cameron worked with themes similar to those that interested Hawarden, albeit at a slightly later date. Both women used the phrase "study from life" to describe the genre in which they were working. Unlike Hawarden, Cameron usually identified her sitters and gave her photographs full, descriptive titles. She photographed her family, friends, and servants in roles she assigned them; the album she presented in 1865 to her friend and mentor Lord Overstone is divided into "Portraits," "Madonna Groups," and "Fancy Subjects for Pictorial Effect."[44]

From the beginning of her photographic career, Cameron took a visible, public role, exhibiting with the Photographic Society. She registered her work for copyright and published it. According to one of her models, Cameron "had a notion that she was going to revolutionize photography and make money."[45] Among her possible motives for taking up photography in January 1864[46] was the desire to promote herself, her family, and her friends—who included Lord Tennyson, her neighbor on the Isle of Wight— as an elite group representing the modern inheritors of classical and biblical tradition. She made no secret of her subjects' identities, as noted by a friend in 1865: "[Cameron's photographs exhibited at the South Kensington Museum] are very beautiful, and as

Figure 12
Julia Margaret Cameron,
Sadness (Ellen Terry), 1864

usual she treats the many-headed monster, the public, as her dear familiar and gossip, writing in large hand on these photographs, MY GRANDCHILD, JULIA MARGARET NORMAN, aged 6, with her nurse, and so on."[47]

Though both Hawarden and Cameron photographed beautiful young women in fancy dress and draperies, only Hawarden was admired for her technique, especially for her command of depth of focus. Contemporary reviewers found Cameron's work distinctly lacking in technical refinement. In 1865, the *Photographic News* belittled Cameron's "idea of what constituted the artistic in photography . . . consisting in the main in a piece of light or dark drapery pulled about the figure or over the head of some person in modern costume, which is concealed with some difficulty by much tucking in here and pulling out there, and in the photographing thereof with a lens turned out of focus."[48]

Figure 13
William Holman Hunt,
The Awakening Conscience,
1853–54

Hawarden's sensuous use of costume and drapery combined with her daughters' uninhibited self-expression also bring to mind Pre-Raphaelite paintings. But Hawarden's contemporaries did not include her work in the ever-expanding category of Pre-Raphaelitism. According to Rejlander, "There was nothing of mysticism nor Flemish pre-Raffaelistic conceit about her work."[49] She does not seem to have associated with any member of the Pre-Raphaelite Brotherhood, nor do any of her photographs quote from or reproduce any of their works. Although the Pre-Raphaelites were considered a clique in the early 1860s, the term could be applied loosely to the work of other artists, denoting a style broadly based on a received idea of the tenets of Pre-Raphaelitism or referring to subject matter that was in keeping with their preoccupations—for instance, Arthurian or Dantesque themes.

The photograph on page 97 has been considered an example of "Pre-Raphaelite photography" because of the similarities between Clementina's pose and that of the woman in William Holman Hunt's *The Awakening Conscience*. While it is not known whether Hawarden ever saw the painting (or a reproduction of it), clearly both works share the same subject: a moment of revelation. In the painting, Holman Hunt provides many clues to help the viewer understand a complicated story that carries a simple moral of redemption. As in most of her photographs, however, Hawarden gives few clues to her meaning and, as always, the photograph is untitled. The vignetting of the photograph during printing softened the edges and obscured the object in Clementina's hands, which appears to be a die-throwing cup, an allegorical attribute of fate. The snake—a reminder of temptation before the fall—clasped round her throat further suggests her role as a fateful female.

Comparison of Hawarden's work from the late 1850s and 1860s with that of James McNeill Whistler from the same period reveals similar concerns and transitions. The progression in choice of subject matter—from landscapes, to portraits, to interiors with figures, to "subjectless" figure studies, to costume tableaux—may be compared to similar changes in Whistler's oeuvre. He moved from the realism of such paintings as *At the Piano* (1858–59)—in which the discernible stylistic influences are as diverse as Vermeer, Velázquez, and Courbet—to subject pictures with touches of japonaiserie, as in *The Little White Girl: Symphony in White, No. II* (figure 25).

Figure 14
James McNeill Whistler, *Weary*, 1863

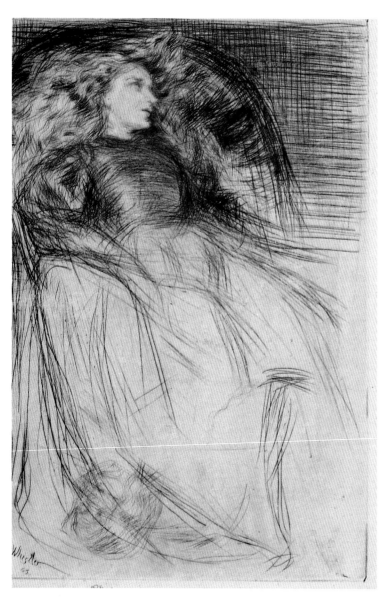

There may be more than a generic connection between Hawarden's and Whistler's work. Though it has not been established that they knew each other, nor that Whistler ever had occasion to see her photographs, they could have been introduced by his brother-in-law Francis Seymour Haden, with whose family Whistler lived at times until about 1860. Like Hawarden, Whistler focused on intimate domestic interiors at this time, and, significantly, the home featured in these works is that of the Haden family. His etched portraits of his nephew and niece have a photographic quality that compares to early portraits by Hawarden.

In mood and composition, the photograph on page 99 is reminiscent of Whistler's *Weary* (figure 14), which shows his mistress Jo Hiffernan half-reclining in an armchair, her hair loose around her. In the print, drypoint lines fill the background, while the photograph describes a similar texture in the shadows cast by the pattern in the net curtain.

Whistler's increasing rejection of narrative was neither new nor unique. However, his increasing disregard for transparent meaning—as demonstrated in *The White Girl: Symphony in White, No. I* (1862)—was not generally acceptable. Working in the genre of the photographic study, Hawarden was not bound by conventions of narrative and composition in the same way that Whistler, an artist who hoped for recognition by the Royal Academy and the Paris Salon, would have been.

Francis Seymour Haden

Among the links connecting Hawarden to her contemporaries in South Kensington, the most important is her association with the etcher and surgeon Francis Seymour Haden. Haden's life and work have been carefully documented, his work extensively commented on, and three catalogues raisonnés of his oeuvre prepared, two of these completed during his lifetime with his cooperation. Known and respected as an etcher as well as a print collector and connoisseur (notably of Rembrandt), he was

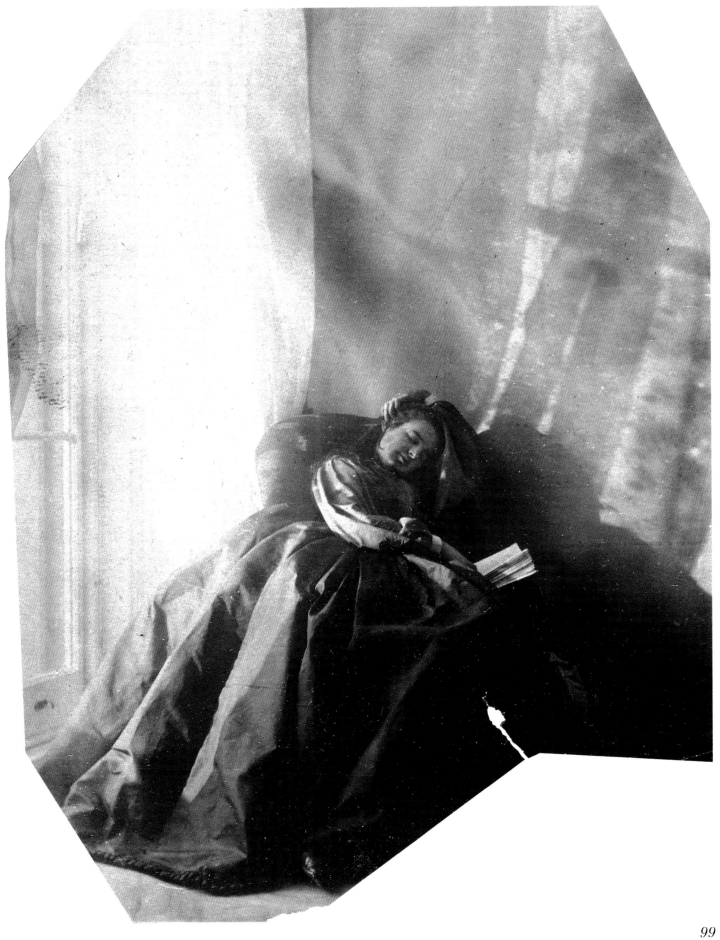

knighted for his contributions to etching in 1895. His association with Hawarden provides a unique opportunity to examine in some detail the specific ways in which she clearly exerted an unrecognized influence on the work of a contemporary.[50]

Hawarden probably met Haden as his patient in 1859, when she was expecting her eighth child, and therefore knew Haden during the years of her prime achievement. This was the most fruitful period of Haden's artistic career as well, a time when he launched himself as an artist of international stature with the publication of his article "About Etching" in 1865.

The importance of their association is evident in the work of each. Haden's most renowned prints are Dundrum landscapes, which bear stylistic similarities to Hawarden's Dundrum scenes. Second, Haden prints appear in a Hawarden photograph. Third, the two apparently worked with Hawarden's daughters, as models and shared figures, motifs, and subjects in their separate mediums.

Figure 15
Francis Seymour Haden,
La Belle Anglaise, 1864

Finally, in some instances, Haden seems to have relied on Hawarden's photographs to provide figures fixed in poses, at times transferring forms from her photographs to his etchings. Paradoxically, Haden promoted himself as a highly gifted, individualistic interpreter of nature and played down his more than passing interest in the representation of the figure. With his brother-in-law Whistler, Haden was at the forefront of the Etching Revival, a movement that sought to return to printmaking its artistic credentials as an original, rather than reproductive, medium. Haden expressed a dislike bordering on contempt for the work of the copyist, writing that "there is not [and] never was, anything that could be called a rivalry between the etchers and the later engravers. They represent distinct classes—the class of artist and the class of copyist."[51] Such sentiments, expressed by Haden with characteristic force, have influenced Haden scholars to adopt his own stance on the subject of copying. This attitude has long obscured the sources of those of his etchings which did not derive solely from nature, such as those which can be shown to have derived entirely or partially from photographs by Hawarden.

Haden was likely invited to Dundrum to enjoy the abundant salmon fishing available in the area. Both he and Lord Hawarden were enthusiasts. Haden visited Dundrum several times, producing there some of his most famous works, including *A By-Road in Tipperary* (figure 16) and what is considered by Haden connoisseurs to be his masterpiece, *A Sunset in Ireland* (1863). Between 1859 and 1864, Haden made seven prints of Dundrum scenes. He apparently had a press at Dundrum, probably in the stables, and would have had ample opportunity to observe Hawarden at work outdoors. The connection between their work is evident in an etching like *A River in Ireland* (figure 17), and the Hawarden photograph on page 103.

Besides inviting Haden as a guest to their country estate, the Hawardens collected their doctor's artwork, and displayed his avant-garde efforts in their London home (page 93). Above the mantel five Haden prints surround what appears to be a family portrait, the arrangement surmounted by Rejlander's photograph *After Raphael's Sistine Madonna* (ca. 1857).[52] The Haden prints are, beginning at the lower left and moving clockwise, *Out of Study Window* (1859), *Thames Fishermen, No. I* (1859), *A By-Road in Tipperary* (1860), *Mytton Hall* (1859), and *Egham* (1859).

Though Haden pronounced that "the painting of the figure, of action, represents movements or passing emotions which are for me less suitable for remaining permanently before my eyes,"[53] he clearly relied on Hawarden's photographs to provide fig-

ures fixed in poses. These he incorporated into genre scenes, perhaps briefly regarding photography as a tool, in keeping with the tenets of the photographic study. The subject of Haden's etching *La Belle Anglaise* (figure 15) is readily recognizable as Hawarden's daughter Clementina. Her fine, large hands were particularly expressive, and in the Haden print she holds one of them to her neck, with the same sort of gesture she often employed in her mother's photographs. No extant photograph by Hawarden corresponds precisely to *La Belle Anglaise*, although the photograph on this page shows Clementina in a similar pose and feathered hat, suggesting that either Haden saw Hawarden's photograph or that Clementina posed for them both during the same sitting.

Close comparison of another Hawarden photograph (page 123) with Haden's etching *The Assignation* (figure 26) reveals that he copied the central figure directly from the photograph, which shows Isabella Grace holding a fan to her head and leaning against a balustrade. She wears a dress with a distinctive dark band (the same one she wears in the photograph on page 93). When a tracing made from an impression of the first state of the etching is laid over the photograph, the two figures square precisely, differing only in the lateral reversal of the figure in the print. Pencil additions to the skirt in one impression turn its irregularly waving band into a smoothly rising curve, alterations that Haden incorporated into later states of the etching.[54]

In the photograph on page 105, as in many photographs by Hawarden, her daughter Clementina, in fancy dress, is the center of a composition that has neither explicit meaning nor explanatory detail. A genre scene is suggested, however, by the slight droop of her head, the way she supports herself by leaning on the door, and her picturesque attire. Hawarden, as always, seems more concerned with formal contrasts: light and dark, plain and patterned, simple and elaborate, juxtapositions that occur again and again in her work. Haden's prints *The Letter, No. I* (figure 18) and *The Letter, No. II* (figure 19) almost certainly derive from this photograph, although he did

Figure 16 (above): Francis Seymour Haden, *A By-Road in Tipperary*, 1860
Figure 17 (below): Francis Seymour Haden, *A River in Ireland*, 1864

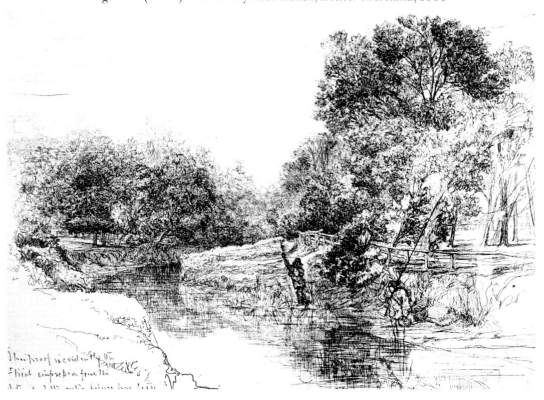

not acknowledge this. He added a slip of paper on the floor, thus enhancing the anec-
dotal elements of the scene, and elaborated with a narrative title: *Tristesse! A young girl
has just received a painful letter.*[55]

The French critic Philippe Burty wrote that these prints were the first produced by
Haden after a two-year interruption, marking the beginning of a "new series" in his
work.[56] When Burty asked Haden about his two-year hiatus, Haden replied, "in order
to work, I have to have a bit of fever."[57] Might he have caught the fever to take up etch-
ing again from Hawarden, or an idea shared with or borrowed from her?

Haden may have considered experimental his prints that borrow from or are based
on photographs by Hawarden. Indeed, relatively few impressions were pulled from some
of the plates in question. When such prints came onto the market during his lifetime,
Haden reasserted his claim that he worked almost entirely *sur le motif* and did not explain
why or how he had used Hawarden's work. Hawarden died long before Haden, and, as
her photographs were not exhibited after 1865, at the height of Haden's fame no one
(outside the Hawarden and Haden families) was likely to see any connection between
the prints and the photographs.

The association between Hawarden and Haden remains intriguing. Whatever con-
clusions may be drawn concerning Haden's motives for borrowing from Hawarden's
work, it is important to note that during the years of their association both reached the
pinnacle of achievement in their separate mediums. And, if Hawarden's example influ-
enced Haden's precepts about working from nature, then it may be said that in this way
she influenced a generation of British etchers.

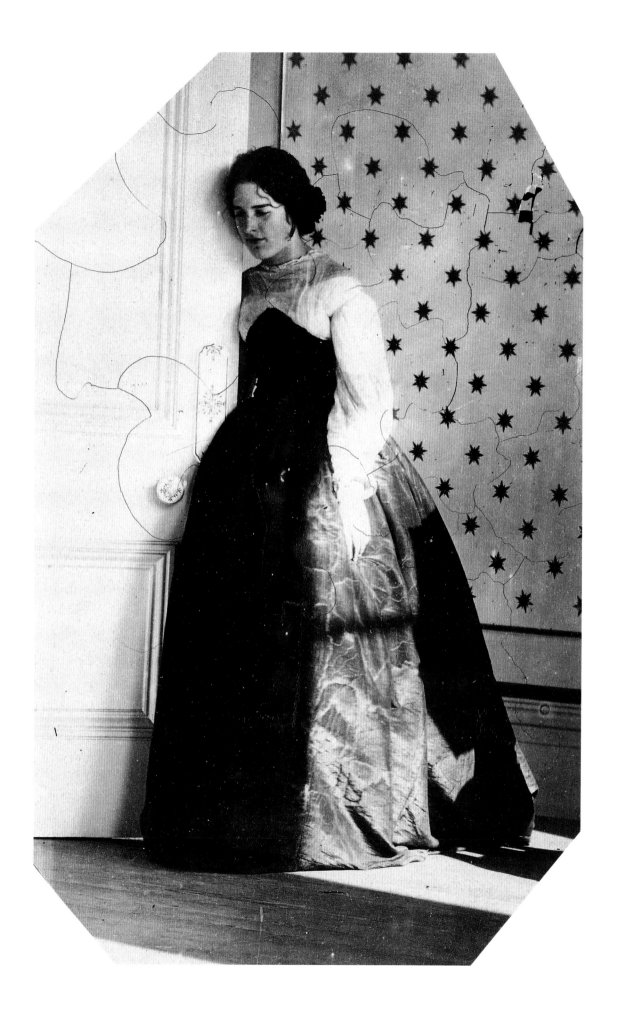

Epilogue

Lady Hawarden died at 5 Princes Gardens on January 19, 1865, after suffering from pneumonia for one week.[1] She was forty-two years old. Afterward, Lord Hawarden wrote of "the severe loss which it has pleased God to inflict upon myself and family—a loss the more severe as it was unexpected."[2]

She was eulogized in the photographic press, nowhere with more appreciation than in an obituary signed simply "O. G. R.":

IN MEMORIAM.—We generally hang out the hatchment *when the photographic community has sustained the loss of a useful member. It has just now lost a member as useful as a clasp and bright as a diamond. The Lady Hawarden is gone to the source of all light. She was an earnest believer in the progress of photography, and that it could be used as an art and abused like a daub. She worked honestly, in a good, comprehensible style. She aimed at elegant and, if possible, idealised truth. There was nothing of mysticism nor Flemish pre-Raffaelistic conceit about her work. So also was her manner and conversation—fair, straightforward, nay manly, with a feminine grace. She is a loss to photography, for she would have progressed. She is a loss to many, many friends. She is an enormous loss to a loving family. Peace everlasting and good will be with her![3]*

She died without leaving a will. Cumbernauld, which she had inherited upon her brother's death in 1861, passed to her son Cornwallis. He sold the estate in 1876[4]—breaking a centuries-old tie, which, to judge by Hawarden's efforts to prevent her brother from selling the property, had been priceless to her.

Her work was exhibited one last time after her death, at the Dublin International Exhibition in 1865. It won the same high praise that greeted her photographs at the 1863 and 1864 Photographic Society of London exhibitions. The *Photographic News* noted:

One entry . . . 'Hawarden, Viscountess—Five Photographic Studies'—brings sad recollections. These pictures, like others before exhibited, are so full of grace and beauty, so original in their style, so perfect in their photographic delicacy and excellence, as well as

*in their pictorial arrangement, that they must bring to all lovers of photography a sense
of poignant regret that the hand and brain which produced them can no more contribute
to elevate the art she so loved and so adorned.*[5]

Lord Hawarden was elected to the Photographic Society on March 14, 1865, soon
after his wife's death.[6] In 1867, he was a member of the committee for "Photographic
Proofs and Apparatus" at the Paris Exposition Universelle,[7] a post that probably was
arranged through Henry Cole's influence.

On December 11, 1866, the Photographic Society held an awards ceremony for their
medal winners. Hawarden had won two medals, but she never saw them, as they were
cast only after her death. At the ceremony, her former colleagues expressed sorrow that
she was not present to receive this tangible proof of their high esteem for her. The order
in which the medals were presented indicates her elevated status among this group.
Records of the event say:

*Mr. Roger Fenton received the first medal, as the founder of the Society. Lady Hawar-
den's name was mentioned next, as having two medals due. The Secretary referred to the
unhappy early death of this gifted lady, and read a letter from Viscount Hawarden, say-
ing how the medals would be prized by the family of the deceased lady.*[8]

After this ceremony was documented, Hawarden's name disappeared from the pages
of the photographic journals. When her generation of colleagues in the Photographic
Society died out, so did her reputation. Her family, of course, kept her prints, recog-
nizing their importance and value, but did not exhibit the work—though we do not
know whether they were ever asked to do so.

Lord Hawarden became a member of Queen Victoria's household, as had his father
before him. He was made the 1st (and last) Earl de Montalt in 1885. When he died in
1905, having sold Dundrum in 1903,[9] Lady Hawarden had been dead for forty years.
Almost thirty-five more years passed before her photographs came home to South Kens-
ington—to the V&A—and her legacy returned to light.

Chronology

1822 Born Clementina Elphinstone Fleeming, at Cumbernauld House, near Glasgow, Scotland, on June 1; daughter of Admiral Charles Elphinstone Fleeming of Cumbernauld and Catalina Paulina Alessandro, originally of Cádiz, Spain.

1841 Sojourns in Rome with mother, sisters, and uncle Mountstuart Elphinstone, former governor of Bombay.

1842 Returns to London.

1845 Marries Cornwallis Maude.

1846 Gives birth to Isabella Grace Maude, the first of ten children born between 1846 and 1864.

1856 Husband succeeds to the title of Viscount Hawarden and inherits Dundrum, an estate in County Tipperary, Ireland.

1857 Moves with husband and children to Dundrum, where she takes her first photographs.

1859 Moves with family to new home, 5 Princes Gardens, South Kensington, London. Begins association with Francis Seymour Haden, etcher and surgeon.

1863 Exhibits for first time, with Photographic Society of London. Receives silver medal for best contribution by an amateur and is elected to the society.

1864 Exhibits for second and final time with the Photographic Society and wins silver medal for composition. Participates in the Female School of Art fête, where Lewis Carroll buys five of her photographs.

1865 Dies suddenly of pneumonia, at the age of forty-two, on January 19.

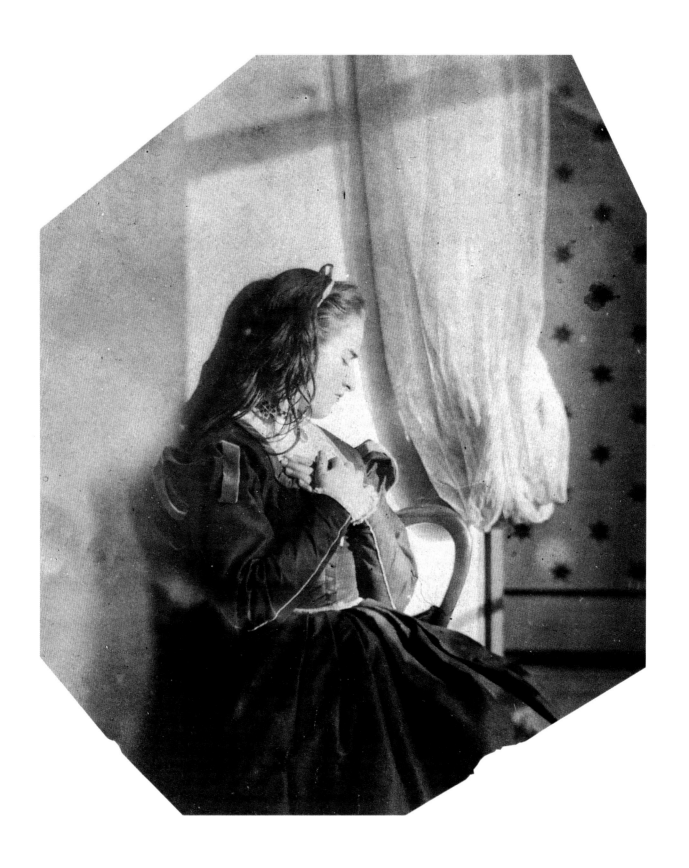

The Return of Lady Hawarden

BY MARK HAWORTH-BOOTH

Lady Hawarden's work and reputation slumbered from the 1860s until 1939, when her photographs, freshly torn or cut from their albums, arrived at the Victoria and Albert Museum (V&A). There they slept again, stirring from time to time but reawakening only as the whole project of photography as an art medium was vigorously rediscovered in the 1970s. This is the story of Lady Hawarden's return and the critical transformation of her work in recent times.

In 1939, one hundred years after William Henry Fox Talbot's photographic invention was publicly announced by Michael Faraday at the Royal Institution, the Victoria and Albert Museum presented its "Exhibition of Early Photographs to Commemorate the Centenary of Photography, 1839–1939." The show, which opened on January 25, was organized by Charles Gibbs-Smith, curator of the museum's photography collection. The exhibition was widely reviewed, though modest in size, and contained wonderful pieces from the museum's already rich collection—works by Talbot himself, David Octavius Hill and Robert Adamson, Roger Fenton, Gustave Le Gray, Camille Silvy, and Julia Margaret Cameron.

Lady Clementina Tottenham, Lady Hawarden's granddaughter, attended the show and made a point of seeking out Gibbs-Smith afterwards. She asked why her grandmother had been omitted from the centenary exhibition, as she had been an important pioneer of photography. Gibbs-Smith replied that the museum, unfortunately, possessed no examples of Hawarden's work. Soon thereafter, Tottenham returned to the museum with 775 of her grandmother's photographs and donated them. The gesture appears to have been as spontaneous as it was generous.

The 1930s was a decade of great gifts from the families of photography's pioneers. In 1937 William Henry Fox Talbot's granddaughter, Matilda Talbot, gave her grandfather's cameras and many thousands of photogenic drawings, negatives, and prints to the Science Museum. Such institutions had begun, at last, to recognize the importance of photography's early history. There was not as yet a serious market for photographica, but the descendants of early photographers felt an obligation to protect their heirlooms and to place them in the public domain.[1]

World War II, however, interrupted this blossoming of photographic studies and acquisition. Collections were evacuated from London, museums were closed, and their staff joined the war effort. In the turmoil of war and reorganization, Hawarden's life work was mislaid and forgotten.

In 1951 the Festival of Britain, celebrated nationwide, brought closure to the long, austere aftermath of the war. As part of the celebrations, the V&A exhibited "Masterpieces of Victorian Photography, 1840–1900, from the Gernsheim Collection." Again, Lady Clementina Tottenham attended the show—and noticed a familiar-looking photograph of a young lady posed between balcony windows and a cheval glass. In Helmut Gernsheim's exhibition catalog, the photograph appeared as plate 24, *The Toilet*, attributed to O.G. Rejlander (page 48). The piece, however, was Hawarden's and should have been entitled

"Photographic Study" or "Study from Life." Tottenham set the record straight, and Gernsheim obligingly inserted an erratum slip with the correct attribution.

The following year, in 1952, Tottenham visited the museum expressly to see the Hawarden collection she had donated. None of the photographs could be found. About a year later, Gibbs-Smith moved a pile of boxes in the corner of his office. There in a mass of tight rolls were all the Hawarden works. The museum subsequently mounted the prints on cards.

Appreciation of Hawarden did not really flourish, however, until the early 1970s. Several path-finding exhibitions had increased public interest in photography in Britain. Cecil Beaton's work was shown at the National Portrait Gallery in 1968, Henri Cartier-Bresson's at the V&A in 1969, and Bill Brandt's at the Hayward Gallery in 1970. In 1972, the Arts Council of Great Britain organized a landmark exhibition at the V&A entitled, " 'From Today Painting is Dead': The Beginnings of Photography." The chief selector was Dr. David Thomas of the Science Museum, assisted by a young American scholar, Gail Buckland, then based at the Royal Photographic Society. An image by Hawarden illustrated the cover of the catalog. This photograph, showing two girls on the terrace of Hawarden's house in Princes Gardens, has subsequently become almost her "signature" work (page 43). "Untitled studies" by Hawarden were shown in the "Faces and figures" section alongside works by her peers and contemporaries—among them Antoine-Samuel Adam-Salomon, Julia Margaret Cameron, Edouard Carjat, Lewis Carroll, David Octavius Hill and Robert Adamson, Nadar, Charles Nègre, O. G. Rejlander and David Wilkie Wynfield. The catalog succinctly described Hawarden as "an amateur photographer awarded medals in the early 1860s for composition." The exhibition was presented as a sequence of elaborate tableaux—with the Lacock Abbey window opening a vista here, Nadar's balloon plunging through the ceiling there, and the mannequin of a frock-coated photographer tak-

ing portraits in a mocked-up studio. Modern prints were shown with vintage originals. The show introduced a large new audience to many of the medium's greatest, hitherto unknown, monuments.

The following year, a small display of Hawarden's photographs was arranged in the V&A's library galleries. The first book on her work followed a year later—*Clementina Lady Hawarden*, edited by the painter Graham Ovenden, published by Academy Editions in 1974. Though the reproductions were muddy, and the photographs' ragged corners and edges were trimmed for publication, the book brought an important selection

Figure 20: Sally Mann, *Sherry and her grandmother, both age 12*, from the series "At Twelve," 1988

of Hawarden's photographs, all from the V&A, into public circulation for the first time. Ovenden's brief introduction outlined Hawarden's family history and noted the connection with Lewis Carroll. He also made the first critical case for Lady Hawarden:

Although her work has often been linked to that of Julia Margaret Cameron, the best-known woman photographer of the Victorian epoch, Clementina Hawarden struck out into areas and depicted moods unknown to the art photographers of her age. Her vision of languidly tranquil ladies carefully dressed and posed in a symbolist light is

at opposite poles from Mrs. Cameron's images. There are also in her work elements of an acute romanticism, reminiscent of an earlier generation of artists, and some of her images recall the oeuvre of Caspar David Friedrich. But she remained quintessentially Victorian, even in the obsessively ambiguous sensuality which haunts so much of her era's art, and her work, in which there are remarkably few failures, constitutes a unique document within nineteenth-century photography.

Ovenden himself had published a suite of screenprints in 1970 which imbued Carroll's Alice with the "obsessively ambiguous sensuality" he found in the work of Hawarden and her contemporaries. In 1975 Hawarden was included in another large exhibition, "The Real Thing: An Anthology of British Photographs, 1840–1950," selected by Ian Jeffrey for the Hayward Gallery in London. Her work also appeared for the first time in one of the new generation of reference books on photography—*The Magic Image: The Genius of Photography from 1839 to the Present Day* (1975) by Cecil Beaton and Gail Buckland. They wrote that, "With such a bold attack, uncluttered line and obliteration of all extraneous detail, her work might be that of a man."

In 1977, the V&A transferred the photography collection from the library to the Department of Prints, Drawings and Paintings—a move which reclassified photographs as works of graphic art, rather than illustrative adjuncts to printed books. In the past twenty years, generations of students, scholars, and visitors have seen Hawarden's photographs in the print room or in museum exhibitions. She and Cameron have become the most studied photographers in the collection. This reflects not only the rise of interest in photographic history and in women's studies but also the frank exploration of sexuality and related issues in contemporary and, by extension, earlier photography. For example, the image which illustrated the catalog of " 'From Today Painting is Dead' " reappeared on the cover of Lillian Faderman's book *Surpassing the Love of Men*, published in 1981.

In 1984, Hawarden's photographs reached a large audience as part of the V&A's exhibition, "The Golden Age

of British Photography, 1839–1900," which traveled to the United States under the auspices of the Philadelphia Museum of Art. The catalog was published in association with Aperture, and, for the first time, images by Hawarden (six works) were reproduced with extraordinary accuracy, in Tritone printing by Meriden Gravure.

Also in 1984, Virginia Dodier, then a student at the Courtauld Institute of Art, began her study of Hawarden, receiving a distinction for her M.A. report on the work. In 1987, a generous J. Paul Getty Trust grant enabled the V&A to hire Dodier to compile her exemplary catalogue raisonné of Hawarden's oeuvre, which is available in the V&A print room. This project led to the first full retrospective exhibition of the work, organized by Dodier as well. A selection of 125 photographs was shown at the V&A in 1989, fifty years after Lady Clementina Tottenham's gift. In 1990, the British Council toured a group of some fifty photographs to the Musée d'Orsay, Paris; The Museum of Modern Art, New York; and the J. Paul Getty Museum, Malibu. An estimated audience of 250,000 saw this show.

Regarding the Museum of Modern Art show, *The New Yorker* said, "Lady Hawarden is no longer a delicious secret. . . . This is work of outstanding subtlety and beauty." Andy Grundberg reviewed it in the *New York Times* (July 27, 1990), and noted that the doubling in the photographs linked them to surrealist ideas, while the distressed appearance of the prints chimed with the work of Doug and Mike Starn. Grundberg wrote, "Lady Hawarden [created] a condensed and mysterious simulacrum of her Victorian reality. Her awareness that fancy and fact coexist in a photograph, and that this coexistence is at the very heart of the photographic enterprise, may explain why her otherwise old-fashioned work seems comfortably at home in the present and in a museum presumably devoted to much more modern art."

A. D. Coleman dissented in *The New York Observer* (September 10, 1990). He wrote, "In no way do any of [Hawarden's photographs] prefigure anything we think of as modern in art or photography." On the contrary, as Hawarden's work has made its way into discussions about

Victorian visual arts in general, considerable claims for its influence have been made. The circles of Hawarden and Whistler overlapped, as Dodier has shown, through Francis Seymour Haden. Richard Dorment has cited Hawarden's photographs as part of the rich visual hinterland available to the cosmopolitan Whistler when he settled in London in 1859.[2] In conversation recently, Dorment emphasized his view that the "subjectless picture" came into painting from photography, and that Hawarden's work was crucial.

In the autumn of 1997 at a conference at the Tate Gallery, London, Christopher Newall, who helped organize the exhibition "The Age of Rossetti, Burne-Jones & Watts: Symbolism in Britain, 1860–1910," hypothesized that Hawarden's photographs informed Whistler's *The Little White Girl: Symphony in White, No. II* (figure 25) from 1865. This was not only a matter of similarity in subject matter—a woman in white, a mirror, and a reflection. This key work exemplified for Newall "the new understanding of the way in which works of art might operate upon the spectator's imagination [which] came about in the progressive circles of English painting" in the 1860s. These new works of art functioned by "bringing image and symbol together in order to present a psychological state independent of any narrative element."[3]

It is principally female writers who have continued to discover and explore ambiguities in Hawarden's work, from Whitney Chadwick in *Women, Art and Society* in 1990, to Julie Lawson, in the exhibition and catalog *Women in White: Photographs by Lady Hawarden* (Scottish National Portrait Gallery, Edinburgh) in 1997. When the Hawarden tour was completed, Ingrid Sischy published an article entitled "Let's Pretend" in *The New Yorker* (May 6, 1991). Just as Graham Ovenden saw Hawarden

in the light of his preoccupations as a painter, Sischy interpreted the imagery through the avant-garde New York art of her time: in particular, through the work of Cindy Sherman. She wrote:

Until I saw Lady Hawarden's show, I took Sherman's use of costume for granted. Dressing up was just part of her style, and it's not so surprising a tactic: many artists use costume as an element of their work. But the similarities between the photography of Sherman and Hawarden raised questions. Is it the dressing up that makes the pictures by both these women so powerful? Is that what's so

Figure 21: Cindy Sherman, *Untitled #74*, from the series "Rear Screen Projections," 1980

haunting about what they do? And in the idea of dressing up is there something especially meaningful to women?

I'd like the answer to the last question to be no, because generalizations about women and men are what got us into trouble in the first place. But to take away the specificity of what Sherman and Hawarden have created with dressing up is to drain their work of its impact, and to miss what is perhaps the most meaningful implication of their connection. Together, they suggest how dressing up could be used as a thread to weave in and out of the history of photography in order to help find what has been missing: the presence of women. . . . Let's remember: from the minute

they're out of diapers, women have to deal with the world of appearances in a more inexorably pressured way than men do. That's what makes this a subject on which women are expert witnesses: all women—not only Clementina, Lady Hawarden, and Cindy Sherman.

Among the connections between these artists, we might mention the female figure contrasted with the hallucinatory, dissolving mass of the cityscape—a motif we find many times in Hawarden (figures sequestered on a balcony or terrace, buildings looming beyond) and in Sherman's bright ingenue foregrounded in the canyons of Manhattan (figure 21).

Figure 22: Hannah Starkey, *Untitled—May 1997*

The politics of the gaze in Hawarden's light-fractured, windowed, mirror-laden images are analyzed by Helen Grace Barlow in her doctoral thesis for the University of Kent at Canterbury in 1994. About a Hawarden odalisque from ca.1863–64 (pages 72–73), Barlow writes:

The discrepancy between object and mirror image is central to the function of Hawarden's odalisque. The photograph shows the head and restricted profile seen from two different angles that are sufficiently unlike to give a subtle but unsettling impression of not quite belonging to the same person. Such an effect defeats the object of the conventional odalisque/nude in suggesting a gap between conventional

function and private identity. It also, in the case of Hawarden's odalisque, raises the possibility of a certain autonomous space to which the figure has access but where the viewer is not admitted. . . . One might put this another way by saying that the image reclaims the idea of the feminine as other from neutralizing strategies of male representations.[4]

Doubles and the averted female gaze are characteristic themes of the 1990s, seen in the imagery of Lorna Simpson, for example. Female adolescents are the subject of haunting work from America's pioneering and widely exhibited Sally Mann and Britain's recently emerged Hannah Starkey. Mann's *Sherry and her grandmother, both age 12*, from the series "At Twelve," 1988, contrasts a vibrant, ripening, and modern young body with its amply clothed and covered nineteenth-century prototype (represented by a photograph of a young girl) (figure 20). The image perfectly symbolizes the way in which preoccupations of the present interact with the relative obscurity of the past by finding startlingly familiar outlines and seeking living desire inside period costume. Hannah Starkey stages contemporary tableaux (figure 22), updating Hawarden with "everyday experiences and observations of inner city life from a female perspective." Her scenarios are peopled by strangers, unknown actresses she advertised for, whom Starkey then "cast according to which personality would suit a fictional character."[5]

The close reading of photographs in recent times has been practiced very notably by writers with backgrounds in literary studies—such as Roland Barthes, Mike Weaver, and Carol Mavor. The author of *Pleasures Taken: Performances of Sexuality and Loss in Victorian Photographs* (1995), Mavor makes Hawarden the focus of her new book, *Becoming: The Photographs of Clementina, Viscountess Hawarden*, scheduled for publication by Duke University Press in June 1999. In a recent essay, Mavor takes her starting point from Barthes's tour de force of photographic interpretation, rhapsody, and self-analysis, *La chambre claire* (1980), published in English as *Camera Lucida* in 1981. She offers close, subjective readings

of individual images, and a poetic interpretation of Hawarden's whole career, set within an understanding of the ambiguous position of women in Victorian society:

Hawarden's pictures of her teenage girls in sexualized, and even compromised, positions emphasize the Victorian crisis around the invisible yet tantalizing category of adolescence. Just who was a child and who was an adult (with adolescence falling between the cracks, remaining unnamed

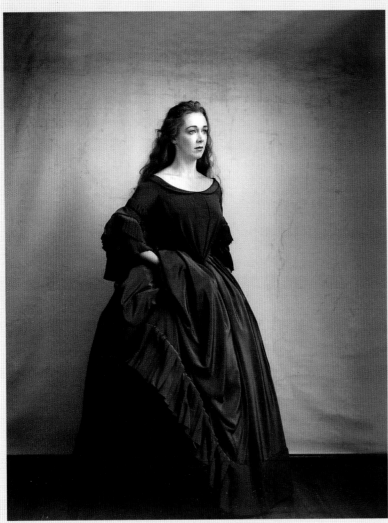

Figure 23: Tessa Traeger, *Portrait of Rosa Mannion as Pamina in* The Magic Flute, 1994

until the end of the nineteenth century) was a hotly debated topic, fueled by the changing laws of the period. In 1861, the year in which Hawarden began her most sexually insistent photographs of her daughters, the Offences Against the Person Act raised the age of consent from ten to twelve (the brink of female adolescence).[6]

Other viewers may doubt the extent of the sexuality identified in these photographs. However, Mavor wisely emphasizes the range and variety of the oeuvre and its openness to interpretation. She conceptualizes Hawarden's "becoming space" as "suspended like an adolescent in a state of undecided development; it is a heterological space that makes room not only for Hawarden's most surprising and erotic photographs of her daughters, but also for those that display the more conventional aspects of Victorian femininity."[7]

The dramatic critical transformation of Hawarden's photographs is reminiscent of the reworking of her imagery in a recent opera production. The story is told by the London photographer Tessa Traeger, and refers to her photograph (figure 23) of Rosa Mannion playing the part of Pamina in Mozart's *The Magic Flute*:

This was a production designed by Patrick Kinmonth and directed by Robert Carsen for the Aix Festival in Provence in 1994. Patrick decided to set the costumes in the mid-nineteenth century, so he went to the V&A and asked to see all the photographs by Lady Hawarden. It took us two afternoons to look at it all. Afterwards he designed his costumes with these photographs in mind. At one point in the opera, Tamino sees a vision of Pamina. Patrick effected this by lowering down her portrait as a life-size 'daguerreotype' for him to see. While he is looking at her image, it dissolves, and the Queen of the Night appears behind as if by magic. The trick is that the photograph was printed on a kind of gauze so that when lit from the front it seemed solid; when lit from behind it became translucent.[8]

Just so has Hawarden's oeuvre—formerly invisible, obscure, and opaque—itself become translucent, open to interpretation, pregnant with symbolism and disclosure, spectacularly illuminated by art practice, by theory, and by contemporary art history. While male photographer-entrepreneurs famously explored antique and unknown lands in the 1850s and early 1860s, Hawarden, at home in South Kensington, pioneered the continent later named as adolescence and mapped a new world of femininity.

Illustrations

The photographs reproduced on the pages listed below are untitled "Photographic Studies" and "Studies from Life" by Clementina Hawarden, featuring her family at their homes, Dundrum, County Tipperary, Ireland, and 5 Princes Gardens, South Kensington, London. All are albumen prints from wet-collodion-on-glass negatives. Unless otherwise indicated, the photographs are in the Photography Collection, Department of Prints, Drawings and Paintings, Victoria and Albert Museum, London. Each entry includes the catalogue raisonné number and, where applicable, the V&A museum number.

Page 2: Isabella Grace Maude, Dundrum, ca. 1859–64; 228 x 279 mm (9 x 11 in.); V&A PH 457-1968: 149/D195.

Page 17: Clementina and Isabella Grace Maude, 5 Princes Gardens, ca. 1861; 115 x 90 mm (4 ¹/₂ x 3 ¹/₂ in.); V&A PH 457-1968:548/ D292.

Page 19: Cornwallis Hawarden, 5 Princes Gardens, ca. 1861; 190 x 146 mm (7 ¹/₂ x 5 ³/₄ in.); Paul F. Walter Collection, New York/ D383e.

Page 22: Unidentified man, Dundrum House, ca. 1857–60; 78 x 142 mm (3 ¹/₁₆ x 5 ⁹/₁₆ in.) (stereoscopic); V&A PH 457-1968:58/ D39.

Page 23: Dundrum quarry, ca. 1857–60; 75 x 141 mm (2 ¹⁵/₁₆ x 5 ⁹/₁₆ in.) (stereoscopic); V&A PH 457-1968:123/D25.

Page 24: Admiral James E. Katon, Togge House, Dundrum, ca. 1858–61; approx. 180 x 200 mm (7 ¹/₁₆ x 7 ⁷/₈ in.); Polwarth Collection, England/D169a.

Page 25: Multeen River, Dundrum, ca. 1857–60; 78 x 141 mm (3 ¹/₁₆ x 5 ⁹/₁₆ in.) (stereoscopic); V&A PH 457-1968:36/D50.

Page 26: Clementina Maude and Cornwallis Hawarden, Dundrum, ca. 1859–61; 117 x 93 mm (4 ⁵/₈ x 3 ⁵/₈ in.); V&A PH 457-1968:166/ D187.

Page 27: Florence Elizabeth Maude, Cornwallis Hawarden, Clementina Maude, and unidentified man, Togge House, Dundrum, ca. 1859–61; 240 x 284 mm (9 ⁷/₁₆ x 11 ³/₁₆ in.); V&A PH 275-1947/ D190.

Page 28: Unidentified man, stables, Dundrum, ca. 1858–61; 116 x 91 mm (4 ⁵/₈ x 3 ¹/₂ in.); V&A PH 457-1968:20/ D131.

Page 29: Florence Elizabeth and Clementina Maude, Togge House, Dundrum, ca. 1859–61; 232 x 211 mm (9 ¹/₈ x 8 ⁵/₁₆ in.); V&A PH 342-1947/ D182.

Page 31: Clementina Maude, 5 Princes Gardens, ca. 1863–64; 236 x 279 mm (9 ¹/₄ x 10 ¹⁵/₁₆ in.); V&A PH 353-1947/ D668.

Page 32: Isabella Grace Maude on balcony, 5 Princes Gardens, 1861; 95 x 159 mm (3 ³/₄ x 6 ¹/₄ in.) (stereoscopic); V&A PH 457-1968: 455/D279.

Page 33: Isabella Grace Maude on terrace, 5 Princes Gardens, ca. 1861; 101 x 161 mm (3 ¹⁵/₁₆ x 6 ⁵/₁₆ in.) (stereoscopic); V&A PH 457-1968:443/D345.

Page 34: Clementina Maude, 5 Princes Gardens, ca. 1862–63; 216 x 232 mm (8 ¹/₂ x 9 ¹/₈ in.); V&A PH 296-1947/D559.

Page 36: Woodcock Grove, Dundrum, ca. 1857–64; 242 x 286 mm (9 ¹/₂ x 11 ¹/₄ in.); V&A PH 457-1968:114/D198.

Page 37: Clementina Hawarden or Anne Bontine with Donald Cameron of Lochiel, 5 Princes Gardens, ca. 1861–62; 101 x 68 mm (4 x 2 ¹¹/₁₆ in.); V&A PH 457-1968: 423/D359.

Page 38: Clementina and Florence Elizabeth Maude, 5 Princes Gardens, ca. 1861; 94 x 148 mm (3 ¹¹/₁₆ x 5 ¹³/₁₆ in.) (stereoscopic); V&A PH 457-1968:608/D332.

Page 39: Isabella Grace Maude and H. B. Loch on balcony, 5 Princes Gardens, 1861; 112 x 81 mm (4 ⁵/₁₆ x 3 ³/₁₆ in.); V&A PH 457-1968:595/D339.

Page 40: Isabella Grace Maude, 5 Princes Gardens, ca. 1859–61; 100 x 159 mm (3 ¹⁵/₁₆ x 6 ¹/₄ in.) (stereoscopic); V&A PH 457-1968:444/D277.

Page 41: Elphinstone Agnes Maude, 5 Princes Gardens, ca. 1859–61; 105 x 81 mm (4 ¹/₈ x 3 ³/₁₆ in.); V&A PH 457-1968:311/ D257.

Page 42: Isabella Grace, Clementina, and Elphinstone Agnes Maude on terrace, 5 Princes Gardens, ca. 1863–64; 183 x 210 mm (7 ³/₁₆ x 8 ¹/₄ in.); V&A PH 302-1947/D620.

Page 43: Isabella Grace and Florence Elizabeth Maude on terrace, 5 Princes Gardens, ca. 1863–64; 230 x 210 mm (9 ¹/₁₆ x 8 ¹/₄ in.); V&A PH 300-1947/D626.

Page 45: Clementina Maude, 5 Princes Gardens, ca. 1862–63; 235 x 267 mm (9 ¹/₄ x 10 ¹/₂ in.); V&A PH 293-1947/D558.

Page 46: Isabella Grace and Clementina Maude, 5 Princes Gardens, ca. 1862–63; 112 x 80 mm (4 ⁵/₁₆ x 3 ¹/₈ in.); V&A PH 457-1968:555/ D579.

Page 47: Isabella Grace and Clementina Maude, 5 Princes Gardens, ca. 1861–62; 97 x 75 mm (3 ¹³/₁₆ x 2 ¹⁵/₁₆ in.); V&A PH 457-1968:401/ D402.

Page 48: Isabella Grace Maude, 5 Princes Gardens, ca. 1862–63; 206 x 154 mm (8 ¹/₈ x 6 ¹/₁₆ in.); Photography Collection, Harry Ransom Humanities Research Center, University of Texas at Austin/D557b.

Page 49: Clementina Maude, 5 Princes Gardens, ca. 1862–63; 231 x 203 mm (9 ¹/₁₆ x 8 in.); V&A PH 250-1947/ D561.

Page 51: Clementina Maude, ca. 1864; 229 x 218 mm (9 x 7 ¹⁵/₁₆ in.); V&A PH 377-1947/D672.

Page 54: Isabella Grace Maude, 5 Princes Gardens, ca. 1863–64; 227 x 275 mm (8 ¹⁵/₁₆ x 10 ¹³/₁₆ in.); V&A PH 236-1947/D639.

Page 55: Clementina Maude, 5 Princes Gardens, ca. 1862; 116 x 94 mm (4 ⁹/₁₆ x 3 ¹¹/₁₆ in.); V&A PH 457-1968:410/D440.

Page 56: Clementina Maude, 5 Princes Gardens, ca. 1862; 106 x 88 mm (4 ³/₁₆ x 3 ⁷/₁₆ in.); V&A PH 457-1968:195/D441.

Page 57: Isabella Grace and Clementina Maude, 5 Princes Gardens, ca. 1862–63; 147 x 125 mm (5 ¹³/₁₆ x 4 ¹⁵/₁₆ in.); V&A PH 457-1968:218/D553.

Page 58: Clementina Maude, 5 Princes Gardens, ca. 1862–63; 116 x 91 mm (4 ⁹/₁₆ x 3 ⁹/₁₆ in.); V&A PH 457-1968:603/D522.

Page 59: Clementina Maude, 5 Princes Gardens, ca. 1862–63; 145 x 124 mm (5 ¹¹/₁₆ x 4 ⁷/₈ in.); V&A PH 457-1968:202/D577.

Page 60: Clementina Maude, 5 Princes Gardens, ca. 1862–63; 150 x 118 mm (5 ¹⁵/₁₆ x 4 ⁵/₈ in.); V&A PH 457-1968:454/D573.

Page 61: Clementina Maude, 5 Princes Gardens, ca. 1862–63; 152 x 127 mm (6 x 5 in.); V&A PH 457-1968:344/D571.

Page 62: Isabella Grace Maude, 5 Princes Gardens, ca. 1861; 119 x 91 mm (4 ¹¹/₁₆ x 3 ⁹/₁₆ in.); V&A PH 457-1968:324/D313.

Page 63: Clementina Maude, 5 Princes Gardens, ca. 1861–62; 111 x 89 mm (4 ³/₈ x 3 ¹/₂ in.); V&A PH 457-1968:177/D428.

Pages 64–65: Clementina Maude, 5 Princes Gardens, ca. 1863–64; 238 x 275 mm (9 ³/₈ x 10 ¹³/₁₆ in.); V&A PH 291-1947/D648.

Page 66: Clementina and Florence Elizabeth Maude, 5 Princes Gar-

Figures

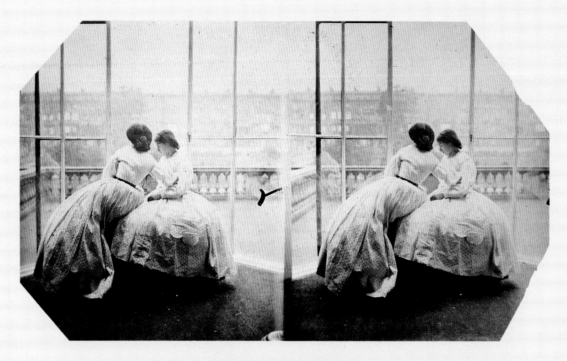

Endnotes

Unless otherwise noted, information about the Fleeming and Hawarden families and their estates is from Burke's Peerage and Baronetage (1867, 1970) and G.E.C. [George E. Cokayne], The Complete Peerage of England, Scotland, Ireland, Great Britain ..., ed. Vicary Gibbs and H.A. Doubleday, revd. ed., vol. 5 (London: The St. Catherine Press, Ltd., 1926). Additional information is from material in the Elphinstone Collection, India Office Library, London; the Elphinstone, Cunninghame Graham and Loch muniments, Scottish Record Office, Edinburgh; and the Cunninghame Graham Papers, National Library of Scotland.

Abbreviations

Correspondents *(relationship to Clementina Hawarden in parentheses)*

AB — Anne Bontine (sister)
AE — Anne Elphinstone (aunt)
CH — Clementina Hawarden
CPK — Catalina Paulina Katon (mother)
DE — David Erskine (uncle)
JE — John Elphinstone (cousin)
ME — Mountstuart Elphinstone (uncle)
RBCG — Robert Bontine Cunninghame Graham (nephew)

Institutions

BM — British Museum, London
IOL — India Office Library, London
NAL — National Art Library, Victoria and Albert Museum, London
NLS — National Library of Scotland, Edinburgh
PD&P — Dept. of Prints, Drawings and Paintings, Victoria and Albert Museum, London
PRO — Public Record Office, Kew, England
RPS — Royal Photographic Society, Bath, England
V&A — Victoria and Albert Museum, London

Periodicals

BJP — *British Journal of Photography*
PJ — *Photographic Journal*
PN — *Photographic News*

Preface

1. Dr. John Physick, departmental files, PD&P, and personal communication.

2. Jean C. Keyte, great-granddaughter, personal communication.

3. CPK to AB, 14 October 1862, Cunninghame Graham Papers, NLS.

4. O. G. R[ejlander], "In Memoriam," *BJP* 12 (27 January 1865):38.

5. Lewis Carroll [C. L. Dodgson] diary, 23 June 1864, BM.

6. Helmut Gernsheim, *Masterpieces of Victorian Photography* (London: Phaidon Press, 1951), erratum slip.

7. Rejlander, "In Memoriam."

Chapter One: Early Life

1. See *Dictionary of National Biography*, s.v. "Mountstuart Elphinstone."

2. Lillian Mansel Lewis, granddaughter, "Notes on her Scottish Ancestry," 1976, private collection.

3. W. Laird Clowes, *The Royal Navy: A History from the Earliest Times to the Present* (London: S. Low, Marston & Co., 1897–1903), cited in ed. R. G. Thorne, *The History of Parliament* (London: Secker & Warburg for the History of Parliament Trust, 1986), 3:705–6.

4. Henry Richard, Lord Holland, *Foreign Reminiscences*, ed. Henry Edward, Lord Holland (London: Longman, Brown, Green & Longmans, 1850), 196 n.

5. Robert Bontine Cunninghame Graham, "The Admiral," in *Hope* (London: Duckworth & Co., 1910), 216–17.

6. Cunninghame Graham Papers, NLS.

7. Mansel Lewis, "Scottish Ancestry."

8. Family legends are recounted in the opening chapters of *Saying Life: The Memoirs of Sir Francis Rose* (London: Cassell, 1961). He was a descendant of Mary Keith Fleeming.

9. RBCG to AB, 3 January 1883, Cunninghame Graham Papers, NLS.

10. [William Adam], *Vitruvius Scoticus ...* (Edinburgh: A. Black, 1780?), plates 125, 126.

11. See Pamela Gerrish Nunn, *Victorian Women Artists* (London: The Women's Press, 1987), 34–43.

12. See Francis Haskell, *Rediscoveries in Art: Some Aspects of Taste, Fashion and Collecting in England and France*, 2nd ed. (Ox-

ford: Phaidon Press, 1976), 198 n. 1.

13. See *Dictionary of National Biography*, s.v. "Margaret Mercer Elphinstone, Comtesse de Flahault …."

14. AB to ME, 11 February 1850, Cunninghame Graham Papers, NLS.

15. ME to AB, 16 February 1850, Cunninghame Graham Papers, NLS.

16. AE to ME, 9 February 1827, Elphinstone Collection, IOL.

17. Robert Bontine Cunninghame Graham, *José Antonio Páez* (London: W. Heinemann, 1929), 309.

18. Cunninghame Graham, "The Admiral," 223.

19. Ibid., 219.

20. Thorne, *History of Parliament*.

21. Ibid.

22. Admiralty Papers, PRO.

23. *Spectator* (London, 1839): 969.

24. Admiralty Papers, PRO.

25. As recalled on a similar journey years later (1851) by AB to ME. Cunninghame Graham Papers, NLS.

26. CH to ME, 14 February 1842, Elphinstone Collection, IOL.

27. CH to ME, 24 February 1842, Elphinstone Collection, IOL.

28. See Haskell, *Rediscoveries*, 87.

29. See Duncan Macmillan, *Painting in Scotland: The Golden Age* (Oxford: Phaidon Press in association with the Talbot Rice Art Centre, the University of Edinburgh and the Tate Gallery, London, 1986), 31–34.

30. *Personal Recollections … of Mary Somerville*, comp. Martha Somerville (London: John Murray, 1873), 238.

31. Margaret M. Brewster Gordon, *The Home Life of Sir David Brewster* (Edinburgh: Edmonston & Douglas, 1869), 21–22.

32. See A. D. Morrison-Low and J. R. R. Christie, *"Martyr of Science": Sir David Brewster 1781–1868* (Edinburgh: Royal Scottish Museum, 1984).

33. Maria Anstruther-Thomson's

album, sold at Christie's, South Kensington, London, 30 June 1987, lot no. 84, contains calotypes of Brewster.

34. *Personal Recollections … of Mary Somerville*, 230–31.

35. CH to ME, 14 February 1842, Elphinstone Collection, IOL.

36. DE to ME, 7 September 1842, Elphinstone Collection, IOL.

37. *Times* (London), 25 March 1845, wedding announcement.

38. JE to ME, 9 May 1845, Elphinstone Collection, IOL.

39. ME to CPK, 4 October 1850, Cunninghame Graham Papers, NLS.

40. I learned the children's nicknames from family correspondence and from Mansel Lewis, "Scottish Ancestry."

41. AB to ME, 20 May 1856, Elphinstone Collection, IOL.

42. ME to CPK, 18 July 1847, Cunninghame Graham Papers, NLS.

43. ME to AB, 5 August 1854, Cunninghame Graham Papers, NLS.

Chapter Two: Dundrum

1. AB to ME, 17 November 1856, Elphinstone Collection, IOL.

2. Dundrum comprised 15,272 acres at a gross annual value of £8,781, according to John Bateman, *The Great Landowners of Great Britain and Ireland*, 4th ed., (London, 1883; reprint, Leicester: Leicester University Press and New York: Humanities Press, 1971), 213.

3. *Arthur Young's Tour in Ireland (1776–1779)*, ed. Arthur Wollaston Hutton, (London: n.p., 1892), 1:392.

4. Ibid.

5. Rev. William P. Burke, *History of Clonmel* (Waterford, Ireland: Clonmel Library Committee, 1907), 361.

6. Thomas G. McGrath, "Interdenominational Relations," in *Tipperary: History and Society*, ed. William Nolan and Thomas G. McGrath (Dublin: Geography Publications, 1985), 277–80; United Kingdom, Parliamentary

Papers, *Report from Her Majesty's Commissioners of inquiry into the state of the Law and Practice in respect to the Occupation of Land in Ireland* (Dublin: n.p., 1845), 20:286–89, 297 and 21:826–33.

7. Tradition at Dundrum says that "the eldest girl of the Maude family was a Roman Catholic for some generations." Grandpa Crowe, "Maude Family," n.d., Dundrum House Hotel, Dundrum, Ireland.

8. *Cashel Gazette*, 28 January 1865.

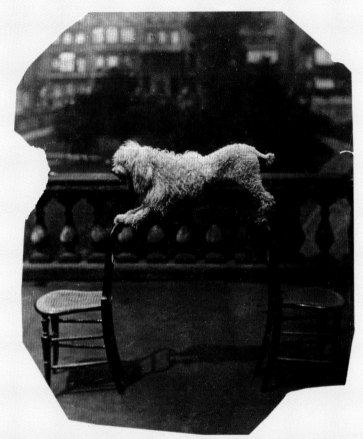

9. Based on reports in the *Clonmel Chronicle*, 1859–65, and the *Cashel Gazette*, 1864–65.

10. CPK to ME, 30 December 1858, Elphinstone Collection, IOL.

11. See Grace Seiberling with Carolyn Bloore in association with the International Museum of Photography at George Eastman House, *Amateurs, Photography and the Mid-Victorian Imagination* (Chicago and London: University of Chicago Press, 1986).

12. William Lake Price, *A Manual of*

Photographic Manipulation, Treating of the Practice of the Art, and Its Various Applications to Nature (London: J. Churchill, 1858), part 4.

13. Ibid., 9.

14. Edgar Yoxall Jones, *Father of Art Photography: O. G. Rejlander, 1813–1875* (Newton Abbot, England: David & Charles, 1973), 9–10.

15. Carroll asked Rejlander's opinion of a room he wished to rent as a photographic studio in Oxford. Carroll diary, 22 April 1863, quoted in Helmut Gernsheim, *Lewis Carroll*

Photographer, rev. ed. (New York: Dover Publications, 1969), 52.

16. Jones, *Rejlander*, 28.

17. See "Memorandum of Association of the United Association of Photography Limited" and Patent Papers, no. 2347, 24 September 1864, PRO. For Stuart Wortley's life and work, see Katherine DiGiulio, *Natural Variations: Photographs by Colonel Stuart Wortley* (San Marino, CA: Huntington Library, 1994).

18. *PN* 7 (27 February 1863): 99.

PRINCES GATE

Terrace

Balcony

PRINCES GARDENS
SOUTH KENSINGTON

Figure 24
Floor plan of 8 Princes
Gardens, South Kensington,
London, 1859

• • •

19. AB to ME, 28 November 1855, Cunninghame Graham Papers, NLS.

20. AB to ME, 24 August 1855, Cunninghame Graham Papers, NLS.

21. Dr. W. D. Hemphill, *The Abbeys, Castles and Scenery of Clonmel and the Surrounding Country* (London and Dublin: n.p., 1860), ix. Additional information from Eric W. D. H. Earle, "Dr William Despard Hemphill ... ," 1984, departmental files, PD&P.

22. *PN* 11 (21 June, 1867): 291.

23. Robert Bontine Cunninghame Graham, "A Sailor (Old Style)," in *Hope* (London: Duckworth & Co., 1910), 92–93.

24. Mary Crowe, Dundrum House Hotel, Dundrum, Ireland, personal communication.

25. See Martin Meisel, *Realizations: Narrative, Pictorial, and Theatrical Arts in Nineteenth-Century England* (Princeton: Princeton University Press, 1983), 338–40.

Chapter Three: South Kensington

1. Jeanne Pingree, former archivist, Imperial College, University of London, generously shared information she culled from the rate books (i.e., local tax records) for the Princes Gardens area. Additional information from Jean C. Keyte, personal communication.

2. F. H. W. Sheppard, ed., *The Survey of London: The Museums Area of South Kensington and Westminster* 38 (London: Athlone Press for the Greater London Council, 1975), 141.

3. Ibid., 282.

4. Lady Kathleen Bushe, daughter, to her granddaughter Jean C. Keyte to me via personal communication. I am grateful to Dr. Clive Wainwright, Dept. of Furniture and Interior Design, V&A, for his helpful comments regarding the interior decoration of 5 Princes Gardens.

5. *PN* 9 (6 January 1865): 7.

6. *BJP* 10 (2 February 1863): 68.

7. ME to AB, 10 August 1859, Cunninghame Graham Papers, NLS.

8. Death certificate, General Register Office, London.

9. "Photographic Extracts from Lewis Carroll's Diaries," transcribed by his niece F. Menella Dodgson, 17 July 1876, Gernsheim Collection, Harry Ransom Humanities Research Center, University of Texas at Austin.

10. Alexander Mackenzie, *History of the Camerons* (Inverness, Scotland: A. & W. Mackenzie, 1884), 257–58.

11. "A Reminiscence of Mrs. Cameron by a Lady Amateur," *PN* 30 (1 January 1886):2–4.

12. See n. 1 above.

13. See *Dictionary of National Biography*, s.v. "Henry Brougham Loch, 1st Baron Loch" and Gordon Loch, *The Family of Loch* (Edinburgh: T. & A. Constable, 1934). Loch was photographed in China by Felice Beato; see the plate reproduced in Isobel Crombie, "China 1860: A Photographic Album by Felice Beato," in *History of Photography* 11(1987): 28, fig. 4.

14. I am grateful to Madeline Ginsburg, formerly of the Textiles and Dress Dept., V&A, for information about the fashions of 1863 and 1864.

Chapter Four: Studies from Life

1. *BJP* 10 (16 February 1863): 70.

2. See Liesbeth Heenk, "The Iconographical Development of the Type of the Fallen Woman in Nineteenth-Century English Art," (master's thesis, University of Leiden, 1988), 114–16.

3. See cat. nos. 63 (painting) and 196 (study) in Mary Bennett et al., *The Pre-Raphaelites* (London: Tate Gallery/Penguin Books, 1984).

4. Reproduced in Lynda Nead, *Myths of Sexuality: Representations of Woman in Victorian Britain* (Oxford: B. Blackwell, 1988).

5. Rejlander, "In Memoriam."

6. See cat. no. 35, *The Pre-Raphaelites.*

7. Lorenz Eitner, "The Open Window and the Storm-Tossed Boat," *Art Bulletin* 37 (December 1955):286.

8. Elizabeth Anne McCauley, *Likenesses: Portrait Photography in Europe 1850–1870* (Albuquerque: Art Museum, University of New Mexico, 1981), 51.

9. *PN* 9 (11 August 1865): 382.

10. I am grateful to Alison Smith, Sotheby's Institute, London, author of *The Victorian Nude: Sexuality, Morality and Art* (Manchester: Manchester University Press, 1996), for her thoughtful comments.

11. See Virginia Dodier, "The Great Amateur," *RA Magazine* (Summer 1989):41.

12. *PN* 10 (2 February 1866):55.

13. See Nicholas Penny, "An ambitious man: The career and the achievements of Sir Joshua Reynolds" in ed. Nicholas Penny, *Reynolds* (London: Royal Academy of Arts in association with Weidenfeld & Nicolson, 1986), 26–29.

14. Sir Joshua Reynolds, *Discourses on Art*, vol. 7, lines 735–46, quoted in Penny, *Reynolds*, 27.

15. I am grateful to Veronica Murphy, formerly of the Indian Dept., V&A, for detailed information about the Indian cabinets in the Hawarden photographs. Though the whereabouts of the cabinets shown in the photographs are not known, two fine Indian cabinets were loaned by Hawarden's daughter Isabella Grace, Lady Colchester, to the V&A from about 1892 to 1927. Ownership of the cabinets was then transferred back to the family of Lord Ellenborough, who had originally given them to Lady Colchester. File photographs show that the Ellenborough cabinets are not those shown in Hawarden's photographs. Registry Dept., V&A.

16. For the "Nubian Series," see Gordon Baldwin, *Roger Fenton: Pasha and Bayadère* (Los Angeles: J. Paul Getty Museum, 1996). I am grateful to Harley Preston, formerly of the National Maritime Museum,

London, and to Kathy Mclauchlan, Sotheby's Institute, London, for information about J. F. Lewis and British Orientalism.

17. See, for example, the reproduction of the engraving by W. Say after Henry Joseph Fradelle's painting *Chatelar Playing the Lute to Mary Queen of Scots* (1821) in Martin Meisel, *Realizations*, 245, fig. 101.

Chapter Five:
The London Art World

1. See Elizabeth Bonython, *King Cole: A Picture Portrait of Sir Henry Cole, K.C.B., 1808–1882* (London: Victoria and Albert Museum, ca. 1982).

2. John Physick, *Photography and the South Kensington Museum* (London: Victoria and Albert Museum, 1975).

3. Registry Dept., V&A.

4. *PJ* 7 (15 November 1862): 165–66.

5. Photographic Society of London, *Exhibition of Photographs and Daguerreotypes ... Ninth Year* (London, 1863).

6. "Minutes of General Meetings," RPS, 178.

7. *PJ* 7 (15 November 1862): 165–66.

8. Jabez Hughes, "A Tribute to Amateurs," *BJP* 11 (1 December 1863):466.

9. [A. H. P.] Stuart Wortley, "On Photography in connexion with Art," *PJ* 8 (15 October 1863): 366.

10. Valerie Lloyd, *Roger Fenton: Photographer of the 1850s* (London: South Bank Board, 1988), 2.

11. Algernon Graves, *The Royal Academy of Arts: A Complete Dictionary ... ,* 2 vols. (London: Henry Graves & Co. and George Bell & Sons, 1905–06).

12. *PJ* 9 (15 March 1864):1.

13. Photographic Society of London, *Exhibition of Photographs and Daguerreotypes ... Tenth Year* (London, 1864).

14. *PN* 8 (24 June 1864):303.

15. *PN* 8 (15 July 1864):337.

16. *BJP* 10 (13 January 1863):56.

17. O. G. Rejlander, "An Apology for Art-Photography," *BJP* 10 (16 February 1863): 76.

18. Rejlander, "In Memoriam."

19. Quoted from *The Reader* in *PJ* 9 (15 August 1864):86.

20. See Female School of Art, *Programme of the grand fête and*

bazaar ..., NAL. This scrapbook was probably compiled by or for Henry Cole, whose diary (NAL) records his involvement in this fundraising project. Marian Cole, his wife, was on the FSA board. See also *Reports of the Female School of Art, 1863–1906*, Central School of

Art and Design Library, London.

21. *Times* (London), 24 June 1864, 14.

22. Ibid. One of the farces performed was *Mumbo-Jumbo* by "William Shakspere" [Henry Cole and his brother Charles Cole]. A copy of the play is in the NAL.

23. C.L.E., "The Fancy Fair of Kensington," *London Society* 4 (1863): 107.

Figure 25: James McNeill Whistler, *The Little White Girl: Symphony in White, No. II*, 1865

24. Carroll diary, 23 June 1864.

25. Ibid., 24–25 June 1864.

26. Gernsheim Collection, University of Texas at Austin.

27. Carroll diary, 22 July 1864.

28. Ibid., 24–25 July 1864.

29. Ibid., 13–17 July 1865.

30. *PN* 7 (27 February 1863): 99.

31. *PN* 8 (15 July 1864):348.

32. Jones, *Rejlander*, 17.

33. According to Jabez Hughes, in *PN* 9 (21 April 1865):188.

34. *PN* 8 (1 January 1864):11.

35. *Illustrated London News* (11 June 1864):575.

Figure 26: Francis Seymour Haden, *The Assignation*, 1865

36. *PN* 7 (27 February 1863):99.

37. Jones, *Rejlander*, 11.

38. According to A. H. Wall, quoted in Jones, *Rejlander*, 38.

39. Jones, *Rejlander*, 37.

40. Carolyn Bloore and Grace

Seiberling, *A Vision Exchanged: Amateurs & Photography in Mid-Victorian England* (London: Victoria and Albert Museum, 1985), 42.

41. Larry J. Schaaf, personal communication.

42. Some fine examples of her work are in the Spencer-Cowper family album, PD&P.

43. See David H. Davison, *Impressions of an Irish Countess: The Photographs of Mary, Countess of Rosse, 1813–1885* (Ireland: Birr Scientific Heritage Foundation, 1989).

44. See Mike Weaver, "A Divine Art of Photography," in his *Whisper of the Muse: The Overstone Album & Other Photographs by Julia Mar-*

garet Cameron (Malibu: J. Paul Getty Museum, 1986).

45. "A Reminiscence of Mrs. Cameron. . ."

46. See Joanne Lukitsh, *Cameron: Her Work and Career* (Rochester, NY: International Museum of Photography at George Eastman House, 1986), 12 n. 6.

47. Kate Perry to William Brookfield, 3 November 1865, quoted in Charles and Frances Brookfield, *Mrs Brookfield and Her Circle* (London: Sir I. Pitman & Sons, 1905), 2:515.

48. A. H. Wall, "A Few Thoughts About Photographic Art Progress," in *PN* 9 (16 June 1865): 283.

49. Rejlander, "In Memoriam."

50. For a complete account of the Hawarden-Haden association, see Virginia Dodier, "Haden, Photography and Salmon Fishing," *Print Quarterly* 3 (1986):34–50.

51. [Francis Seymour Haden], "About Etching," *Fine Arts Quarterly Review* 1 (1865):146.

52. David Wright, V&A, was first to notice the Rejlander on the wall.

53. Francis Seymour Haden to Philippe Burty, quoted in Philippe Burty, "L'Oeuvre de M. Francis Seymour-Haden," *Gazette des Beaux-Arts*, 3 (1865):277. Original in French.

54. Cat. nos. BM 1910-4-21-99 and BM 1910-4-21-100 were traced by the author.

55. Burty, "Seymour-Haden," 286.

56. Ibid., 4:356.

57. Ibid.

Epilogue

1. Death certificate, General Register Office, London.

2. *Cashel Gazette*, 4 February 1865.

3. Rejlander, "In Memoriam."

4. Foundation title writ, Cumbernauld Development Corporation archives, Cumbernauld, Scotland.

5. *PN* 9 (11 August 1865):378.

6. "Minutes of General Meetings," RPS.

7. *PJ* 11 (15 December 1866):174.

8. *PN* 10 (14 December 1866):596.

9. *The Annual Register ... 1905* (London and New York: Longmans, Green, 1906).

The Return of Lady Hawarden

1. The early history of the Hawarden collection at the V&A appears in Mark Haworth-Booth, *Photography: An Independent Art: Photographs from the Victoria and Albert Museum, 1839–1996* (London: V&A Publications; Princeton: Princeton University Press, 1998).

2. Richard Dorment et al., *James McNeill Whistler* (London: Tate Gallery, 1994), 14.

3. Andrew Wilton and Robert Upstone, eds., *The Age of Rossetti, Burne-Jones & Watts: Symbolism in Britain, 1860–1910* (London: Tate Gallery, 1997), 35, 108.

4. Helen Grace Barlow, "Truth and Subjectivity: Explorations in Identity and the Real in the Photographic Work of Clementina Hawarden (1822–65), Samuel Butler (1835–1902), and Their Contemporaries," (Ph.D. diss., University of Kent, Canterbury, 1994), 179–80.

5. Val Williams, *Modern Narrative—The Domestic and the Social* (Sway, Hampshire: Artsway, 1997), 29.

6. Carol Mavor, "Becoming: The Photographs of Clementina Hawarden, 1859–1864," in *Genre* 29 (1997), 108–110.

7. Ibid., 124.

8. Personal communication of the artist. The story is told by Traeger in her interview in the Oral History of British Photography, National Sound Archive, British Library, London.

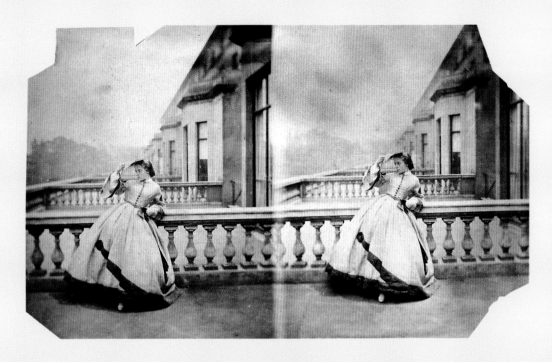

Index

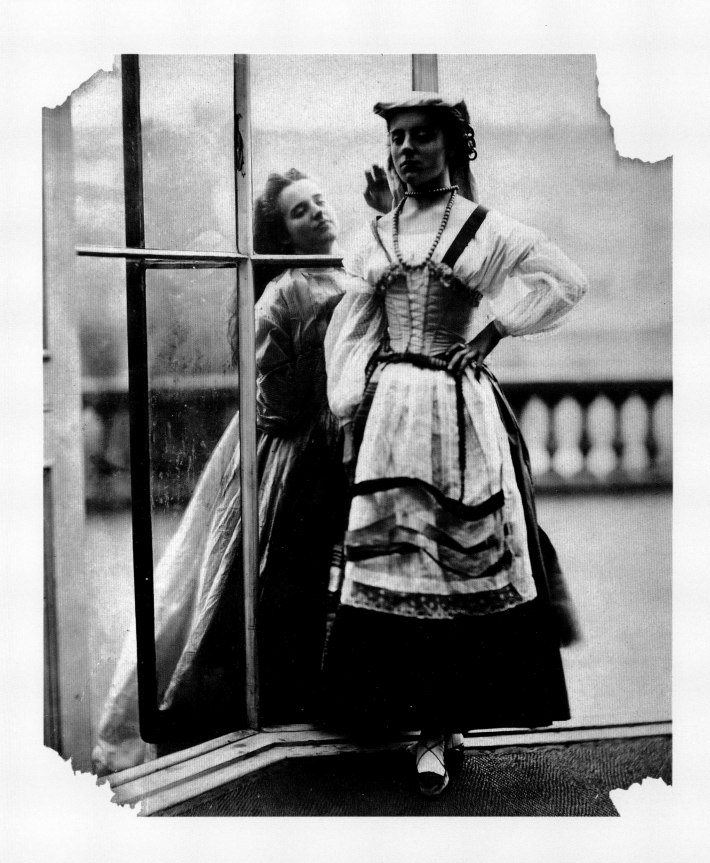

Acknowledgments

No one has had a more important role in this project than Mark Haworth-Booth, Curator of Photographs, Victoria and Albert Museum, London. As a teacher, supervisor, and mentor he is exemplary. He embodies the ideals and principles that I admire most, and his humor and sense of fun are a joy to those lucky enough to work with him. I owe him a great deal, and I hope to have the opportunity to take advantage of his good nature often in the future.

It was a great pleasure to correspond with and to meet many members of Lady Hawarden's family, each of whom was exceptionally friendly, helpful, and kind to me. I particularly regret that her great-granddaughter Jean C. Keyte died before this book was published. I will never forget her warmth, her generosity, and her bright dark eyes, so like those of the children in the photographs. Jean, Lady Polwarth (Anne Bontine's great-granddaughter), freely shared her extensive collection of family papers and photographs (now in the National Library of Scotland, Edinburgh) and has been unstintingly generous with her time. Sir Henry Warner, a great-grandson, and Lady Warner were equally supportive and hospitable. Another great-grandson, David Mansel Lewis, kindly shared family reminiscences with me. The late Viscount Hawarden and Susannah, Viscountess Hawarden graciously made available the family's portrait of Clementina Hawarden.

I would also like to thank Sir Bruno Welby for showing me photographs by his great-granduncle, Henry Stuart Wortley; and Eric W. D. H. Earle for sharing information about the life and work of his great-grandfather, Dr. W. D. Hemphill.

I am grateful to Austin and Mary Crowe and their staff at Dundrum House Hotel, County Tipperary, Ireland, for their warm hospitality, and for digging deep into their knowledge of local history.

Much of the research for this volume was accomplished in 1986–88, when the V&A employed me to compile a catalogue raisonné of its Hawarden collection. The funds for this project were generously provided by the J. Paul Getty Trust Grant Program, to which I will remain indebted for making possible this unique research opportunity. With the support of the museum's Department of Prints, Drawings and Paintings I was able to enter the catalog information on computer—thus ensuring the accuracy and accessibility of the catalogue raisonné.

For facilitating access to their collections while I was compiling the Hawarden catalogue raisonné, I warmly thank Weston Naef and Gordon Baldwin, the J. Paul Getty Museum, Los Angeles; Pierre Apraxine and Lee Marks, Gilman Paper Company Collection, New York; Françoise Heilbrun and the late Philippe Neagu, Musée d'Orsay, Paris; Colin Ford and Janet Kenyon, National Museum of Photography, Film and Television, Bradford, England; Roy Flukinger and Barbara McCandless, Photography Collection, Harry Ransom Humanities Research Center, University of Texas at Austin; Paul F. Walter; and Richard West-Skinn.

For generously suggesting research leads, I am indebted to Philippe Garner, Sotheby's, London. Robin Garton, Garton & Co., Wiltshire, shared his extensive knowledge of the work of Francis Seymour Haden with me, and introduced me to the Haden scholars Richard S. Schneiderman and John Klein, to whom I am also indebted. I am grateful as well to the late Alexis Pencovic, the noted collector of Haden prints.

Many individuals helped me with questions about Lady Hawarden, her family, her associates, and her times. I would particularly like to thank the following: David Allison, Michael Pritchard, and Lindsey Stewart, Christie's South Kensington, London; Philip Attwood, British Museum; Joanna Banham; Carolyn Bloore; the late Helen Chadwick; Judge Margaret D. Cosgrave; Brigadier C. H. Cowan, Cumbernauld Development Corporation, Scotland; Isobel Crombie, Photograph Collection, Australian National Gallery, Canberra; Laurence Davies, Dartmouth College; Frances Dimond, Photograph Collection, Royal Archives, Windsor; Lord Ellenborough; C. A. J. Elphinston; Lee Fontanella; the late Professor Helmut Gernsheim; Anthony Hamber; Violet Hamilton, Michael Wilson Collection, London; Professor Margaret Harker; Heinz and Bridget Henisch; David Hughes, York University, Ontario; Ken and Jenny Jacobson; Dom Philip Jebb, Downside School, England; G. W. Linton Smith; Valerie Lloyd; the late Jeremy Maas; David Mattison; Ann Monsarrat; Gertrude Prescott Nuding, Wellcome Foundation Ltd.; Terence Pepper, National Portrait Gallery, London; Jeanne Pingree, Imperial College, University of London; Benedict Read; Pam Roberts, Royal Photographic Society, Bath, England; Jonathan Ross, Agar Aids, London; Larry J. Schaaf; Helen Smailles, Scottish National Portrait Gallery, Edinburgh; Robert Sobieszek; Robin Spencer, University of St. Andrews, Scotland; Mark Stocker, University of Canterbury, Christchurch, New Zealand; Dr. Nigel Thorp, Glasgow University Library; John Ward, Science Museum, London; Cedric Watts, University of Sussex; Dr. Mike Weaver; Bill West; Stephen White; Rev. R. G. Wickham; and John Wilson.

For essential assistance and support, I am grateful to present and former staff members in the V&A Department of Prints, Draw-

ings and Paintings, particularly Sarah Postgate and Christopher Titterington. Elizabeth Bonython gave me a great deal of information about Henry Cole and his associates, and allowed me to consult her notes. Dr. John Physick shared his extensive knowledge of V&A history. Other members of V&A staff who helped me over the years—with the catalogue raisonné, the exhibition, and this book—include Marion Baker, Martin Barnes, Charlotte Cotton, Fiona Czerniawska, Clare Davis, Marjorie L. Finnis, Julian Litten, Veronica Murphy, Frances Rankine, Moira Thunder, Margaret Timmers, Marjorie Trusted, Dr. Clive Wainwright, and David Wright. Philip de Bay of the V&A Photography Studio made the excellent color transparencies used in production of this book.

I extend my gratitude and appreciation for long-term professional support to the staffs of the following institutions: British Library, London; British Museum, London; Witt Library, Courtauld Institute of Art, London; India Office Library, London; Library of Congress, Washington, D.C.; National Art Library, London; National Library of Scotland, Edinburgh; The New York Public Library; Princeton University Library; Public Record Office, Kew, England; Royal Commission on Historical Manuscripts, London; Scottish Record Office, Edinburgh; Department of Local History and Archives, Sheffield, England; Somerset House, London; Senate House Library, University of London; and the Harry Ransom Humanities Research Center, University of Texas at Austin.

I am honored to publish this, my first book, with Aperture. I deeply appreciate the level of commitment given by Michael Hoffman, who has always been a fan of Lady Hawarden. I am delighted with Marina Warner's perceptive essay. I cannot express enough gratitude to the Aperture team: Maureen Clarke skillfully pared the text into shape; Nell Farrell oversaw the editorial process with great aplomb; Rebecca Kandel went above and beyond the call of duty to get many of the reproductions; and Michelle Dunn brought it all together with her elegant design. I also warmly thank former members of Aperture staff Diana Stoll and KC Lynch for their assistance.

I wish to thank my good friends in the field who offered advice and assistance during the long process of getting published: Diana Edkins, who read the manuscript and gave me a great pep talk; Helen Gee; Daile Kaplan; Carole Kismaric; Barbara Michaels; Jay Rabinowitz; and Stephanie Salomon, who expertly edited the first draft. Other friends and colleagues helped with the last minute scramble: Julian Cox; India Dhargalkar; Peter C. T. Elsworth; Cornelia Knight; Hans Kraus; Jeff Rosenheim; and Maria Umali. Others who generously gave of their time and expertise were John Trevitt, Cambridge University Press; Dirk Nishen and David Milbank Challis, Dirk Nishen Publishing Ltd., London and Berlin; and John Nicoll, Yale University Press, London.

For organizing the Hawarden exhibition tour in 1990–91, I would like to express my deep appreciation to Brett Rogers and Richard Riley, Fine Arts Department, The British Council.

I would like to warmly thank my former colleagues at The Victorian Society, London, particularly Peter Howell and Teresa Sladen, for patiently accommodating my focus on activities outside the office. In the Department of Photography at the Museum of Modern Art, New York, I received essential guidance and support from my colleagues Susan Kismaric and John Szarkowski, to whose examples I owe so much.

At the Courtauld Institute of Art, University of London, I was fortunate to study with John House and to develop a circle of friends, each of whom has given me advice, opinions, and information freely: Penelope Curtis, Liesbeth Heenk, Elizabeth Prettejohn, Carla Rachman, Alison Smith, Josie Taylor, and Hilary Morgan Underwood. Katrina Rolley helped me immeasurably by assigning each photograph to one of the following categories: "dress," "dressing-up," and "fancy dress."

I attended the Courtauld Institute on a two-year Edward Maverick Scholarship. I am forever indebted to the members of the scholarship committee—Robert C. Kennedy, Mary L. Stoltzfus, and Phelps Warren—as well as to the late Michael Kitson, then deputy director of the Courtauld. I also warmly thank my Cooper Union School of Art teachers Dore Ashton and the late William Gedney for supporting my application.

My parents, Jean and Victor Dodier, provided emotional and material support unquestioningly throughout this project. I wish that my grandmother and grandfather, Nellie and John Hernandez, were still with us to see this beautiful book. Each of my brothers and sisters—Victor, Jean, John, Grace, Robert, Mary, and Katherine—contributed. Besides the essential, practical support that my family gave me, my understanding of Lady Hawarden's life and work owes much to my experience of family life—especially the sense of tribal unity, the absorption in private games, and the nicknames.

I conclude by thanking my close friends, Annie Herron, Fred Johnson, and Kathy Mclauchlan, each of whom has given me so much real help in seeing this through; and David Dean who, as friend, husband, and friend again, has provided every kind of support, tangible and intangible, to this long, long labor of love.

Virginia Dodier
Brooklyn, New York
October 1998

Unless otherwise noted, all images are courtesy of, and copyright by, The Board of Trustees of the Victoria and Albert Museum, London. Fig. 1, p. 9 The Hon. Mrs. Steele, Faversham, England; fig. 2, p. 16 The Lady Polwarth, England; p. 19 Paul F. Walter; p. 24 The Lady Polwarth, England; fig. 3, p. 30 Eric W. D. H. Earle, England; p. 48 Photography Collection, Harry Ransom Humanities Research Center, University of Texas at Austin; fig. 5, p. 52 Guildhall Art Gallery, Corporation of London, UK/Bridgeman Art Library, London/New York (GHA8068); fig. 6, p. 53 The Metropolitan Museum of Art, New York, David Hunter McAlpin Fund, 1952 (52.524.3.2); fig. 9, p. 89 Orsay copyright © Photo RMN—Hervé Lewandowski, Paris; fig. 10, p. 90 and p. 91 Photography Collection, Harry Ransom Humanities Research Center, University of Texas at Austin; fig. 11, p. 92 George Eastman House, Rochester, New York; fig. 12, p. 95 J. Paul Getty Museum, Los Angeles (84.XZ.186.52); fig. 13, p. 96 Tate Gallery, London/Art Resource, New York; fig. 14, p. 98 The Freer Gallery of Art, Smithsonian Institution, Washington, D.C. (F89.28); fig. 15, p. 100 copyright © The British Museum, London; p. 101 The Gilman Paper Company Collection, New York; fig. 16, p. 102 The Cleveland Museum of Art, 1998, Gift of Leonàrd C. Hanna, Jr., Schneiderman 30, V/VI. 1947.400; fig. 17, p. 102 and figs. 18 and 19, p. 104 S. P. Avery Collection, Miriam and Ira D. Wallach Division of Art, Prints and Photographs, The New York Public Library, Astor, Lenox and Tilden Foundations; fig. 20, p.111 copyright © Sally Mann, courtesy Edwynn Houk Gallery, New York; fig. 22, p. 114 Maureen Paley/Interim Art, London; fig. 25, p. 121 Tate Gallery, London/Art Resource, New York; fig. 26, p. 122 The British Museum, London.

Library of Congress Catalog Card Number: 98-89096
Hardcover ISBN: 0-89381-815-1

Book design by Michelle M. Dunn
Jacket design by Kevin Clarke

Color separations by Sfera Srl, Milan, Italy
Printed and bound by Artegraphica, S.p.A., Verona, Italy

The Staff at Aperture for
Lady Hawarden: Studies from Life, 1857–1864 is:
Michael E. Hoffman, *Executive Director*
Stevan A. Baron, *Production Director*
Maureen Clarke, *Text Editor*
Nell Elizabeth Farrell, *Project Editor*
Helen Marra, *Production Manager*
Lesley A. Martin, *Managing Editor*
Phyllis Thompson Reid, *Assistant Editor*
Margaret Carlson, *Foreign Rights Manager*
Rebecca A. Kandel, *Editorial Work-Scholar*
Chelsea Knight, *Design Work-Scholar*
Jorge del Olmo, *Production Work-Scholar*

Aperture Foundation publishes a periodical, books, and portfolios of fine photography to communicate with serious photographers and creative people everywhere. A complete catalog is available upon request. Address: 20 East 23rd Street, New York, New York 10010. Phone: (212) 598-4205. Fax: (212) 598-4015. Toll-free: (800) 929-2323.

Visit the Aperture website at: http://www.aperture.org

Aperture Foundation books are distributed internationally through: CANADA: General/Irwin Publishing Co., Ltd., 325 Humber College Blvd., Etobicoke, Ontario, M9W 7C3.Fax: (416) 213-1917. UNITED KINGDOM, SCANDINAVIA, AND CONTINENTAL EUROPE: Robert Hale, Ltd., Clerkenwell House, 45–47 Clerkenwell Green, London EC1R OHT. Fax: 44-171-490-4958. NETHERLANDS, BELGIUM, LUXEMBURG: Nilsson & Lamm, BV, Pampuslaan 212–214, P.O. Box 195, 1382 JS Weesp. Fax: 31-294-415054. AUSTRALIA: Tower Books Pty. Ltd., Unit 9/19 Rodborough Road, Frenchs Forest, New South Wales. Fax: (61) 29-975-5599. NEW ZEALAND: Tandem Press, 2, Rugby Road, Birkenhead, Auckland, 10 New Zealand. Fax: (64) 9-480-14-55.

For international magazine subscription orders for the periodical *Aperture*, contact Aperture International Subscription Service, P.O. Box 14, Harold Hill, Romford, RM3 8EQ, United Kingdom. One year: $50.00. Price subject to change.

To subscribe to the periodical *Aperture* in the U.S. write Aperture, P.O. Box 3000, Denville, New Jersey 07834. Toll-free: (800) 783-4903. One year: $40.00. Two years: $66.00.

First edition
10 9 8 7 6 5 4 3 2 1